ISBN 978-0-265-85799-1
PIBN 10900282

This book is a reproduction of an important historical work. Forgotten Books uses
state-of-the-art technology to digitally reconstruct the work, preserving the original format
whilst repairing imperfections present in the aged copy. In rare cases, an imperfection in
the original, such as a blemish or missing page, may be replicated in our edition. We do,
however, repair the vast majority of imperfections successfully; any imperfections that
remain are intentionally left to preserve the state of such historical works.

BY THE GREAT MASTERS
OF THE EARLY ENGLISH, FRENCH, FLEMISH
DUTCH, ITALIAN AND SPANISH SCHOOLS

TO BE SOLD AT UNRESTRICTED PUBLIC SALE

UNDER THE MANAGEMENT OF

THE AMERICAN ART ASSOCIATION

MADISON SQUARE SOUTH

NEW YORK

ON FREE PUBLIC VIEW

AT THE

AMERICAN ART GALLERIES

MADISON SQUARE SOUTH, NEW YORK

BEGINNING THURSDAY, APRIL 15th, 1915

AND CONTINUING UNTIL THE MORNING OF
THE DATE OF SALE, INCLUSIVE

HIGHLY VALUABLE PAINTINGS

FROM THE

BLAKESLEE GALLERIES

TO BE SOLD AT UNRESTRICTED PUBLIC SALE

IN THE GRAND BALLROOM OF

THE PLAZA HOTEL

FIFTH AVENUE, 58th TO 59th STREET, NEW YORK

ON WEDNESDAY, THURSDAY AND FRIDAY EVENINGS
APRIL 21st, 22nd and 23rd

BEGINNING PROMPTLY AT 8.15 O'CLOCK

ILLUSTRATED CATALOGUE

OF THE

EXTENSIVE COLLECTION

OF

HIGHLY VALUABLE PAINTINGS

BY THE GREAT MASTERS
OF THE EARLY ENGLISH, FRENCH, FLEMISH
DUTCH, ITALIAN AND SPANISH SCHOOLS

FROM THE WIDELY KNOWN

BLAKESLEE GALLERIES

OF WHICH, ON APPLICATION OF THE COLUMBIA TRUST COMPANY AND
MRS. THERON J. BLAKESLEE, ADMINISTRATORS OF THE LATE THERON J. BLAKESLEE,
SURROGATE COHALAN HAS ORDERED A PUBLIC SALE TO BE MADE

IN THE GRAND BALLROOM OF THE

PLAZA HOTEL

FIFTH AVENUE, 58th TO 59th STREET
ON THE EVENINGS HEREIN STATED

THE SALE WILL BE CONDUCTED BY MR. THOMAS E. KIRBY
AND HIS ASSISTANT, MR. OTTO BERNET, OF

THE AMERICAN ART ASSOCIATION, MANAGERS

NEW YORK
1915

CONDITIONS OF SALE

1. **Any bid** which is merely a nominal or fractional advance may be rejected by the auctioneer, if, in his judgment, such bid would be likely to affect the sale injuriously.

2. **The highest bidder** shall be the buyer, and if any dispute arise between two or more bidders, the auctioneer shall either decide the same or put up for re-sale the lot so in dispute.

3. **Payment** shall be made of all or such part of the purchase money as may be required, and the names and addresses of the purchasers shall be given immediately on the sale of every lot, in default of which the lot so purchased shall be immediately put up again and re-sold.

Payment of that part of the purchase money not made at the time of sale shall be made within ten days thereafter, in default of which the undersigned may either continue to hold the lots at the risk of the purchaser and take such action as may be necessary for the enforcement of the sale, or may at public or private sale, and without other than this notice, re-sell the lots for the benefit of such purchaser, and the deficiency (if any) arising from such re-sale shall be a charge against such purchaser.

4. **Delivery** of any purchase will be made only upon payment of the total amount due for all purchases at the sale.

Deliveries will be made on sales days between the hours of 9 A. M. and 1 P. M., and on other days—except holidays—between the hours of 9 A. M. and 5 P. M.

Delivery of any purchase will be made only at the American Art Galleries, or other place of sale, as the case may be, and only on presenting the bill of purchase.

Delivery may be made, at the discretion of the Association, of any purchase during the session of the sale at which it was sold.

5. **Shipping,** boxing or wrapping of purchases is a business in which the Association is in no wise engaged, and will not be performed by the Association for purchasers. The Association will, however, afford to purchasers every facility for employing at current and reasonable rates carriers and packers; doing so, however, without any assumption of responsibility on its part for the acts and charges of the parties engaged for such service.

6. **Storage** of any purchase shall be at the sole risk of the purchaser. Title passes upon the fall of the auctioneer's hammer, and thereafter, while the Association will exercise due caution in caring

for and delivering such purchase, it will not hold itself responsible if such purchase be lost, stolen, damaged or destroyed.

Storage charges will be made upon all purchases not removed within ten days from the date of the sale thereof.

7. **Guarantee** is not made either by the owner or the Association of the correctness of the description, genuineness or authenticity of any lot, and no sale will be set aside on account of any incorrectness, error of cataloguing, or any imperfection not noted. Every lot is on public exhibition one or more days prior to its sale, after which it is sold "as is" and without recourse.

The Association exercises great care to catalogue every lot correctly, and will give consideration to the opinion of any trustworthy expert to the effect that any lot has been incorrectly catalogued, and, in its judgment, may either sell the lot as catalogued or make mention of the opinion of such expert, who thereby would become responsible for such damage as might result were his opinion without proper foundation.

SPECIAL NOTICE.

Buying or bidding by the Association for responsible parties on orders transmitted to it by mail, telegraph or telephone, will be faithfully attended to without charge or commission. Any purchase so made will be subject to the above Conditions of Sale, which cannot in any manner be modified. The Association, however, in the event of making a purchase of a lot consisting of one or more books for a purchaser who has not, through himself or his agent, been present at the exhibition or sale, will permit such lot to be returned within ten days from the date of sale, and the purchase money will be returned, if the lot in any material manner differs from its catalogue description.

Orders for execution by the Association should be written and given with such plainness as to leave no room for misunderstanding. Not only should the lot number be given, but also the title, and bids should be stated to be so much *for the lot*, and when the lot consists of one or more volumes of books or objects of art, the bid per *volume* or *piece* should also be stated. If the one transmitting the order is unknown to the Association, a deposit should be sent or reference submitted. Shipping directions should also be given.

Priced copies of the catalogue of any sale, or any session thereof, will be furnished by the Association at a reasonable charge.

AMERICAN ART ASSOCIATION,
American Art Galleries,
Madison Square South,
New York City.

CATALOGUE

ITALIAN PICTURES

ATTRIBUTIONS AND CRITICAL NOTES BY

DR. OSVALD SIRÉN, STOCKHOLM

DESCRIPTIONS BY

MR. WILLIAM ROBERTS, LONDON

THE ITALIAN PICTURES IN THE BLAKESLEE COLLECTION

INTRODUCTORY NOTES BY DR. OSVALD SIRÉN, STOCKHOLM

AMONG the sixty-two Italian pictures in the Blakeslee Collection which I had the opportunity of seeing last Spring in New York, is none by any of the most famous masters of the Renaissance, but several by minor painters which are of great interest both to collectors and to students of Italian art. I hope that the following notes may serve to point out the special historic value of a few of them when they are placed in their proper schools, and, wherever possible, under individual names. Most of them had quite arbitrary attributions, if they had any names at all.

I need hardly state that in attributing the pictures to definite artists it has been my endeavor to go as far as possible. But this is only possible at all when the painting shows a marked original character. There are, alas, some other pictures which have gone through so many vicissitudes, in the shape of repeated cleanings and restorations, that they have lost most of what they once may have possessed in the way of genuine style and character. In such cases the expert's work becomes almost futile, and it must be left to the intelligent beholder to use his own discrimination.

As the Catalogue contains short statements about every artist or school to which the pictures are attributed, and, where necessary, a few remarks about the quality of the pictures, I can here limit myself to shortly touch upon some of the more important paintings, giving additional reasons for their identification.

The earliest period of Italian Renaissance Art (if we reckon its beginning from Giotto), the Trecento, is represented in the collection by one picture only, but it is of considerable historic interest. It bears the name of

Cimabue, an honor bestowed even upon many less important and less early Trecento-paintings, though it is evident that the picture has nothing to do with the Tuscan School at all. It has been done by Bologna's leading Trecento-master, Vitale, usually nicknamed "Vitale delle Madonne."

In an article in *Rassegna d'Arte,* Feb., 1910, Dr. T. Gerevich gives documentary dates to the life of Vitale. The painter was born during the first decade of the fourteenth century and died between 1360 and 1370.

Vitale's artistic style is known to us mainly through three Madonnas in his native city; one in the Pinacoteca, one in the church of San Salvatore and one in the Palazzo Davia-Bargellini; the one in the Vatican Gallery in Rome being sadly repainted. The first named is signed and dated 1320. But there can be little doubt that the date has been altered at some later epoch; the style of he painting proves that the master did not work in the second decade but towards the midst of the century. This is also confirmed by the date on the Madonna in the Palazzo Davia-Bargellini, which is 1345, and by another Madonna, published by D'Agincourt (pl. CXXVII), with the same date. The Blakeslee picture is possibly still younger; it stands in the closest relation to the "Madonna della Vittoria," now in San Salvatore, but formerly in San Giovanni at Monte, outside Bologna. The composition is practically the same in both, and the Madonna's elongated type of face with the long nose and the large almond-shaped eyes show scarcely any variation. The two boys are also very closely related, the one in the Blakeslee picture being perhaps a little more solemn in his performance of the ritual blessing while sucking at the mother's breast. Two monumental Saints and some small figures on the pediments add to the decorative effect of the picture which has only been infringed by cutting off a piece at the bottom.

Two other pictures in the collection reveal still the Trecento tradition, though they are painted three or four decades after the close of the fourteenth century. Both represent the Madonna seated in a low position, on a cushion or on a bed of clouds, with the one leg bent under her and the other knee raised so as to offer a suitable support for the child. This ele-

ment of composition is a favorite one among the late Gothic painters in Italy, because it offers a fine opportunity for rich display of undulating mantle-folds and sweeping contours. The Virgin and the Child are united in a group which harmonizes perfectly with the *ogival* arch of the enclosing tabernacle. The figures are more pattern of design than representations of human beings; the principal aim of the artist being not representation, but pure decorative beauty.

The first of the Madonnas in the Blakeslee Collection is of *F*lorentine origin; it is painted by the very attractive master I characterized some twelve years ago in my book on Lorenzo Monaco as "il Maestro del Bambino Vispo," but who later on has been identified by me as *Parri Spinelli*. The picture belongs to a comparatively early period in his career, when he still worked under the predominating influence of Lorenzo Monaco, the probable date of it being about 1415-20.

The other Madonna-picture is not at all *F*lorentine, though it seems to be showing a general resemblance to the first one in regard to its composition; it is by a painter of the Marches. The school becomes evident in the Virgin's heavy, flat type and in the exquisite ornamentation of her precious white dress. But the individual master is in this case not so easily found. There are many unknown painters among the March-men of the early fifteenth century. The leading master of that school was, at the beginning of the Quattrocento, Lorenzo da San Severino; but he is, as a whole, more primitive and rustic than the painter of this winning Madonna-picture. We must look around among Lorenzo's immediate followers to find its master, but these smaller men of the Marches are as yet too little studied to make an affirmative attribution safe. The most marked individuality known among them is *Fra Matino Angeli*. His signed and dated (1442) altarpiece at Monte Vidon Combatte affords apparently affinities of style to the Blakeslee Madonna, particularly in the drawing of the Virgin's mantle and of the boy; he might possibly have painted the Little Madonna some years earlier.

The *F*lorentine Quattrocento is represented by six or seven pictures, among which are some problems worth a more thorough discussion than we

in this short introduction can bestow; we must limit it to the most necessary remarks on the anonymous masters.

"*The Master of the San Miniato Altarpiece*" is the name given by Mr. Berenson to a follower of Pesellino and *F*ra *F*ilippo, whose principal work is a Madonna between four saints at San Miniato al Tedesco. Besides this large painting, he has done several small Madonnas of rather unequal quality; we have seen recently two of his Madonnas in the market. And here in the Blakeslee Collection is the third. This picture comes very close to the one acquired by the Minneapolis Museum (formerly belonging to Lady Theodora Guest). Both are to be counted among his better works, where a sensible echo of the *F*ra *F*ilippo-Pesellino tradition still is to be felt. The master is a dependent man, who occasionally charms us, when nothing better is at hand, but who probably in his life-time had not the name of anything more than a humble artisan; still, he worked during the golden epoch of *F*lorentine art.

Much higher in quality and a little later in time stands the anonymous master whom we have given the temporary name: "*M*aster of the Oriental Sash*.*" The name needs hardly any explanation. It has been chosen because most of the artist's Madonnas wear an Oriental sash, used either as a belt or as a bandage to support the child; it may be added, the master has a general predilection for embroidered and richly ornamented material.

This is all confirmed by the picture in the Blakeslee Collection representing the Holy Virgin, nursing the Child, attended by St. John. The boy wears an embroidered frock and he sits on the Oriental sash which is tied around the mother's neck. The group is placed under a marble arch inlaid with colored slabs and cut at the top. The preservation of the picture is, as anyone can see, not the best; it has been rubbed off a good deal. But it is perfectly characteristic of this anonymous master, who, as we follow him through his various works, appears to be one of the most charming (though not one of the strongest) among *F*lorentine Quattrocentists. As his artistic personality never yet has been defined, we will use this occasion to say a few words about his development and his principal works. We find them in several museums ascribed to various masters:

Florence, *U*ffizi Gallery, Nr. 1278[bis], "Scuola del Andrea del Verrocchio" Altarpiece representing the Madonna on a throne of multicolored marble with arched top; on the sides stand St. Zenobius and St. John the Baptist; kneeling in the foreground are St. *F*rancis and St. Nicholas. In the very laconic catalogue of the Uffizi Gallery (English edit., 1904) this picture is accompanied by the following note: "It is one of the finest specimens of *F*lorentine art and lay hidden and forgotten till 1881 in the storerooms of the Royal *U*ffizi Gallery. Having then been discovered and examined by the members of the royal commission of art, it was pronounced a painting by Verrocchio." The royal commission seems later to have arrived at another result, because nowadays the picture is more safely ascribed to the school of Verrocchio.

Florence. *U*ffizi; from Sta Maria Nuova, Nr. 23: Madonna and three angels. This picture is officially ascribed to "*F*ra *F*ilippo Lippi(?)" and by Mr. Berenson to "Amica di Sandro." ("*F*lorentine Painters," 3d edit., p. 100.)

Florence. Prof. Luigi Grassi: Madonna standing under an arch suckling the Child, who is supported by the Oriental sash, tied round the mother's neck. This Madonna is the exact counterpart of the one in the Blakeslee Collection, the only difference being that the picture is larger and better preserved, and that St. John is replaced by a vase of flowers.

Englewood, N. J. Mr. *D. F.* Platt: Madonna holding the Child on a cushion while he is kicking with his feet and blessing with his hand. A very interesting, probably early picture, close to the Madonna in Paris and Munich (see below).

London. National Gallery, Nr. 589, "School of Lippi": The Virgin seated under an arch, an angel presenting the infant Christ to her. The composition is inspired by Botticelli's Chigi Madonna, now belonging to Mrs. Gardner in Boston. There is another version of the same Madonna, with two angels, in the museum at *Naples*. It is probably a somewhat later work by our master, though less obvious.

Milan. Museo Poldi-Peszoli, Nr. 156, attributed in the catalogue of 1911 to Botticelli: Madonna; child standing on her knee, an angel is present-

ing a vase with flowers. Picture showing influence of Cosimo Rosselli, besides Verrocchio and Botticelli.

Munich. Julius Boehler: Madonna caressing the Child, who is supported by two angels. Closely related to Mr. Platt's Madonna.

Paris. Louvre, Nr. 1345, "Ecole de *F*ra *F*ilippo Lippi": Madonna seated on a cushion on the ground offering a pomegranate to the boy. Adoring angels with flowers form a niche behind her. One of the master's best pictures.

Paris. M. Henri Heugel: Virgin and the little St. John adoring the child. The Virgin's mantle is lined with beautiful brocade stuff; rocky landscape, very attractive. Ascribed by Mr. Berenson to Botticini ("*F*lorentine Painters," 3d edit., p. 121), and in Sedelmeyer's Catalogue, 1902, to *F*ilippino Lippi.

No doubt the list of this anonymous master's works could easily be enlarged, but those mentioned afford enough material for a just appreciation of his artistic ability; the attributions quoted above may serve to throw some light on the general uncertainty about his derivation and his position in the *F*lorentine School.

Evidently, the painter is to be reckoned among Verrocchio's pupils, although he might have begun his artistic career already with some older master, like Cosimo Rosselli. Verrocchio's severe, somewhat harsh style is predominant in the large Uffiizi altarpiece. But the master's own temperament seems to have brought him in closer contact with Botticelli's art; several of his smaller Madonnas (for instance, Platt's and Boehler's) show interesting affiliations with Botticelli's early works. Possibly—and this is the most natural assumption—he was an assistant first with Verrocchio and then with Botticelli. Thus he came also in contact with Botticini. And, indeed, this is the master with whom he is most easily confounded. Their lines of evolution run at least in the beginning paral'el; they step out of Verrocchio's workshop about the same time, and they are both second-rate men often engaged in multiplying known compositional forms and figures. Botticini is perhaps the stronger draughtsman, but he is also harder and dryer than the "Master of the Oriental Sash." He lacks the tone of dream and yearning which is

characteristic of so many of the anonymous master's Madonnas, connecting them with Botticelli's blessed Virgins.

Anyone who will take the trouble to examine the pictures enumerated above will easily recognize the identity of the painter and his most pronounced morphological characteristics. The Madonnas have all the same type; a short triangular face with a broad forehead and pointed chin; the hands are feeble in comparison with those of Verrocchio, Botticelli or even Botticini; the drawing of the boneless fingers being particularly deficient. The *bambino* is rather clumsy, with an excessively large round head. But, in spite of that, his liveliness is very marked, especially when he is not entirely engrossed in the appeasing of his appetite. His playfulness in connection with the heavy, contracted limbs give him sometimes almost likeness with a bear's cub.

The master is a poorer landscape painter than most of his contemporaries; when he occasionally gives some nature view in the background it is hard and schematic, he evidently prefers to fill the background with some architectural motive. The incrusted marble arch reappears, as we have seen in several of the pictures, entirely or partly, enframing the Madonna group.

Another painter of the Botticelli school is represented in the Blakeslee Collection by a Madonna-*tondo* of more common character. He is considerably later than the Master of the Oriental Sash and individually less marked, thus reflecting the Botticellian art more directly, and at a later, more decadent period. We learn from him more about Botticelli's mannerisms and exaggerations than about his charm and expressiveness.

The same stylistic group is completed by *Jacopo de Sellajo's* Madonna formerly ascribed to Botticini, but marked by the characteristic mannerism of Sellajo at his latest period.

Still later in date and further developed in style are two *tondos,* the one of the school of Lorenzo di Credi and the other of the school of Piero di Cosimo, both representing the Nativity. The first is painted by a well-known artistic personality whose name, however, has not yet been found. Morelli used to call him *"Tommaso,"* identifying him with a certain Tommaso di Stefano, mentioned by Vasari among Credi's pupils; but if Vasari is right about the

master's age (born 1494), this identification is hardly convincing. The style of this individual is, however, easily recognizable in a number of pictures in the Uffizi, Pitti, and Borghese Galleries and in several private collections, most of them representing the Holy Virgin kneeling in adoration before the puffy child, sometimes accompanied by an angel, as we see her in the Blakeslee *tondo*. A drawing which probably has been used for one of "Tommaso's" kneeling Madonnas is to be found in the National Museum in Stockholm. The type of the Virgin and the treatment of the mantle folds are exactly the same as in the Blakeslee picture.

None of the very popular Sienese Quattrocento painters meet us in the Blakeslee Collection, but there are two characteristic specimens of Sienese Cinquecento art; we refer to the playing angels by Pacchiarotto and to a Madonna by Girolamo da Pacchia. The angels, which were honored by the name of Melozzo da Forli, are evidently cut out from some larger altarpiece like the Ascension of Christ in the Siena Academy. We find there their exact counterparts in the singing and playing angels, floating around the Saviour, who ascends the clouds in a dancing movement. These joyous beings seem to be a humorous mixture of seraphs and satyrisques.

A particularly fine Madonna by *Domenico Puligo* should be pointed out among Florentine Cinquecento pictures. It is not often that we find this master represented by a work of so solid and homogeneous a character. And, indeed, it is no less pleasure in the study of art than in life to find one's expectations surpassed by reality. Another good Tuscan picture, from the end of the century, is Francesco Vanni's large representation of the Madonna with St. Katherine of Siena. It is true that it shows a certain superficiality of handling and looseness of form. But the light, transparent colors endow it with an effervescent beauty, recalling French Rococo paintings.

Turning from the Tuscan painters to the Central Italians, we may observe a connecting link in a Madonna formerly ascribed to a Florentine pupil of Benozzo Gozzoli, but evidently by the Umbrian *Boccati da Camerino*, who also felt some influence from Benozzo, although his main education was that of a March-man. He represents the Madonna, as usual, on a throne of elaborate architecture, surrounded by angels who do their utmost in playing

and singing her praise. All the morphological details, the type of the Madonna and of the angels, their claw-like fingers, their whimsical movements, correspond exactly to the same details in Boccati's Madonnas in the gallery at Perugia (No. 9). There is a touch of fresh naïveté in the whole representation which might reconcile us with much of the awkwardness and deficiency in the drawing of the figures, and it remains, in spite of restorations, a rather winsome provincial idyll. A picture of stronger individual character and intrinsic drawing is the Madonna by a companion of *Lorenzo Costa*. If we dare follow Venturi, the master might be Galasso Galassi, a name proposed by the learned writer for two panels in Budapest, by the same hand as our Madonna, representing music-making angels. (Cf. "Storia dell' arte *I*taliana," vol. VII, part III, p. 496.) These angels are officially attributed to *F*rancesco Cossa and by Mr. Berenson to Marco Zoppo (?). To us it seems evident that they are by a companion of Tura, though it is hard to tell whether he was Galasso or not, as we know of no signed work by this artist. The artistic personality is marked, anyhow, and he reveals himself in the most favorite way in the Blakeslee Madonna, a picture of refined and original character in good preservation.

The central master of the *U*mbrian School, Pietro Perugino, is not represented by any work of his own, but there is a Madonna in his style probably executed by his follower *Giannicola Manni*. A comparison with Manni's large altarpiece, the Madonna between St. *F*rancis and St. Jacob, in the gallery at Perugia, offers ample reason for this attribution.

A smaller octagonal picture representing the Virgin between the Two St. Johns shows the Peruginesque School tradition mixed with the current of the *F*rancis School at Bologna. The blending of these two different currents took place especially in the Romagna. There can be little doubt that the present picture was executed in that region.

Giovanni Battista Bertucci of *F*aenza is the nearest designation we can propose for the picture; it is somewhat finer and more graceful than Bertucci's large altarpiece in *F*aenza and in Berlin. But the style is the same, and the artist probably handled the smaller painting with greater care.

The Milanese pictures are not very numerous in the Blakeslee Collec-

tion, but among them are two or three of particular interest. The first is an altarwing attributed to Butinone. The picture has been discussed by Herbert Cook in the *Burlington Magazine* (1904, p. 94), who reckons it as one of the few known authentic works by this rare master of Treviglio. "It dated apparently from the era of the Treviglio altarpiece, i. e., about 1485, with which comparison of detail should be carefully made. In particular the metallic luster of St. John's face and the curious drawing of the bony fingers are characteristic of our painter." Bernardino de' Conti's Madonna is interesting because of the predominant influence from Leonardo's art it exhibits. The landscape is in a cold greenish tone, and the Virgin's type is Leonardesque. Had it not been so much rubbed, it would take a prominent place in the school of Leonardo.

The best picture in this group, is however, *Andrea Solario's* "Madonna dei fiori." The unusually attractive motive of the Virgin offering some flowers in her outstretched hand gives a pleasant feeling of Solario's close affiliation with Venetian art. It is the same motive which has become famous through Titian's "*F*lora" in the *U*ffizi. *I*s it possible that the painters have invented it independently, or have they borrowed it from a common source? Solario can at least not have taken it from Titian, because his Madonna picture is nearly twenty years earlier than Titian's "*F*lora." It stands in closest relation to the Holy *F*amily with Saint Jerome in the Brera, dated 1495.

Another outsider who, like Solario came under predominating Venetian influence was *Boccaccio Boccaccino* of Cremona. We are inclined to attribute to him a little Madonna, formerly ascribed to Giacomo Francia. The attribution is sustained by several details such as the Virgin's left hand, the draping of her mantle, the delicate treatment of the landscape, and above all by the characteristic boy; he is the typical Boccaccino *bambino,* with a large head and precocious expression. The Virgin's type is a little more Venetian than we are used to find in Boccaccio's pictures.

The other North Italian pictures in the Blakeslee Collection need scarcely be discussed; they are noted with deserving remarks in the Catalogue. The most problematic among them is the Madonna catalogued under *Girolamo dai Libri's* name. The attribution is about as hard to con-

firm as to disprove, because so much of the picture's original character has been lost in the restorer's shop. But it possesses still an undeniable charm, and much can be said in favor of it being an original by Girolamo dai Libri. Anyhow, its Veronese origin is evident.

The Bellini School, the central hearth of Venetian painting at the end of the Quattrocento, can be studied in several second-hand works. Pissolo is represented by a nice and soft Madonna and by a still more attractive bust of the Saviour, both in light and hazy colors; *Girolamo da Treviso* by a characteristic signed Madonna of unusual size, and *Girolamo da Santa Croce* by a very decorative Madonna being an imitation of the Bellinesque composition.

Palma Vecchio's Holy Family is a well-known picture from the Butler sale, which always will hold its place as an effective piece of decoration. The same is true in still higher degree of the large portrait representing a lady with her dog from the *Farrer* Collection. It is, indeed, a picture of very remarkable decorative quality; the silver brocade in the lady's dress and the transparent white sleeves are painted with an admirable technique. The landscape view is given in pastos colors almost in a Titianesque manner, but the handling of the face, the hands and the neck is more timid. It is evident at the first glance that the portrait stands in close relation to Paolo Veronese's art, and this has also found expression in the traditional attribution to Paolo's son Carlotto, but the individual master is perhaps not quite so evident. We know nothing by Carlotto of nearly as good and solid quality as this picture. It is also earlier in date; the treatment of the landscape, as well as the manner in which the face is painted, is pre-Veronesque, and the costume is to be seen in Titian's portrait of his daughter, Lavinia, in Dresden, about 1555. The nearest analogies to this portrait we have been able to find are the two portraits in the Museum in Vienna (Nos. 395 and 297), now unanimously given to Paolo Veronese's teacher, Antonio Badile. They exhibit the same kind of solid, somewhat provincial translation of Titian's art, the same timid handling of the flesh parts and gorgeous stuff painting as we have observed in the Blakeslee portrait. The attribution is also supported by a comparison with Badile's large altarpiece in the museum at Verona,

which is inspired by Titian's Pesaro-Madonna and includes the same kind of silver brocade as we find in the lady's dress. Badile was a poor inventor, with little or no imaginative gifts, but a good painter; he knew how to teach Paolo the brushwork!

Several pictures by various Bolognese and Neapolitan painters illustrate the *tenebroso* and academic schools of the seventeenth century; they should be appreciated from a historical point of view, whereas the small canvases by Piazzetta, Pittoni and Domenico Tiepolo may afford some æsthetic enjoyment, revealing a touch of the last brilliant effervescence of painting in Italy.

TUSCAN SCHOOLS

FIRST NIGHT'S SALE

WEDNESDAY, APRIL 21, 1915

IN THE GRAND BALLROOM

OF

THE PLAZA

FIFTH AVENUE, 58th to 59th STREET

BEGINNING PROMPTLY AT 8.15 O'CLOCK

NOTE: The attributions and critical notes of the Italian pictures are by Dr. Osvald Sirén of Stockholm, and the descriptions have been written by Mr. William Roberts of London.

No. 1

MASTER OF THE SAN MINIATO ALTARPIECE

A Florentine painter of the school of Pesellino and Fra Filippo. His actual name is as yet unknown, but he is a distinct artistic personality, named after his principal achievement, the altarpiece in the right transept of San Domenico at San Miniato al Tedesco (Cf. Berenson, "Catalogue of the John G. Johnson Collection," Vol. I, p. 23).

MADONNA AND TWO ADORING ANGELS

(Thick Panel)

Height, 25 inches; width, 19 inches

SMALL three-quarter length of the Virgin, in scarlet dress, gold mantle lined with blue, and brownish head-dress, seated on a marble bench; the Infant in white, seated on her knee, His right hand upraised, the two first fingers extended; an angel in red dress and golden hair on either side with hands clasped.

From the Conte Galli-Tassi Collection, Florence.

This picture is one of the anonymous Master's most attractive creations.

No. 2

ANGELO ALLORI (called BRONZINO)

Florentine; 1502-1572. Pupil of Pontormo, imitator of Michelangelo.

PORTRAIT OF A LADY OF QUALITY

Height, 25 inches; width, 19 inches

SMALL half-figure of a young lady with set features, directed to front and looking slightly to left; rich crimson and black dress embroidered with white and gold, edged with white lace at neck and wrists, plastron elaborately embroidered with pearls and gems, long heavy gold neck chain, held with left hand, yellow gauntleted gloves in right hand, jeweled rings on both hands; reddish-brown head-dress with white chiffon cap.

Transferred from panel to canvas.

No. 3

TUSCAN MASTER

LATTER PART OF THE FIFTEENTH CENTURY

PORTRAIT OF A LADY
(Panel)

Height, 14 inches; width, 11 inches

HEAD and shoulders to front, looking to left, yellow low dress, cut square at neck and shoulders and with black lacets; golden hair, yellow and red patterned close fitting head-dress with blue border, and heart-shaped point over forehead; gold necklace of five rows; blue background.

Inscribed on the parapet, LAVRA PETRARCHÆ.

Collections of P. Manfrin, Florence; and J. Edward Taylor, London, 1912, *No.* 20.

This is one of the best copies done from the famous miniature portrait in a *Codex* now in the Laurentian Library in Florence, ascribed to Simone Martini and said to represent Petrarch's Laura. We have seen in private collections other copies of the same miniature, but they are of less good quality.

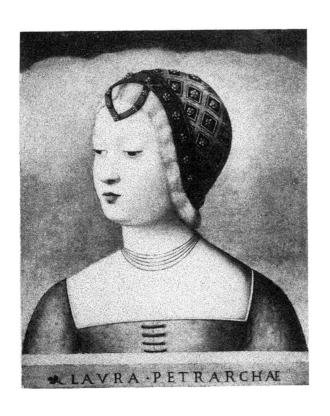

LAVRA · PETRARCHÆ

No. 4

JACOB DEL SELLAJO

Florentine; 1442-1493. Pupil of Fra Filippo; a very versatile painter, imitating Pesellino, Cosimo Rosselli and especially Botticelli.

VIRGIN AND CHILD

Height, 31½ inches; width, 17 inches

HALF-LENGTH figure, standing to front, scarlet dress, blue-hooded cloak, golden hair, holding in right hand pomegranate on which the Infant's right hand rests; he is in light bluish drapery and stands before her on a bright scarlet cushion which rests on ledge or parapet across the foreground; gray wall background, with conventional tree on either side, scarlet and gold curtains; arched top.

Transferred from wood to canvas. In contemporary carved frame.

No. 5

GIACOMO PACCHIAROTTO

Sienese, 1475-1540. Pupil of Matteo di Giovanni, influenced by Fungai and Francesco di Giorgio.

ANGEL MUSICIANS

(Pair)

Each: Height, 13 inches; length, 17 inches

(*a*) Three youthful angels walking to right and looking up; in red and greenish dresses, playing violin and cymbal, the end one praying.

(*b*) Three youthful angels to left in green, yellow and white dresses; the first two playing instruments.

Two small pictures, transferred from wood to canvas, fragments of a large altarpiece. Vivid color scheme, in good condition. In carved Renaissance frames.

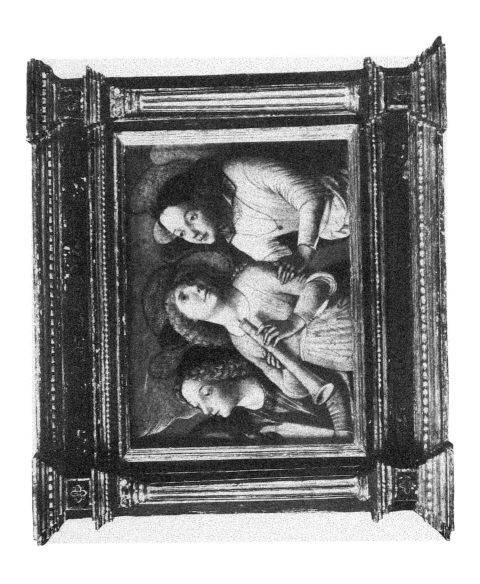

No. 6

MADONNA AND CHILD

BY

PARRI SPINELLI

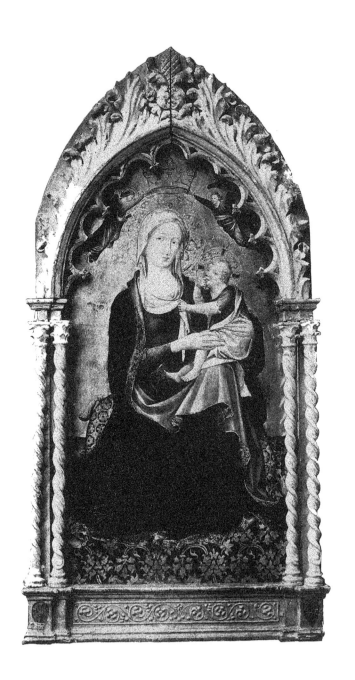

PARRI SPINELLI

Florentine school; 1387-1453. Son and pupil of Spinello Aretino; influenced by Ghiberti and Lorenzo Monaco. A full account of Parri's artistic development and his early works, which were formerly given to an anonymous master, "Il Maestro del Bambino Vispo," is to be found in *The Burlington Magazine*, March and April, 1914.

MADONNA AND CHILD

(Panel—arched top)

Height, 34½ *inches; width,* 18 *inches*

SMALL whole-length figure of the Virgin to front seated on a cushion on floor covered with brilliant scarlet and gold carpet; red dress, blue gold-embroidered cloak, loose white head-dress with long ends; the Infant in blue and scarlet, seated on his Mother's knee, holding her head-dress in left hand, and sucking forefinger to right; two angels supporting a crown over the head of the Virgin; gold background.

In contemporary carved gilt frame.

Formerly in the Galli-Dunn Collection, Pogginbonsi.

Exhibited at the Mostra dell' Antica Arte Senese, Siena, 1904.

Mentioned in "The Burlington Magazine," p. 24, *April,* 1914.

No. 7

MASTER OF THE ORIENTAL SASH

Florentine; temporary name for an artistic personality formed in Verrocchio's studio and influenced by Botticelli. A closer account of this interesting master is to be found in the introductory notes.

MADONNA, CHILD AND ST. JOHN

Height, 20 inches; width, 14 inches

SMALL half-figure of the Virgin standing under an archway to right, in red dress and blue cloak, head inclined to left, fair hair, dark head-dress, nursing the Infant, who is supported by a red and black "sling" suspended from His Mother's shoulders; the Child in gray patterned shirt at right; infant St. John in red cloak and grayish dress is carrying a cross and holding a scroll inscribed "Ecce" (Agnus Dei); green background.

Transferred from wood to canvas and framed in a Quattrocento tabernacle.

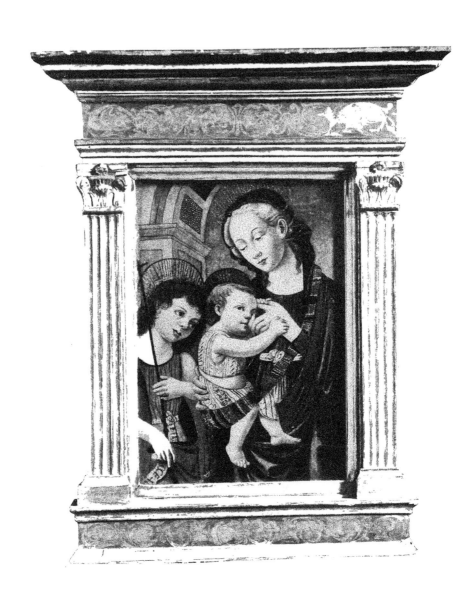

No. 8

MAESTRO TOMMASO

This is the name given by Morelli ("Die Gallerien Borghese und Doria-Panfili in Rom," p. 115) to a follower of Lorenzo di Credi whose principal works, all representing the adoration of the Christ-child in tondo-form, are to be found in the Borghese Gallery, Rome, and in the Pitti Palace, Florence.

THE NATIVITY

(Panel)

Height, 33½ inches; width, 33 inches

WHOLE-LENGTH figure of the Madonna in a landscape, to left, kneeling in adoration before the nude Infant, who is reclining on a rug on the floor; she is in scarlet low dress edged with white, white head-dress, blue cloak, fair hair; over the head of the Infant an angel is placing a floral wreath, and behind St. John is seen; to right St. Joseph in red and brown dress holding a staff; background an undulating landscape with hills.

Tondo, in original carved frame.

No. 9

DOMENICO PULIGO

Florentine; 1475(?)-1527. Pupil of Andrea del Sarto, influenced by Ridolfo Ghirlandajo.

MADONNA, CHILD AND ST. JOHN

(Panel)

Height, 32 inches; width, 25 inches

YOUTHFUL Madonna to right, directed to left, in pink, blue and yellow draperies with brown head-dress, supporting the Infant, who is holding a blue and gold striped ball handed to him by St. John, whose staff and red cloak are on the table.

A large and fine specimen of this interesting pupil of del Sarto.

No. 10

FRANCESCO VANNI

Sienese; 1565-1609. Pupil of Arcangelo Salimbeni, influenced by Andrea del
Sarto and Barocci.

VIRGIN AND CHILD AND ST. KATHERINE

Canvas: Height, 38½ inches; width, 28 inches

NEARLY whole-length of the Virgin, seated to right, directed to left; scarlet
dress with blue hood, white head-dress, brown hair; the slightly draped
Infant seated on her lap and looking up to left; St. Katherine of Siena,
with white nun's veil, holding lily branch and kneeling in adoration to left,
hands resting on book.

The figures are probably cut out of a larger composition. An attractive
painting, in light blue, green and white colors.

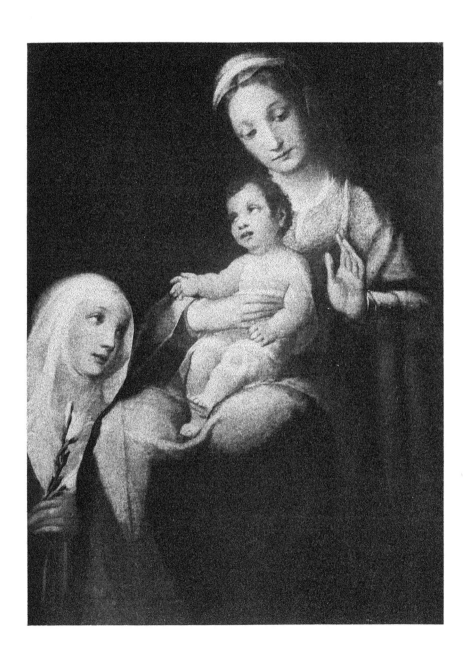

No. 11

ANGELO ALLORI (called BRONZINO)
FORENTINE: 1502—1572

PORTRAIT OF A LADY OF THE CORNARO FAMILY

Height, 34 inches; width, 27 inches

HALF-FIGURE, about thirty standing by a stone balcony; scarlet over-dress, white and gold patterned sleeves, white lace collar, pearl necklace and earrings; fair hair with pearl rope, bracelets of precious stones, right hand holding fan, left with cameo portrait of Luigi Cornaro.

Transferred from panel to canvas.

From the J. E. Taylor Collection, London, 1912, No. 16.

This portrait was evidently done in Bronzino's studio, but only partly by the master himself.

CENTRAL ITALIAN SCHOOLS
Bologna, Ferrara, Umbria and the Marches

No. 12

SCHOOL OF COSIMO TURA

Ferrarese master working about 1450, influenced by Tura and Francesco Cossa. Two angels by the same painter in the Museum at Budapest are ascribed to Cossa.

MADONNA AND CHILD

(Canvas)

Height, 22 inches; width, 16½ inches

SMALL half-figure of the Virgin, directed slightly to left, looking down at child; scarlet dress embroidered with gold bands, blue cloak, fair hair with pearl rope, white gauze head-dress; the Infant to left looking up towards His Mother. Both figures have a peculiar gold-spotted aureole.

In a carved Renaissance tabernacle.

From the Charles Butler (Warrenwood) Collection.

A charming picture of pure and refined character.

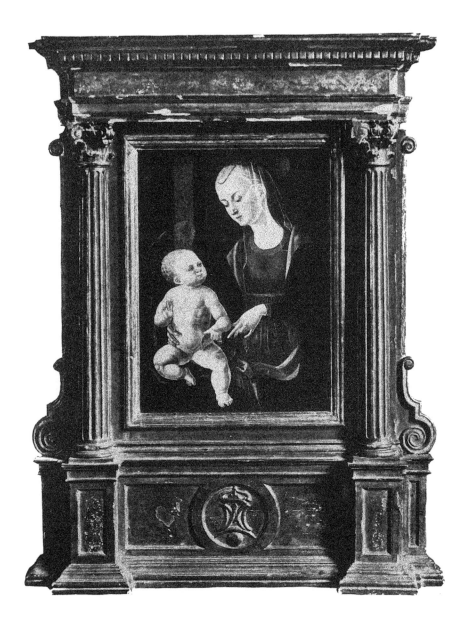

No. 13

GIACOMO FRANCIA

Bolognese, 1486-1557. Son and pupil of Francesco Francia.

MADONNA AND CHILD WITH ST. JOHN

Height, 23½ inches; width, 18¾ inches

HALF-FIGURE of the Virgin to front, head inclined to left; red low dress, blue hooded cloak, thin white muslin head-dress; the Infant in red shirt seated on a blue cushion which rests on a ledge which extends across the center of the picture; to left St. John with cross; blue sky and undulating hills to right.

Transferred from wood to canvas. Characteristic picture in good condition.

Exhibited: New Gallery (Early Italian Art) London, 1893-4, No. 172; and Burlington Fine Arts Club, London, 1894, No. 28

From the collection of Charles Butler, 1911, No. 25.

No. 14

GIOVANNI BATTISTA BERTUCCI

Born at Faenza; worked 1500-1516. Influenced by Perugino, Pinturicchio, Lorenzo Costa and Francia.

MADONNA AND SAINTS

(Panel)

Octagonal, 29¼ inches

THE Madonna, seated to front, scarlet dress with gold edging, blue cloak, fair hair, brownish head-dress, her hand resting on a fruit; the Infant in slight gold drapery on her lap; on left St. John the Baptist, to right St. John the Evangelist, both in the attitude of prayer; green background.

A graceful and well-preserved picture.

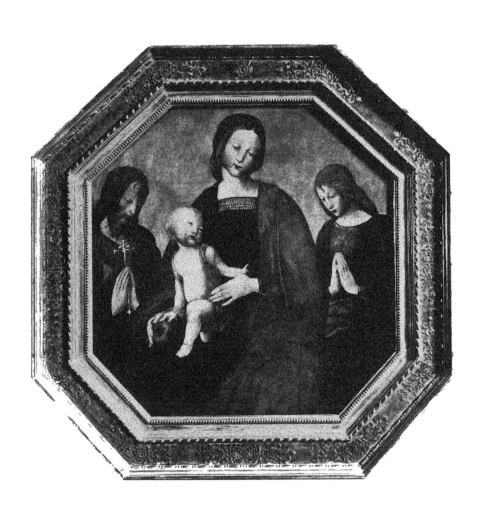

No. 15

DOMENICO ALFANI

Umbrian; 1480—after 1553. Pupil of Perugino, imitator of Raphael, later influenced by Andrea del Sarto and Rosso Fiorentino.

HOLY FAMILY AND ST. JOHN

(Panel)

Height, 26 inches; width 22 inches

An interior, three-quarter figure of the Virgin seated to front, scarlet dress with gold insertion and sleeves, a pearl ornament at her bosom, blue cloak over shoulders and lap; reading a book held in right hand, and with the left supporting the lightly clad Infant, who is seated on her lap and is receiving a cross from St. John; the latter to left holding scroll inscribed "Ecce Agnus Dei"; to right St. Joseph in slate-colored dress and brown cloak, left hand upraised; landscape seen through window to left.

In carved Renaissance frame.

No. 16

COLA DELL' AMATRICO

School of the Marches; about 1480—after 1547; influenced by Vittoria Crivelli and other Marchegian painters, later by Raphael and Michelangelo.

THE ANNUNCIATION

(Panel—arched top)

Height, 30 inches; width, 19½ inches

THE Virgin standing in a hall, in rich red dress and long blue cloak; the angel in gray and red is kneeling at her feet and is holding a lily branch in her left hand; the First Person of the Trinity is seen above in clouds, a dove descending; through an open window to left is seen a hilly landscape.

In old Renaissance frame.

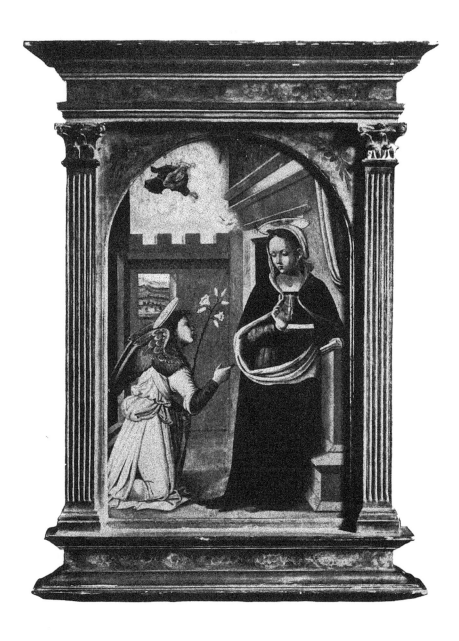

No. 17

FRA MARTINO ANGELI (?)

School of the Marches. Fra Martino Angeli from Santa Vittoria was a follower of Lorenzo da San Severino the elder; a signed picture by him dated 1448 is preserved in S. Biagio at Monte Vidon Combatte.

MADONNA AND SAINTS

(Panel—arched top)

Length, 30 inches; width, 16 inches

SMALL whole-length figure of the Madonna on clouds, in white brocaded mantle ornamented with golden crowns, with long black hooded cloak, and holding the Infant at her left side; she is surrounded by four saints: St. Katherine of Siena, St. Katherine of Alexandria, St. Francis and a Bishop; gold ground. The picture has its original Gothic tabernacle and is as a whole beautifully preserved.

No. 18

GIANNICOLA MANNI

Umbrian; active 1493-1544. Pupil of Perugino, influenced by Pinturicchio and Raphael.

MADONNA AND CHILD

Height, 30 inches; width, 25 inches

SMALL three-quarter figure, seated to front; deep red low dress edged with gold embroidery, blue cloak, brown hair; the nude Infant seated on her lap. His right hand raised; central background, broad strip of curtain (or back of chair), to left winding pathway to castellated buildings, to right seacoast with numerous towers.

Transferred from wood to canvas.

No. 19

GIOVANNI BOCCATIS

Umbrian; active about 1433-1470. Born at Camerino, possibly a pupil of Lorenzo da San Severino the elder, but developed mainly under the influence of Piero dei Franceschi and Benozzo Gozzoli.

MADONNA AND ANGELS

(Panel—with circular top)

Height, 36 inches; width, 23 inches

WHOLE-LENGTH Madonna enthroned in a niche; gold-embroidered dress and blue-hooded cloak; the Infant, seated on her lap and holding her cloak with right hand, is looking down to right at three singing angels; to left are three other angel musicians.

From the Conte Galli-Tassi Collection, Florence.

An interesting picture showing the peculiar mixture of Florentine and Umbrian elements which is characteristic of Boccatis.

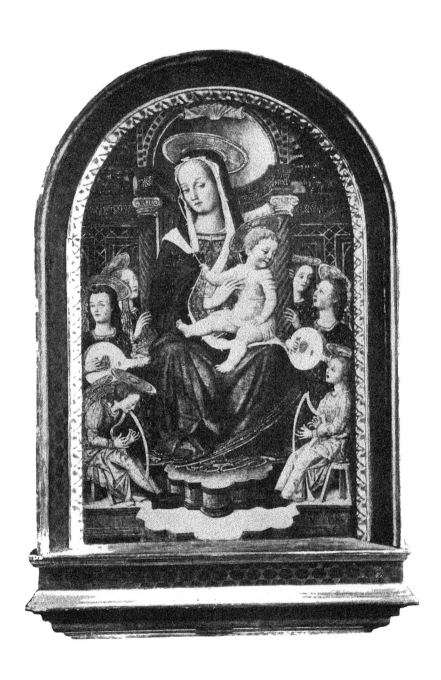

No. 20

UMBRIAN SCHOOL

End of Fifteenth Century

ADORATION OF THE MAGI

Height, 8½ inches; length, 50¼ inches

A GROUP of twelve figures; the Holy Family occupies the center of the picture in front of a cowshed. The wise men, leaving their horses with attendants, are advancing from the left carrying presents; St. Joseph receiving the offering of the foremost, who is prostrate before the Holy Family; the Virgin in blue dress holding the Infant; to right a piping shepherd and a flock of sheep, an angel in the distance; conventional landscape and trees to left.

Transferred from wood to canvas.

A predella picture.

VITALE DA BOLOGNA
(called VITALE DELLE MADONNE)

The earliest artistic personality in Bologna, active about 1330-1360; influenced from Giotto's school in the Romagna and from Siena.

MADONNA AND SAINTS

(Panel)

Height, 34 inches; length, 49 inches

AN altar-triptych. In the center, the Virgin in blue gold-embroidered hooded cloak and light white head-dress, head inclined to left, gold star on left shoulder; the Infant in red and gold drapery supported on His Mother's right arm; scarlet and gold background. To left St. Peter, with keys and red book. To right St. Regolius Papa, with long beard and miter, right hand upraised, left holding open volume in which is inscribed his name. On the three gables are represented the Annunciation, the Crucifixion and a kneeling Magdalen. In two niches formed by the gables are St. Francis receiving the stigmata and St. John the Baptist.

This picture is an important specimen of this rare master, free from restorations, but cut at the bottom.

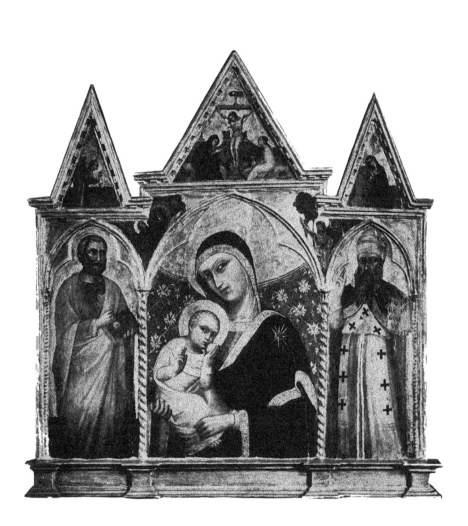

No. 22

GIOVANNI LO SPAGNA

Umbrian; active 1500-1529. Pupil of Perugino and Pinturicchio, influenced by Raphael.

ST. MARY MAGDALENE

(Panel)

Height, 52½ inches; width, 21 inches

WHOLE-LENGTH figure standing in a landscape, to front; dark blue dress with yellow sleeves and embroidered with gold, scarlet overdress and blue cloak, brown hair bound with greenish net, and head-dress which falls over her left shoulder; right hand holding small urn-shaped vessel, red covered volume in left; thin gold necklace, red shoes.

In a Venetian tabernacle frame of about 1550.

NORTH ITALIAN SCHOOLS
Milan, Vicenza, Verona, Venice

No. 23

BOCCACCIO BOCCACCINO

School of Cremona; 1467-1525(?). Studied under Alvise Vivarini in Venice; influenced by Foppa and other Milanese painters.

MADONNA AND CHILD

(Panel)

Height, 15 inches; width, 12 inches

SMALL half-figure of the Virgin, standing to front in a landscape and looking downwards; in scarlet robe, blue-hooded cloak over plain white headdress falling over shoulders, her left hand resting on parapet on which the nude Infant is seated, and is looking at spectator; background, undulating view with trees and river.

A fine picture in good condition; it stands very close to Boccaccino's little "Madonna" in Padua.

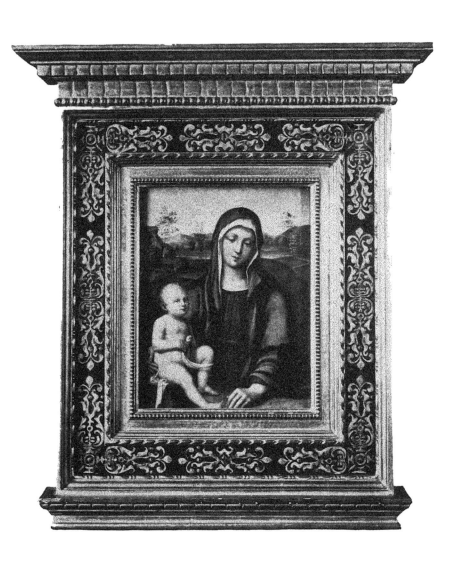

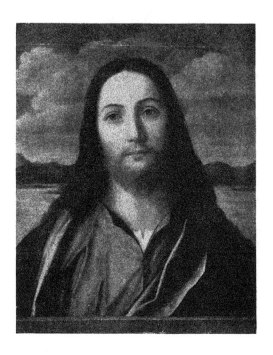

No. 24

FRANCESCO BISSOLO

Venetian School; active 1492-1554. Pupil and assistant of Giovanni Bellini.

CHRIST IN A LANDSCAPE

Height, 19 *inches; width,* 15 *inches*

BUST to front, red dress, slightly open at neck, showing white vest, green cloak, long curly hair flowing over shoulders, background of field, clump of trees and cloudy sky.

Transferred from panel to canvas.

Light and harmonious colors: green, red and brown.

No. 25

ANDREA SOLARIO

Milanese; *circa* 1465—after 1515. Pupil of his brother Christofano; influenced by Antonello da Messina and Alvise Vivarini, finally by Leonardo.

MADONNA AND CHILD

(Panel)

Height, 19 inches; width, 15 inches

SMALL half-figure, seated, of the Virgin in richly embroidered corsage with black lacets, blue cloak, fair hair, large white head-dress with long ends; holding in right hand cherries and other fruit; the Infant, seated on her lap in thin gauze covering, wearing a necklace with gold cross suspended, holding in right hand a single rose and in left cherries; background, narrow panel of red cloth on a dark green wall.

In carved Renaissance frame.

A very attractive although rather late specimen of Andrea Solario's solid art.

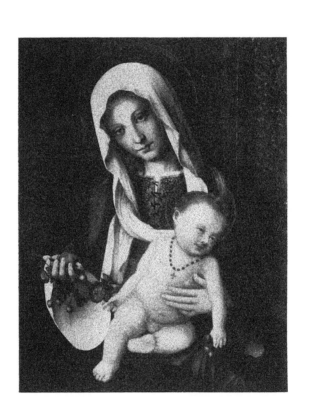

No. 26

PORTRAIT OF A LADY

BY

BARTOLOMMEO VENETO

BARTOLOMMEO VENETO

Venetian School; active 1500-1530. Pupil of the Bellinis, influenced by Berga-mesque and Milanese painters.

PORTRAIT OF A LADY

Height, 21 inches; width, 18 inches

HALF-FIGURE of a lady in green dress embroidered with gold, white chemisette, standing in front of a balcony on which is an open music-book, playing a lute; long wavy hair falling over shoulders.
Transferred from wood to canvas.

> This is a replica or old copy of a picture by Bartolommeo Veneto; other versions are in the Ambrosiana Gallery in Milan, and in the collection of Mrs. Scott-Fitz in Boston.

No. 27

BERNARDINO DE' CONTI

Milanese; 1450—after 1522. Pupil of Zenale, influenced by Leonardo and Boltraffio.

MADONNA AND CHILD

(Panel)

Height, 23 inches; width, 17¾ inches

SMALL half-figure of the Virgin in a rocky landscape; to front, red dress, blue gold-lined cloak fastened at neck with cabochon ruby, long wavy fair hair falling over shoulders; the Infant seated on her lap in blue and gold-edged dress; rocks to left, castellated buildings to right. Green tone.

No. 28

GIROLAMO DA SANTA CROCE

Bergamesque Venetian; about 1480-1556. Follower of Cima, Mansneti and Bellini.

MADONNA AND CHILD

Canvas: Height, 27½ inches; width, 21½ inches

THREE-QUARTER figure of the Virgin, seated in a landscape, directed to left; blue dress, white neckerchief and head-dress, scarlet-hooded cloak, with narrow border of gold; nude Infant on her lap; trees to right, background, houses and stretch of blue-peaked hills.

Transferred from panel to canvas.

From the sale of the Chigi Gallery, Siena, 1857; and the Collection of Charles Butler (Warrenwood), No. 47 in the sale catalogue, where it is ascribed to Filippo Lippi.

No. 29

GIROLAMO MAZZOLA (BEDOLI)

School of Parma; 1500-1569. Developed under the influence of Correggio and Parmigianino.

MARRIAGE OF ST. KATHERINE

Canvas: Height, 22 inches; length, 27 inches

AN interior with five figures. To left the Virgin seated, in red and white drapery and flowing blue cloak; the Infant in light drapery on her lap, looking up towards her and placing the ring on the finger of St. Katherine, who is on the right in brown and red dress, her left hand on a large wheel; through a doorway in the center two elders are seen; blue curtain to right.

Transferred from panel to canvas.

A characteristic specimen of the post-Correggiesque Parma School.

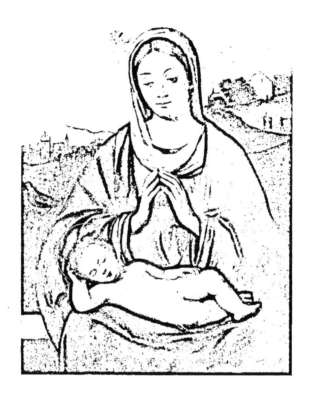

No. 30

FRANCESCO BISSOLO

VIRGIN AND CHILD

Canvas: Height, 27 inches; width, 21 inches

THE Virgin, seated to front in a landscape, red dress, blue cloak, white long head-dress, hands folded as in prayer; the Infant slightly covered asleep across His Mother's lap, head resting on His right hand; to left a bird perched on a twig, church and hill in distance, to right building and figures.

Although overcleaned the picture has still a soft charm.

No. 31

PALMA VECCHIO

Venetian School; 1480-1528. Pupil of Giovanni Bellini; influenced by Giorgione and Lotto.

HOLY FAMILY AND ST. KATHERINE

(Panel)

Height, 26 inches; length, 38 inches

HALF-FIGURE of the Virgin, seated in the center under a green curtain canopy; red dress with white loose head-dress and blue cloak, holding the Infant in slight gold drapery; to left, St. Joseph in blue and yellow cloak; to right, St. Katherine in scarlet dress and green cloak, holding pen in right hand.

From the Munro of Novar Sale, 1878, No. 70; and Charles Butler Collection, 1911, No. 100.

Described by Dr. Waagen, "Art Treasures of Great Britain," II, 134.

BERNARDINO BUTTINONE

Milanese School; *circa* 1436—after 1507; developed under the influence of Vincenzo Foppa, working together with Bernardo Zenale.

ST. JOHN AND ST. LAWRENCE

(Panel)

Height, 47½ inches; width, 19 inches

Two whole-length figures, standing, St. John the Evangelist, in green dress and scarlet cloak, holding gold chalice in right hand and inscribed open book in left; St. Lawrence to left in white and brown robes elaborately embroidered with scroll designs and enriched with precious stones; holding in right hand a palm branch, and in left a gridiron; on floor in foreground two volumes on which is perched an eagle.

From Dowdeswell and Dowdeswell. Reproduced in "The Burlington Maga-
zine," 1904, Vol. IV, facing p. 93; mentioned in the "Allgemeines
Lexicon der bildenden Künstler," Vol. V, p. 30.

A wing of a large altarpiece.

No. 33

ANTONIO BADILE

School of Verona; 1517-1560. Pupil of Carotto; influenced by Torbido,
Brusasorci and Paolo Veronese.

PORTRAIT OF A LADY

Canvas: Height, 48 inches; width, 40½ inches

THREE-QUARTER length of stout middle-aged lady, standing slightly to left,
nearly full face; black low dress almost entirely covered with silver embroid-
ery, the corsage with white and gold horizontal stripes, white sleeves with
small gold spots, white chiffon over shoulders; pearl necklace and earrings,
golden hair dressed flat and with pearl ornaments; gold bracelets, right hand
resting on pet dog which is standing on red covered table, left hand on hip;
distant landscape through portico to left, gray background.

*Exhibited: Burlington House, London, 1884, No. 157 (Frederick W. Farrer),
when it was "attributed to Paolo Veronese."*

A beautiful and important picture of the leading master of the Verona
school about the middle of the sixteenth century. It shows close affinity of
style with Badile's two portraits in Vienna.

No. 34

ERSDI DI BONIFAZIO

Pupils and assistants of Bonifazio di Pitati (1467-1553), carrying on his workshop even after his death.

THE RESURRECTION OF LAZARUS

Canvas: Height, 52 inches; length, 36 inches

GROUP of nine figures, some of which are only partly visible. Lazarus being raised from the sepulchre, woman in bright yellow costume, kneeling.

Portion cut out of a larger composition.

No. 35

BATTISTA ZELOTTI

School of Verona; about 1532-1592. Pupil of Badile; influenced by Paolo Veronese.

HISTORICAL SCENE

Canvas: Height, 75 inches; length, 95 inches

A VICTORIOUS military commander surrounded by five allegorical female figures in classical costumes. The central figure, a middle-aged man with short beard, in armor, with pink cloak around neck and on left leg, a baton held by both hands; the figure on the left holding jar of golden coins; the others are apparently presenting a carved wood scroll-shaped tablet with inset of a miniature of a young woman; a laurel wreath is on the ground; pillar and wall background.

A large decorative composition by this clever imitator of Paolo Veronese.

No. 36

GIROLAMO DA TREVISO

Venetian School; 1497-1544. Son and pupil of Pier-Maria Pennacchi; influenced by Giovanni Bellini.

MADONNA AND CHILD

(Panel)

Height, 58 inches; width, 24½ inches

WHOLE-LENGTH of the Madonna, enthroned in a niche, to front; brown dress, richly embroidered with conventional design in red, white head-dress, blue and green cloak; nearly nude Infant seated on His Mother's lap, holding a fig in left hand, right hand upraised.

In Venetian tabernacle of the time.

Signed on a table at foot of picture: HIERONYMUS TARVISO P.

LATE ITALIAN SCHOOLS
Seventeenth and Eighteenth Centuries

No. 37

GIOVANNI BATTISTA PIAZZETTA

Venetian School; 1682-1745. Pupil of Molinari.

LAUGHING GIRL

Canvas: Height, 20 inches; width, 17 inches

BUST of a laughing girl in Dutch-like costume; greenish tone.

No. 38

GIOVANNI DOMENICO TIEPOLO

Venetian school; 1726—after 1770. Son and pupil of Giov. Batt. Tiepolo.

PORTRAIT OF AN OLD MAN

Canvas: Height, 22 inches; width, 16 inches

HEAD and shoulders of an elderly man (probably a Jewish dignitary) in Oriental costume, brown-lined fur coat with high collar, reddish turban-like cap, red belt with cameos around chest; right hand holding belt.

*Exhibited at the "Mostra del Ritratto Italiano," Florence, 1911, No. 101.
 (Prof. Emilio Constantini.)*

GIULIO CESARE PROCACCINI

Bolognese School; 1548-1625. Son and pupil of Ercole Procaccini; influenced by Correggio.

"SIBILLA PERSICA"

Canvas: Height, 28 inches; width, 23 inches

HEAD and shoulders, life size, to front, head inclined to right; bluish low dress, long brown hair falling over her shoulders, blue and white head-dress; in left hand open volume inscribed on the edge "Sibilla Persica," in right hand a pen which is being guided by an attendant angel leaning on her right shoulder.

No. 40

LUCA CAMBIASO

School of Genoa; 1527-1585. Son and pupil of Giovanni Cambiaso; influenced by Spanish art.

MADONNA AND ST. JOHN

(Panel)

Height, 29½ inches; length, 23½ inches

SMALL three-quarter length of the Virgin, seated to right, directed to left; dull red dress with yellow sleeves, blue cloak on lap, holding the Infant; St. John to right, ruins to left.

No. 41

GIOVANNI BATTISTA PITTONI

Venetian school; 1687-1767. Pupil of Francesco Pittoni; strongly influenced by G. B. Tiepolo.

THE HOLY FAMILY APPEARING TO ST. ANTHONY

Canvas: Height, 31 inches; width, 21 inches

GROUP of eight figures. St. Anthony of Padua kneeling and holding staff, near a balcony; the Virgin, St. Joseph and four youthful angels appearing in the clouds; the St. Esprit in the form of a dove to right.

A clever imitation of Tiepolo but technically inferior.

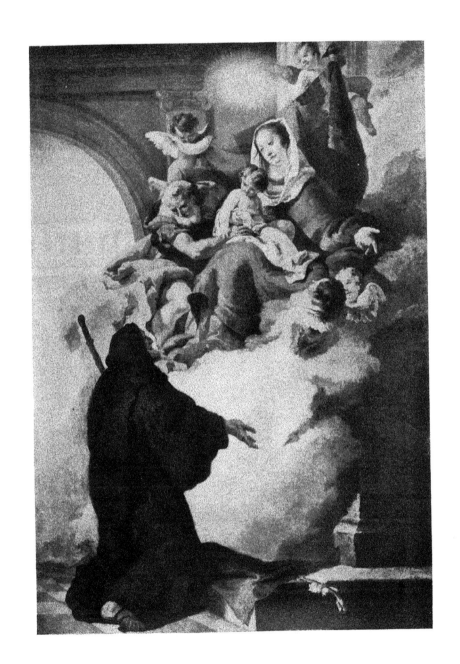

No. 42

MICHELE MARIESCHI

Venetian School, about 1700-1743. Pupil of and imitator of Canaletto.

VIEW OF THE GRAND CANAL

Canvas: Height, 27 inches; length, 46 inches

A BROAD view of the Grand Canal, Venice, with numerous boats and the Rialto.

A very fine work of this clever Canaletto pupil.

No. 43

LUCA GIORDANO (called FA-PRESTO)

Neapolitan School; 1632-1705. Pupil of Ribera; influenced by Pietro da Cortona.

THE HOLY FAMILY

Canvas: Height, 37½ inches; length, 40 inches

To left three-quarter figure of the Madonna in red, blue and white draperies, her hands pressed to her bosom, gazing towards the lightly clad Infant on the right; His left arm encircling a wood cross; in the center St. Joseph in brown dress, holding staff.

FRANCESCO SOLIMENA

Neapolitan School; 1657-1747. Influenced by Luca Giordano and the Carracci.

MARY AT THE TOMB OF CHRIST

Canvas: Height, 30 inches; width, 25 inches

GROUP of five figures. The dead Christ extends across the picture, on white and scarlet draperies; three women kneeling around the body and weeping, one pressing His left hand to her lips; to right a child-angel is pointing to the recumbent figure; on the ground to left, gold salver with emblems of the Crucifixion.

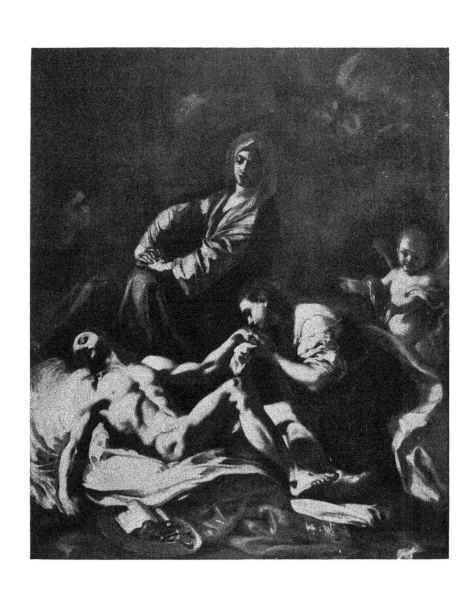

No. 45

CANALETTO (ANTONIO CANALE)
ITALIAN: 1697—1768

CANALETTO'S CONCEPTION OF A GRAND OPERA HOUSE IN VENICE

Canvas: Height, 38 inches; length, 50 inches

A VIEW of the Canal with the Rialto Bridge, the artist's conception of a grand opera house on the right: a massive two-story building with balconies and a dormer roof; at the main entrance a crowd of brilliantly clad people are gathered under and around a temporary canopy, apparently indicative of the opening ceremony; the canal is alive with gondolas and other boats; blue sky with fleecy clouds.

No. 46

TITIAN (Ascribed to)

SUSANNAH AND THE ELDERS

Canvas: Height, 51 inches; length, 70 inches

AN open landscape, with a nude Venus directed to right, reclining on red drapery, occupying nearly whole of the foreground, and looking at the reflection of her face in a small mirror which is held up by a dark-bearded elderly man in rich Oriental costume, and who is looking at her with a smiling expression; behind her a man in red dress and cap with gold-embroidered cloak is unfastening the band which had been placed over her eyes, her golden hair is plaited and a jeweled bracelet is on her right wrist; in the middle distance figures and sheep.

Exhibited: Art Treasures, Manchester, 1857, No. 254; and Old Masters, Burlington House, 1871, No. 365.

From the Earl of Dudley's Collection, June 11, 1900, No. 31.

No. 47

TIBERIO TINELLI (?)

Venetian School; 1586-1638. Pupil of Contarini and Leandro Bassano, imitating Van Dyck and the Spaniards.

PORTRAIT SAID TO BE FRANCESCO DE ALTAMIRA

Canvas: Height, 84 inches; width, 51½ inches

WHOLE-LENGTH, life size, early middle-aged, to front, black dress embroidered with gold, large white collar extending over shoulder, white cuffs; dark long hair, mustache and chin tuft; left hand holding hilt of sword, right hand holding black felt hat; coat-of-arms in top left-hand corner, red curtain to right.

From the Marcelle von Nemes Collection, in the catalogue of which it is attributed to Carreno de Miranda.

SPANISH, DUTCH, FRENCH AND FLEMISH PICTURES

INTRODUCTION

THE pictures by artists of the Spanish, Dutch, French and Flemish schools, described in the following pages, constitute a very varied and interesting feature of the Blakeslee Collection. They have been gathered in many lands, but chiefly in England and France, and, with a few inevitable eliminations, would form an excellent nucleus for a private or public gallery. The average quality is high, and many have already figured in well-known collections, notably that of the late Charles Butler, a man of wide artistic sympathies and sound judgment. A good many have only their artistic quality and historical associations to recommend them, for they have passed from their previous owners by private contract into Mr. Blakeslee's stock, either direct or through one of his many sources of acquisition, and nothing can be said as to their *provenance*.

This section of Mr. Blakeslee's pictures is dominated by the great gallery work by Rubens, "The Adoration of the Magi," which came to light in recent years after all trace of it had been lost to students for over half a century. This noble picture, with its Oriental magnificence, its brilliant coloring and its wealth of carefully thought-out detail, is the most important work of its kind by the master in the new world; and all students will re-echo the wish that it may find a permanent home in a public gallery, or church, where it will remain for all time, a lasting memorial to one of the world's greatest painters. The history of the picture is singularly clear from the time it was painted for the Church of St. Martin, Berg-Saint-Vinox (or Bergues, as it is now called), some five miles from Dunkirk. The church was rebuilt in the seventeenth century, and still contains a number of interesting paintings; doubtless it was its "noteworthy high-altar" which this picture adorned until it was sold in 1766. The history of the picture is fully told in the "Report" of the late Mr. Max Rooses (reprinted in this catalogue), who made Rubens a life-study, and whose great book on the subject of the master and his works will remain for generations the

standard authority. But if the picture had no history, its transcendent scheme, its wealth of imagination, its brilliant coloring and the care with which every detâil is worked up into a harmonious whole would stamp it as the work of the master mind of Rubens. There are many interesting pictures of the Dutch and Flemish Schools, chiefly by the minor artists—"the Little Masters" as they are sometimes called—men who just failed to attain the first rank. Special mention here can only be made of a few of the pictures, and two of the earliest in the alphabetical arrangement include the signed group by *F.* Bol, which was once in the collection of a well-known London amateur; and a portrait of excellent quality by Jacob Gerritsz Cuyp, of a child, which recalls the group of three children by the same artist at Rotterdam, and also a child-picture in the J. Pierpont Morgan Collection which has so far baffled experts in their efforts to suggest the name of a likely painter. The history of the Van Dyck portrait of a lady of the Coningsby family cannot be traced further back than thirty years, its first recorded owner being Sir George *D.* Clerk, a member of an old and distinguished Scotch family; the portrait is of fine decorative quality. To the few examples of Johannes van Kessel in the United States the beautiful little landscape in this collection is a notable addition in which we can distinguish the influence of Jakob van Ruysdael.

There are characteristic examples of Judith Leyster and N. Maes; by the latter there is a signed and dated portrait of a lady who does not seem to have got much joy out of her life—not an uncommon feature of Dutch seventeenth century portraits. The Metsu "Visit to the Nursery" is one of the many versions which the artist and his pupils must have been called upon to supply: the most beautiful example of all is the Rodolphe Kann picture, dated 1661, now in Mr. Pierpont Morgan's Collection and on loan at the Metropolitan Museum. It is curious that the present version should have the much earlier date of 1641. The more interesting of the two by Miereveld is the portrait of Marguerite van Bromkort, with her coat-of-arms (or more probably that of her husband) and the date 1623; and close to this is a capital portrait of Miereveld's pupil, Paulus Moreelse, of a famous patroness of the Elizabethan poets, Lucy Countess of Bedford.

There are many portraits of this lady, but this is later than any of the others, and represents her as apparently much older than she would have been in 1613. This portrait has long passed as representing the "Sister of Sir Philip Sidney and wife of Sir James Harington," but the two statements are contradictory, and neither can apply to this picture. By the younger Francis Pourbus we have a portrait of the Queen of Louis XIII, painted soon after she had taken up her residence in France. Another of the portrait painters whose work is uncommon in the auction room, Joachim von Sandrart, is represented by a signed and dated example. A considerable amount of investigation has been devoted to fixing the exact identities of the Lord and Lady Burghley who appear under Zuccaro, but even so without conclusive success. The biographies given in the catalogue must be regarded as tentative. Judging from the dresses and other features, they are probably portraits of the famous Lord Burghley's grandson and his wife, in which case "Lady Burghley" would not be a correct title, for the husband did not become Lord Burghley until his father was advanced to the Earldom of Exeter in May 1605—or fourteen years after his wife's death. At the date of the portrait, 1588, there was only one Lady Burghley, the wife of the famous Lord High Treasurer, and she died aged sixty-three in 1589. This kind of confusion has often occurred in connection with family portraits of which the identities have been left for posterity to establish.

If the pictures by artists of the Spanish and French Schools do not include any great masterpiece, there are nevertheless many excellent in quality and of good *provenance*. The most important of the Spanish pictures is undoubtedly the Velasquez portrait of Mariana of Austria, a replica of the famous work at the Prado, Madrid. The French pictures are nearly all by artists of the eighteenth century, and, for the most part, of people who played a prominent part in the annals of France. The two great rival women portrait painters, Madame Labille Guiard and Madame Vigée Le Brun, are adequately represented; the former by one of the Princesse de Lamballe, a prime favorite of Marie Antoinette and one of the earliest victims of the French Revolution; and Madame Le Brun by the Comtesse de Verdun and a highly attractive portrait of Madame Vestris. The exact

identity of the last named has not been made out. The Vestris family was a somewhat numerous one both in England and France, the most famous of the English branch being a granddaughter of Bartolozzi the engraver and successively the wife of Auguste Vestris the dancer and Charles James Mathews the actor. This lady, who was born in 1797 and who lived till 1856, was only seven years old in 1804, when this portrait was painted, so it cannot represent her. It probably represents her first husband's mother. Five portraits and subject pictures are by N. de Largillière, and the most important of these is the brilliant picture of a lady of the Court of Louis XIV.

Among the French pictures catalogued under Carle van Loo will be found a companion pair which appear in Mr. Blakeslee's stock as of the King and Queen of Austria. These titles, as students of European history will hardly need to be told, are manifestly inaccurate. It is not known whence the late owner obtained the pictures, presumably by private purchase and not at public sale. Nothing therefore is known of their *provenance*. They are obviously state portraits and probably represent Francis Duke of Lorraine (1708-1765), who was elected Emperor of Germany in 1745, and his wife Maria Theresa (1717-1780), daughter of Charles VI, and who was Queen of Hungary. Both portraits, which would therefore be correctly described as of the Emperor and Empress of Germany, are ascribed to Carle van Loo, who is not known to have painted these two historical personages. Their state painter was Martin van Mytens (1695-1770), who was of Dutch origin, but who lived for many years in Vienna, where he died. His portraits of the Emperor and Empress, painted *circa* 1742, have been frequently reproduced; there are two of the former and one of the latter in the Szepmuvészeti Múzeum at Budapest. It is permissible to suggest that our two portraits may have been copied by order of Marie Antoinette, their daughter, for some dignitary of the French Court.

By Van Loo also we have a portrait of the Comtesse de Beaufort *en Sultane*: this lady was probably the "dame de qualité de Franche-Comté" referred to by Voltaire in his letter to the Duc de Richelieu of July 20, 1771, and whose husband, "un des plus honnêtes gentilshommes de la pro-

vince," was accused of having killed "un coquin de prêtre." By Rigaud there is a fine portrait of the Duc d'Antin, and another of the artist's wife. Two other famous French artists are represented: Louis Tocqué by a lady playing a guitar, and J. F. de Troy by one of a lady whose name is not known. Later in date, but overlapping the active period of each of the two last named, Antoine Vestier is represented by an unusually good portrait of the Comtesse de la Garde.

<div style="text-align: right">W. ROBERTS.</div>

LONDON.

SPANISH AND ROMAN SCHOOL

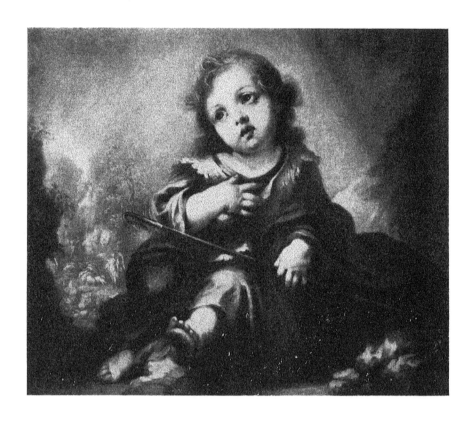

No. 48

B. E. MURILLO

SPANISH: 1617—1682

THE LITTLE SHEPHERD

Canvas: Height, 22 inches; length, 26 inches

SMALL whole-length figure of a little fair-haired barefooted child, seated in a rocky landscape; plum-colored dress and blue cloak, holding in left hand a shepherd's crook; in distance to left two angels are seen guarding a flock of sheep.

No. 49

CLAUDIO COELLO

Spanish: 1621—1693

PORTRAIT OF A LADY

Canvas: Height, 24 inches; width, 19 inches

Head and shoulders of a young Spanish lady, to front looking at spectator; dark mantle elaborately embroidered with gold, cream-colored sleeves only slightly seen, elaborate white ruff delicately edged with pink; pearl necklace and earrings; dark hair with thin row of curls over forehead, aigrette of jewels and pearls over right ear, small jeweled ornament over left ear; dark background.

Collections: Arthur Seymour, 1896; and Charles Butler, May 26, 1911, No. 165.

No. 50

DIEGO RODRIGUEZ DE SILVA Y VELASQUEZ

SPANISH: 1599—1660

QUEEN MARIANA OF SPAIN

Canvas: Height, 27½ inches; width, 20 inches

Daughter of Ferdinand III, Emperor of Austria; born in 1634; betrothed to Don Balthasar Carlos (eldest son of Philip IV), but he died suddenly in 1646, and she married in 1649 his father Philip IV, as his second wife; died in 1696.

To front, black dress with broad silver stripes; face rouged, red hair arranged in ringlets which fall over one another regularly, each tied at the end with a red ribbon, the whole forming a broad mass; a long white feather (spotted with red) falls over the hair on her left; scalloped white collar, rich gold chain with pendant.

Collections: M. Cordova, a painter at Madrid; King Louis Philippe, May 7, 1853, No. 150; and Duc d'Aumale. Curtis, "Velazquez," No. 243b.

A replica of the head and shoulders of the well-known portrait at the Prado, Madrid, painted 1658-60 and described by Curtis, No. 236.

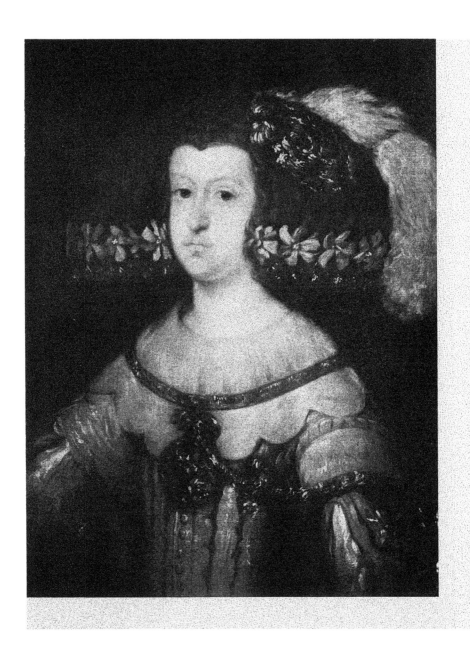

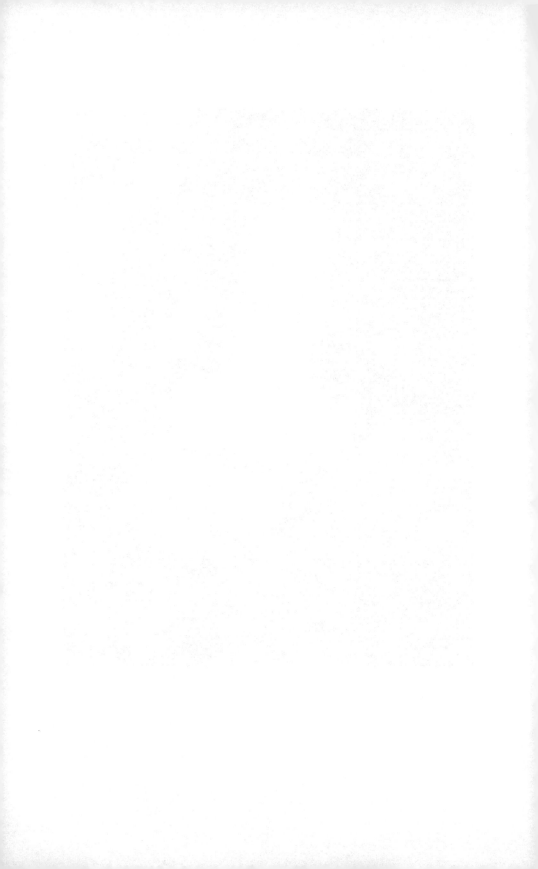

No. 51

FEDERIGO ZUCCARO

Roman: 1543—1609

EDWARD VI *(Said to be)*

(Panel)

Height, 29 inches; width, 21 inches

HALF-FIGURE of a thin, sharp-faced effeminate youth, standing to front and looking at spectator; black-patterned white dress with reddish waistband which apparently serves as swordholder; black neck-chain from which depends a jewel with pearls, broad turned-down lace collar; fair hair, white hat with pink lining, plume of feathers and pearl ornament; right hand holding white gloves, left hand on hip.

No. 52

FRANCISCO JOSÉ DE GOYA Y LUCIENTES

SPANISH: 1746—1828

KING CHARLES III OF SPAIN (1716-1788)

Canvas: Height, 29 inches; width, 24 inches

HEAD and shoulders of elderly man, directed slightly to right, looking to left, in uniform of blue with gold facings, white waistcoat and neckerchief, red sash passing over right shoulder and star of an Order partly seen on breast; powdered wig; wart on left side of mouth; gold-headed staff in right hand.

No. 53

CLAUDIO COELLO

Spanish: 1621—1693

AN AUSTRIAN PRINCESS

Canvas: Height, 32 inches; width, 26½ inches

HALF-FIGURE of stout middle-aged lady, to front; black dress with white sleeves, gray collar with broad edging of lace extending over shoulders, large red and black rosettes on corsage and left shoulder; pearl necklace and pendant; earrings of jet set in gold; dark matted hair with black head-dress, scarlet band, black feathers and precious stones; brownish background.

No. 54

FEDERIGO ZUCCARO

Roman: 1543—1609

LORD BURGHLEY

(Panel)

Height, 43 inches; width, 33 inches

William Cecil Lord Burghley, son of first Earl of Exeter; by his first wife; born in 1566; succeeded his father as second Earl in February, 1622-3; died July 6, 1640; buried in Westminster Abbey.

THREE-QUARTER figure of middle-aged man, standing, directed slightly to left, looking at spectator; green dress embroidered with gold, white lace cuff and white broad collar, green cloak over left shoulder; golden hair, narrow pointed beard; right hand resting on table, left on hilt of sword.

Formerly attributed to Sir Antonio Moro.

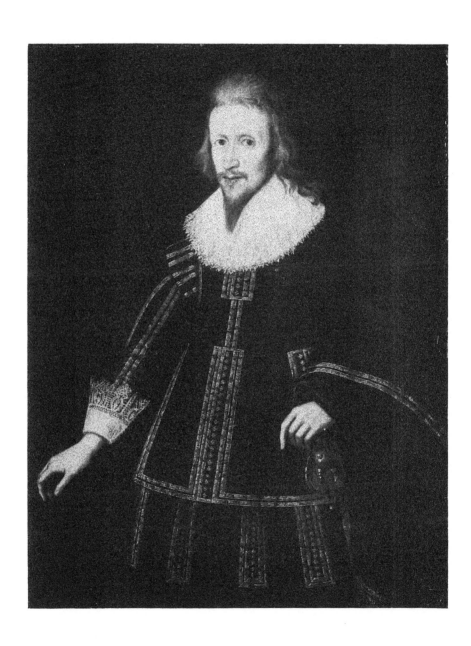

No. 55

FEDERIGO ZUCCARO

Roman: 1543—1609

LADY BURGHLEY (?)

(Panel)

Height, 35 inches; width, 28 inches

Elizabeth, Baroness de Roos, daughter and heiress of Edward (Manners), Third Earl of Rutland; married, as his first wife, Wiliam Cecil, afterwards Lord Burghley; died in May, 1591; buried in Westminster Abbey.

HALF-FIGURE to front of thin-faced lady; white skirt with black-patterned over-dress with puffed sleeves and gold bead-like ornaments, wedge-shaped corsage, white stiff lace-trimmed collar, black bead-like pearls at neck; pendant with pearl and precious stones and inset with cameo of woman and child fastened on left shoulder with red ribbon; long gold chain of many rows, gold bracelets, black and white reflexed cuffs; right hand holding pink flower, gloves in left; red hair massed over ears and with black head-dress at back, pearl earrings.

Inscribed in gold letters at top right hand corner: ÆTATIS SUÆ 22 AN° 1588.

This and the preceding portrait are referred to in Mr. Roberts's Introduction.

No. 56

JUAN B. DEL MAZO MARTINEZ

Spanish: 1610—1687

PORTRAIT OF A YOUNG LADY

Canvas: Height, 49 inches; length, 36½ inches

THREE-QUARTER length, about twenty, standing, directed to left, looking at spectator; black dress almost entirely covered with silver embroidery, white lace collar with blue ribbon, pearl and jewel necklace; black hair falling over ears, with pearl ornament; right hand holding bunch of red roses, left hanging down by side, ring on penultimate finger of each hand; dark gold-edged curtain to right.

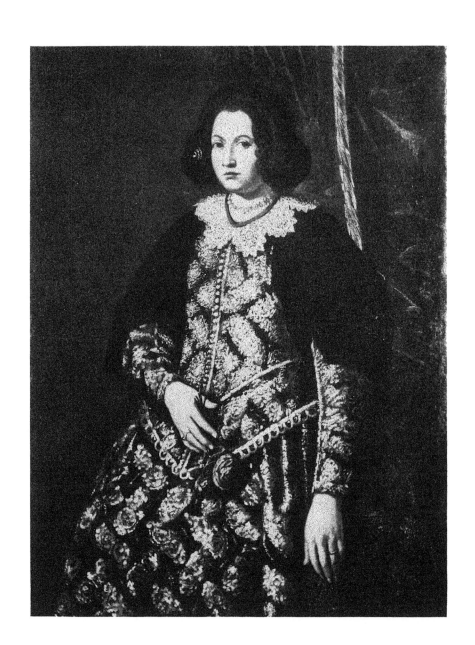

JUAN PANTOJA DE LA CRUZ

SPANISH: 1551—1609

THE INFANTA ISABELLA EUGENIA CLARA, GOVERNESS OF THE NETHERLANDS

Canvas: Height, 75 inches; width, 41½ inches

Daughter of Philip II of Spain; born in 1566; married the Archduke Albert; Governess of the Netherlands from 1598; a patron of Rubens; entered the monastic order of St. Clara; died in 1633.

WHOLE length, about thirty, standing to front; long black cloak richly lined with red, creamy white circular lace collar and cuffs; golden hair dressed flat in compressed plaits, white feather at back; right hand resting on red-covered table, a six-row gold and red bead bracelet on wrist; left hand resting in a gray lace scarf sling and holding white gloves with red borders; green curtain background.

Collections: The Duke of Marlborough at Blenheim, until 1886; and Charles Butler, May 26, 1911, No. 167.

Sir George Scharf, "Catalogue Raisonné" of the Blenheim pictures, 1862, p. 16.

JUAN B. DEL MAZO MARTINEZ

Spanish: 1610—1687

PORTRAIT OF A SPANISH PRINCESS

Canvas: Height, 55 inches; width, 42 inches

THREE-QUARTER length, age about twenty, to front, black dress with green-ish under sleeves elaborately embroidered with gold, oversleeves and shoulder studded with pearl-like ornaments; pearl necklace and bracelets, long neck-chain of precious stones with ruby and emerald brooch at side, center of corsage with pointed rosette of precious stones; black hair in plaits, with band of pink ribbon and pearl ornament; right hand holding fan, left on red-covered chair, red curtain to left and right.

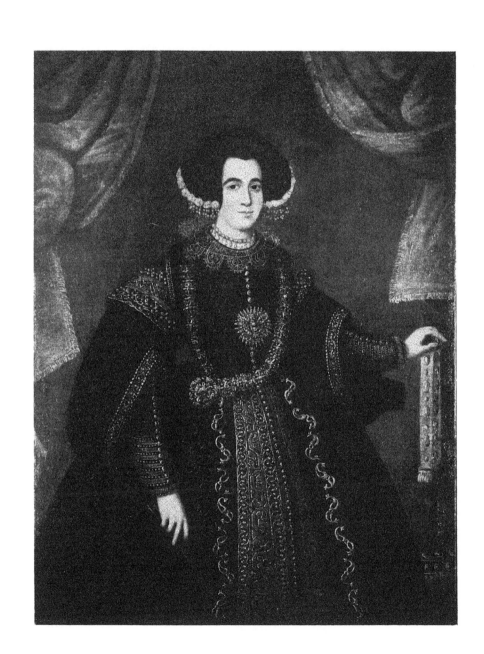

No. 59

ALONSO SANCHEZ COELLO

SPANISH: 1515—1590

ANNE OF AUSTRIA, WIFE OF PHILIP II OF SPAIN

Canvas: Height, 78½ inches; width, 42½ inches

Daughter of the Emperor Maximilian of Austria; born in 1549; married at Segovia in 1570, as his fourth wife, her uncle Philip II of Spain; died in October, 1580.

WHOLE length, when young, standing, directed to front; white dress richly patterned and embroidered with row of six curious bifurcated designs (apparently fasteners), the narrow wedge-shaped corsage richly ornamented with precious stones, pendant at bosom; long two-row pearl necklace, white lace cuffs and starched ruffle, pearl earring, fair hair with small brown cap and white rosette; right arm leaning on red chair holding partly opened volume in hand, left holding lace handkerchief.

Exhibited: Guildhall, London (Spanish art), 1901, No. 57.

Collections: Prince Esterhazy; and Arthur Sanderson, June, 1911.

DUTCH SCHOOL

No. 60

JACOB WILLEMSZOON DELFF
DUTCH: 1619—1661

MARIA JACOB VAN DE WOOT

(Panel)

Height, 19 *inches; width*, 16 *inches*

HEAD and shoulders of elderly thin-lipped woman, to front looking at spectator; black-patterned dress, large starched circular ruff; dark hair with close fitting slight black head dress.

> A portion of the artist's initials "W. D." interlaced is seen on the left hand side. The name of the personage is inscribed on the back of the panel but is now difficult to decipher.

No. 61

WILLEM WISSING

DUTCH: 1656—1687

PORTRAIT OF ENGLISH NOBLEMAN

(Panel)

Height, 12½ inches; width, 10¼ inches

SMALL bust of a young man, directed slightly to left, looking at spectator, in armor with white linen collar, long golden hair falling on shoulders.

Collection: Henry Doetsch, June, 1895, No. 200.

No. 62

JAN VERSPRONCK

DUTCH: 1597—1662

THE TOPER

Canvas: Height, 28 inches; width, 23 inches

HALF-FIGURE, facing right, of elderly man smiling and leaning back in his chair; brown dress, black cloak over left shoulder, white cuff and white broad flat collar, large black felt hat, slight mustache and chin tuft, holding in right hand goblet nearly full of liquor; medallion in sash; green background.

> The initials, "F. H.," entwined on left, form the signature of Frans Hals, to whom the picture was formerly attributed. It appears to be a variant of "The Toper" (a much smaller picture), described in C. Hofstede de Groot's edition of Smith's "Catalogue" *infra* HALS, Vol. III, No. 65.

No. 63

GERARD PIETERSY VAN ZYL
(Gherard van Leyden)
DUTCH: 1606—1667

PORTRAIT OF A NUN

(Panel)

Height, 18 inches; width, 12½ inches

SMALL three-quarter length of middle-aged lady, standing to front, in nun's costume, black cloak with white cuffs and broad stiff white double collar, black cap with reflexed brims; fair hair; mauve curtain and distant landscape background.

No. 64

SIGMUND HOLBEIN
GERMAN: 1465-70—1540

PORTRAIT OF A LADY

(Panel)

Height, 23 inches; width, 17 inches

SMALL half-figure to front, black dress, red sleeves, white collar cut square over shoulders and edged with red, dark hair with white hood; gold waist chain, white cuffs; hands clasped, holding a pink; gray background.

Inscribed at top to right: ÆTATIS SUÆ. 19.

Collection: Camille Marcille, 1876 (as by H. Holbein).

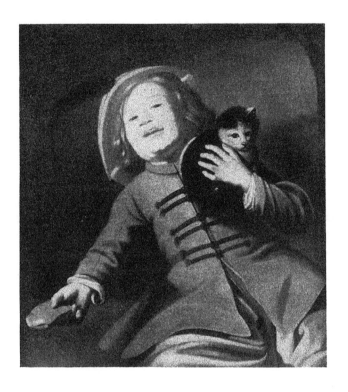

No. 65

JUDITH LEYSTER

DUTCH: 1600—1660

YOUTH WITH CAT

Canvas: Height, 24½ inches; width, 23 inches

HALF-FIGURE to front of red-faced peasant boy in brown coat, green breeches and red hat with black feather, leaning back and smiling, holding in right hand a piece of cake, and with the other fondling a small black kitten which is looking unconcernedly out of the picture; gray background.

From an anonymous sale at Christie's, June 20, 1913, No. 61.

No. 66

LUCAS CRANACH

GERMAN: 1472—1553

THE JEWELER'S DAUGHTER

Height, 30 inches; width, 23 inches

HALF-FIGURE of a young woman about twenty-five, directed to right looking at spectator; scarlet and gold embroidered low dress; carrying with both gloved hands a tray with open jewel case showing pearl necklace, pearl and jeweled belts, and antique cameo; close-fitting head-dress with white feathers, red cap perched jauntily on side of head; three rows of necklaces with pearls and jewels; blue curtain background. Canvas transferred from panel.

Signed at top left hand corner with the artist's crest: a flying dragon with a crown upon its head.

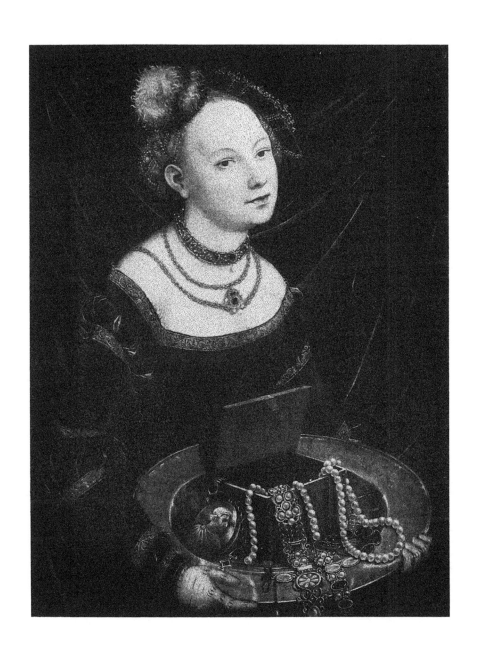

CORNELIS JANSSENS
Dutch: 1593—1664

PORTRAIT OF MAN WITH LACE COLLAR

Canvas: Height, 29 inches; width, 24 inches

Head and shoulders of young man, to front, looking at spectator; black-embroidered dress over white vest (or shirt), elaborate lace collar covering shoulders; masses of black hair falling over neck, slight mustache and chin tuft; gray background.

Signed with initials and dated in lower left hand corner: C. J. fecit 1635.

From an anonymous sale at Christie's, July 12, 1912, No. 16.

No. 68

GABRIEL METSU

Dutch: 1615—1658

A VISIT TO THE NURSERY

Canvas: Height, 30 inches; length, 31 inches

An interior with six figures. The mother seated to right, her face seen in profile, in white dress, red dressing jacket and white cap, holding the infant in yellow swaddling clothes on her lap. Standing by her side, her husband, dressed in gray large puffed shirt-sleeves, long wig, large felt hat in his right hand, is welcoming the visitor, an elderly lady in blue and black velvet dress, black lace shawl, holding a fan and accompanied by a little dog. The visitor is followed by a servant woman carrying a chair in her left hand, and a little box in her right; in front of the fireplace and leaning her right arm over the cradle is the elderly nurse in black. A fireplace with a Renaissance chimney-piece, over which hangs a large sea picture, occupies the center of the background; to right a blue and gold bedstead, table with Oriental cover, on which are a basin, ewer, etc.; the stone floor of black and white marble slabs, with red carpet.

Signed and dated over doorway to left: G. Metsu, 1646.

Collections: Madame de Falbe, May 19, 1900, No. 106; and Lesser Lesser, February 10, 1912, No. 75 (Hofstede de Groot, No. 110).

One of several versions of the picture described in Smith's "Catalogue," No. 19; and by De Groot, No. 110, which version, however, is dated 1661.

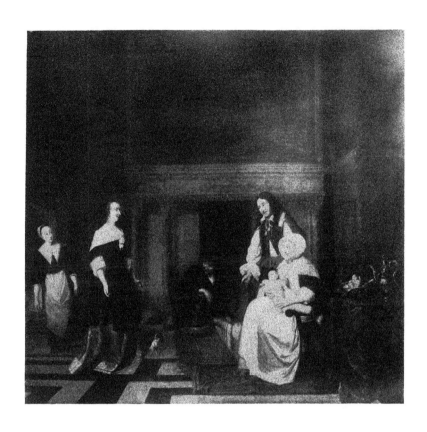

No. 69

DANIEL MYTENS

Dutch: Died 1656

PORTRAIT OF A GIRL

Canvas: Height, 31 inches; width, 25½ inches

THREE-QUARTER figure of a little girl, about seven or eight, standing by a balcony, directed to right, looking at spectator; white satin low dress with jewel at center of bodice, jeweled bracelets; golden curly hair with pearl band, pearl necklace, both hands holding wreath of flowers; scarlet curtain and pillar to left, distant landscape to right.

No. 70

COSWIN VAN DER WEYDEN
DUTCH: 1465—1538

FAMILY OF THE VIRGIN

Canvas: Height, 38 inches; width, 26½ inches

INTERIOR with six figures. To right, St. Joseph a middle-aged bearded man in blue dress, ermine shoulder cape, scarlet hat and yellow boots, looking, with hands upraised, towards the youthful seated Virgin, who is in scarlet dress and gold-embroidered cap and is reading from a Book of Devotions. The four children carry the emblems of their future callings, the youthful Christ has his cross, the carpenter his saw, the architect his rule and the blacksmith his hammer; background gray wall with open window (over which are two carved trumpeteers and scalloped shell), showing houses and distant hills.

Exhibited at Charleroi, 1911.

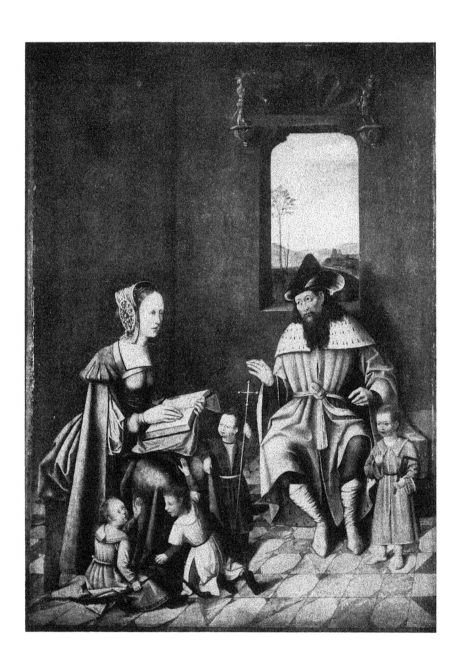

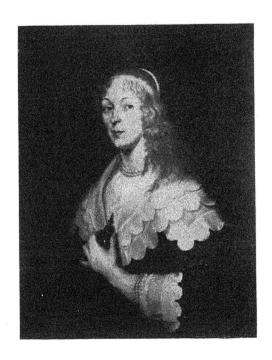

No. 71

JOACHIM VON SANDRART
DUTCH: 1606—1688

PORTRAIT OF A LADY

Canvas: Height, 35 inches; width, 26½ inches

HALF-FIGURE, about thirty, directed to left and looking at spectator; bluish black low dress with red bodice, short sleeves with broad white cuffs; three-row pearl bracelet on left arm, which is raised, the hand holding pearl and jeweled pendant at breast, broad white crossover, two-row pearl necklace; long golden hair falling over shoulders, small scarlet pearl-trimmed cap at back of head.

Signed and dated to left in black letters, J. SANDRART, F. 1643.

Collection: Charles Butler, May 26, 1911, No. 212.

No. 72

JACOB GERRITSZ CUYP

Dutch: 1575—1649

PORTRAIT OF A CHILD

Canvas: Height, 36 inches; width, 28 inches

SMALL whole-length figure of six or seven, standing to front in the open, looking at spectator; dark red dress, black bodice, white apron, broad white collar fastened with yellow bow; fair close-fitting white cap edged with lace and gold-embroidered band, red coral bracelets; right hand holding posy of flowers; straw basket suspended from left arm; background castellated buildings, partly in ruins, and gray cloudy sky.

From an anonymous collection at Christie's, June 7, 1912, No. 90.

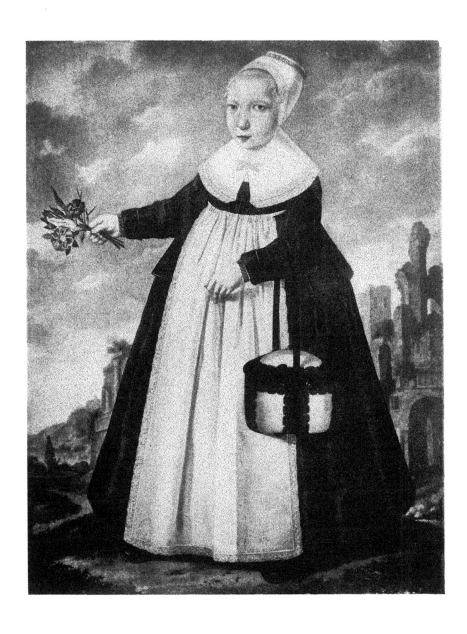

No. 73

JACOB A. BACKER
Dutch: 1608-9—1651

MAN WITH PEN IN HAND

Canvas: Height, 35½ inches; width, 29 inches

HALF-FIGURE of middle-aged man (apparently a Jewish rabbi) seated at a red-covered desk, to front, looking seriously to left as if solving a mental problem; dark dress and fur overcoat, gold neck-chain; brownish beard, black cap, right arm resting on open book on desk holding pen in hand, left hand clenched on lap, ring on last finger; gray background.

Painted under the influence of Rembrandt.

No. 74

MICHIEL J. VAN MIEREVELD
Dutch: 1567—1641

LADY WITH RUFF

(Panel)

Height, 39 inches; width, 30 inches

THREE-QUARTER length of a good-looking young Dutchwoman of quality, standing, directed to left, looking at spectator; dark greenish patterned dress embroidered with gold, white reflexed cuffs, large circular starched ruff, white linen and lace head-dress; dark hair; a ring on the penultimate finger of each hand, the right resting on arm of chair; to left table with gilt-edged Bible with silver clasps; greenish background.

Dated in gold letters at top right-hand corner: ÆTATIS 30, 1631.

From an anonymous sale at Christie's, July 5, 1902, No. 128, where it is ascribed to N. Elias.

FERDINAND BOL

DUTCH: 1611—1681

LADY AND TWO CHILDREN

Canvas: Height, 41 inches; width, 32 inches

THREE-QUARTER figure of young woman under thirty, seated, directed to left, looking at spectator; green dress cut square and embroidered with gold, white insertion at elbow and white cuffs, left hand on lap; fair hair, black and gold head-dress with long streamers; younger child in green and gold-embroidered dress, white cap and collar, seated on its mother's lap, holding a basket of grapes in one hand and offering with the other a bunch to its mother; the elder child in gold dress and red cap standing by its mother's side and holding ribbons; gray background.

Signed and dated in gold letters in lower right hand corner (the F. B. intertwined), F. BOL, 1655.

From an anonymous sale at Christie's, June 20, 1913, No. 111.

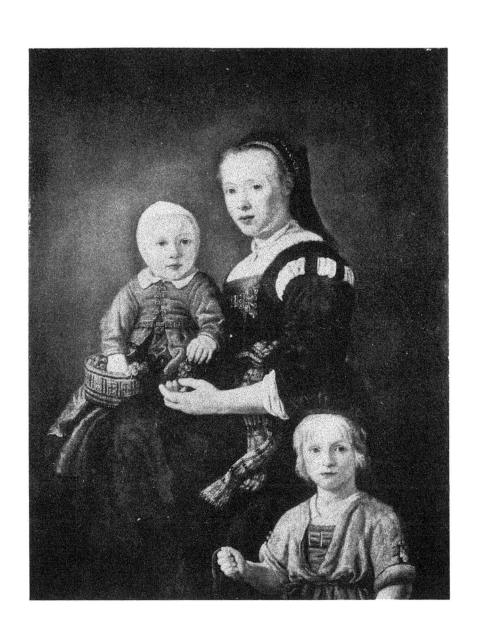

No. 76

JOHANNES VAN KESSEL

Dutch: 1648—1698

LANDSCAPE

Canvas: Height, 33 inches; length, 46 inches

A BROAD stretch of rich summer irregular landscape, the center of the picture occupied by low-lying lands through which passes a canal or lake with boats; in the foreground red-tiled cottages, a herd of cattle, and a cavalier passing towards a rustic bridge, and in the distance a cornfield with sheaves of corn; to right the undulating landscape ends in a deep sandy cliff.

Collections R. Wynne Williams, February, 1863; and anonymous owner, April 25, 1913.

NICOLAES MAES

DUTCH: 1632—1693

PORTRAIT OF A LADY

Canvas: Height, 44 inches; width, 33 inches

THREE-QUARTER length of middle-aged thin-faced lady, to front; low white satin dress, short sleeves, pearl pendant at center of corsage and on left sleeve; fair curly hair in ringlets falling on shoulders and with pearl ornament; pearl necklace and drop earrings; right arm resting on ledge of rock, left hand in tiny stream of water which falls from the rocks.

Signed and dated on rock to left, N. MAES, 1670.

Purchased from Messrs. Sulley & Co., London.

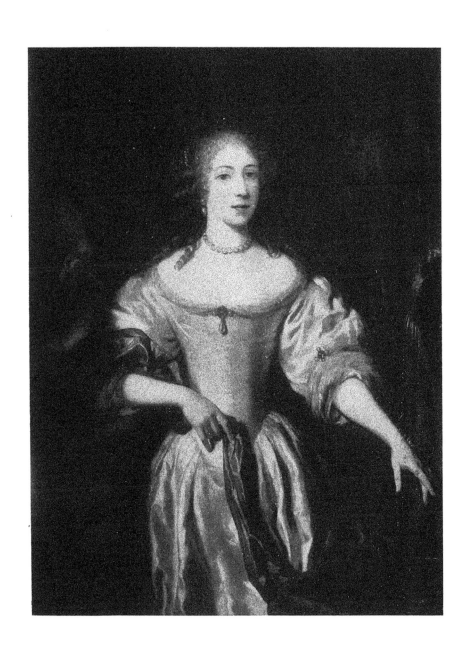

No. 78

NICOLAES MAES

Dutch: 1632—1693

FAMILY GROUP

Canvas: Height, 36 inches; width, 28 inches

THREE small whole-length figures on a balcony. The middle-aged full-faced husband, in blue dress, yellow cloak, white large cuffs and long wig, standing to right; left arm leaning on sculptured flower vase and holding baton in hand. The wife, a young woman, seated to left in white low dress with pearl and jewel pendant at center of corsage, red cloak across shoulders and on lap, the end held in right hand; dark curly hair with pearl rope, pearl earrings and necklace; left hand holding child's right arm, on the hand of which a bird is perched; the child, in pink dress and red felt hat with white feathers, is by its mother's side; red curtain, building and trees to left, distant landscape to right.

MICHIEL J. VAN MIEREVELD

DUTCH: 1567—1641

MARGUERITE VAN BROMKORT

(Panel)

Height, 48½ inches; width, 33½ inches

THREE-QUARTER figure of a young lady of quality, directed to left and looking at spectator; dark gray dress with elaborately embroidered corsage which ends in a broad tongue-shape flap; long white lace cuffs, gold bracelets, red and gold gloves held in right hand, on the index finger of which is a large ring; black hair with pearl and gold ornament, stiff high lace head-dress, broad white lace ruffle, long gold neck-chain of many rows, with center piece of ruby and emeralds; green background.

With coat-of-arms, name of personage and date, 1623, at top left hand corner.

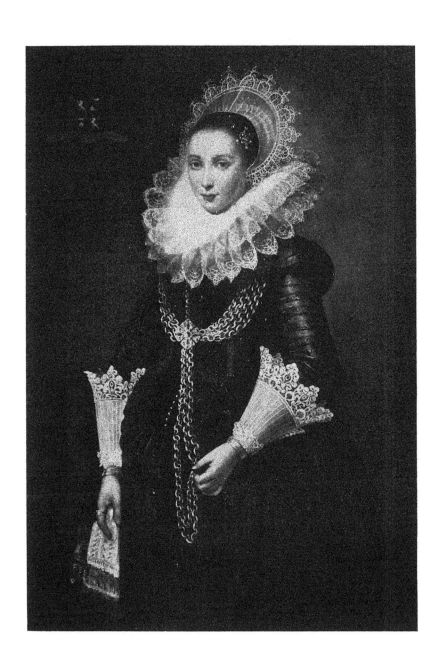

SALOMON DE KONINCK

Dutch: 1609—1668

SOPHONISBA

Canvas: Height, 58 inches; length, 65 inches

INTERIOR with four figures. Sophonisba to left in white satin low dress and rich red and old gold cloak; fair hair with pearl rope; left hand holding handkerchief and looking apprehensively towards a dolphin-shaped golden urn, which is held up by a man in a demi-suit of armor, and of which an old woman is lifting the lid; beside her is a weeping servant woman; portico to right, dark green curtain to left.

MICHIEL VAN MÜSSCHER

Dutch: 1645—1705

THE CONCERT

Canvas: Height, 54 inches; length, 57 inches

A SPACIOUS hall with three small whole-length figures. The gentleman
to right in black dress with white cuffs, tasseled neckerchief and long hair
(or wig) is seated on a wood chair playing a violoncello; to left the lady
in white low satin dress with ruby and other ornaments, and blue shawl,
is encouraging a pet dog whose fore-paws are on her lap; in the center is a
table with dessert and decanters of wine, and a serving maid holding a dish
of oranges; gray and white slate floor; to right trees and house, pillar and
dark curtain to left.

Signed and dated on lower end of pillar to left, M. V. Müsscher,
Pinxit Aº. 1671.

*Illustrated and described in C. Sedelmeyer's "Second Hundred of Paintings by
Old Masters," in 1895, p. 28.*

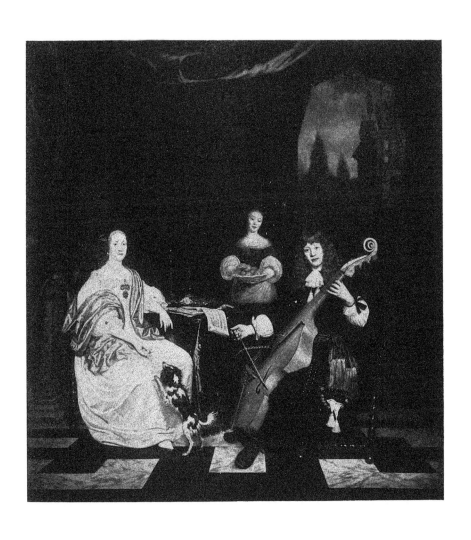

PAULUS MOREELSE

DUTCH: 1571—1638

LUCY HARINGTON, COUNTESS OF BEDFORD

Canvas: Height, 43 inches; width, 32½ inches

Eldest daughter of John, first Lord Harington; married, in 1594, Edward, third Earl of Bedford; died May 31, 1627. The Countess was a great patron of poets, notably Dr. Downe, Ben Jonson, Drayton and Daniel, all of whom wrote verses in her praise. The Duke of Bedford owns her portrait by Honthorst, and two others by unknown artists.

THREE-QUARTER length of elderly thin-faced lady standing to front and looking at spectator; black dress with elaborate garniture of large black beads, white cuffs and large white lace ruff, brown hair with small black cap, black earrings, locket with pearl pendant at breast; left arm resting on back of red chair, right hand holding fan; dark red curtain background.

Dated in silver letters at top right hand corner, 1613.

Collection: *Charles Butler, May 26, 1911, No. 199.*

EARLY FRENCH SCHOOL

SECOND NIGHT'S SALE

THURSDAY, APRIL 22, 1915

IN THE GRAND BALLROOM

OF

THE PLAZA

FIFTH AVENUE, 58th to 59th STREET

BEGINNING PROMPTLY AT 8.15 O'CLOCK

No. 83

MADEMOISELLE J. PHILIBERTE LEDOUX

FRENCH: LATE EIGHTEENTH CENTURY AND UNTIL 1815

GIRL ASLEEP

Canvas: Height, 18 *inches; width,* 14 *inches*

GREUZE-LIKE head of a young girl in white dress and blue sash, her head leaning to right on the edge of a blue sofa.

Mademoiselle Ledoux was the "élève chérie" of Greuze; authentic examples of her work are exceptionally rare. She approached so nearly to her master that most of her pictures have long passed as by him.

No. 84

MADEMOISELLE J. PHILIBERTE LEDOUX

FRENCH: LATE EIGHTEENTH CENTURY AND UNTIL 1815

GIRL LISTENING

Canvas: Length, 18 *inches; width,* 14½ *inches*

ANOTHER Greuze-like picture of a young girl, to front, with her ear to the keyhole of a door; white dress, black satin shawl loosely tied across shoulders; right bosom uncovered; golden hair with rope of pearls.

No. 85

MADAME VIGÉE LE BRUN

French: 1755—1842

COMTESSE DE VERDUN

Canvas: Height, 25 inches; width, 20 inches

Probably Pulchérie Tranquille de Lannion, daughter of the Comte de Lannion; married in February, 1766, Charles Armand Marquis de Pons en Saintonge, into whose branch the title of Verdun appears to have developed. The Marquise de Pons appears in the list of "Dames pour accompagner Madame" in the "Almanach Royal" of 1788, by which time apparently her husband had succeeded to the Marquisate.

HALF-FIGURE, under thirty, to front, looking at spectator; low white dress; red laced bodice and red shoulder straps; powdered hair, yellow straw hat with blue ribbons and posy of flowers.

Collection: Eugene Kraemer, Paris, May, 1913, No. 52 (with an illustration).

The Comtesse de Verdun sat to Madame Vigée Le Brun several times, in 1776, 1779, and again (with her family) in 1780.

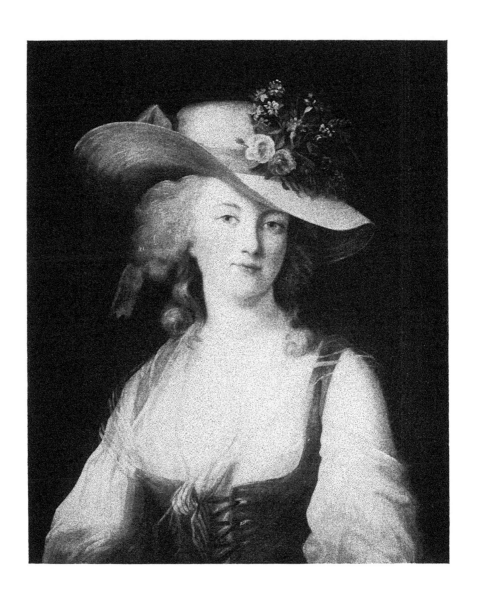

No. 86

FRANÇOIS BOUCHER

FRENCH: 1703—1771

AMORINI

Canvas: Height, 24 inches; length, 28½ inches

THREE amorini on clouds, one of whom is weaving a wreath of flowers around
the miniature of a child; blue drapery; a jewel box, arrow case and two
doves are among the accessories; Cupid to left holding an arrow.

No. 87

N. B. LÉPICTÉ

FRENCH: 1735—1784

HEAD OF A YOUNG GIRL

Canvas: Length, 24 inches; width, 18 inches

GREUZE-LIKE head of a young girl, to front, looking to left, blue striped
white low dress; golden hair, white mob cap with blue ribbon.

No. 88

NICOLAS DE LARGILLIÈRE

FRENCH: 1656—1746

VICOMTESSE DE NARBONNE-PELET

Canvas: Height, 30 inches; width, 25 inches

HALF-FIGURE of a young lady, standing, looking at spectator; low blue dress edged with gold, white insertion and spray of red flowers at bosom, brown patterned rococo-shaped corsage with pearl pendant and row of black beads; scarlet flowing cloak fastened on left shoulder with pearl and jewel brooch; powdered hair bound with blue ribbon and with pearl ornament; trees in background to left and right.

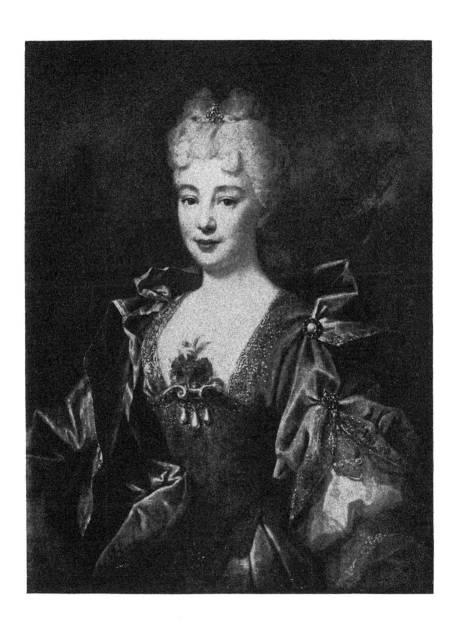

No. 89

JEAN RAOUX

FRENCH: 1677—1734

PORTRAIT OF A LADY

Canvas: Height, 31 inches; width, 24 inches

HALF-FIGURE of attractive looking lady, about twenty, seated, directed to left, looking to right, full face; brown low dress embroidered with gold and with white insertion at corsage, white starched ruff and cuffs; golden hair with black cap and blue and yellow feathers; hands resting on lap, the right holding a sealed letter.

No. 90

PIERRE MIGNARD

FRENCH: 1610—1695

LADY WITH A DOG

Canvas: Height, 33 inches; width, 27 inches

HALF-LENGTH of a middle-aged lady, seated with King Charles spaniel on her lap, by a clump of trees, to front, head turned slightly to left, looking at spectator; white low dress, short sleeves, red and gold patterned over-dress with pearl and jewel fasteners, blue shawl across shoulders, one end on lap; fair curly hair with pearl band, pearl drop earrings, pearl necklace, three pearl bracelets on each wrist, the right having also a black ribbon bracelet set with jewel; distant landscape to left.

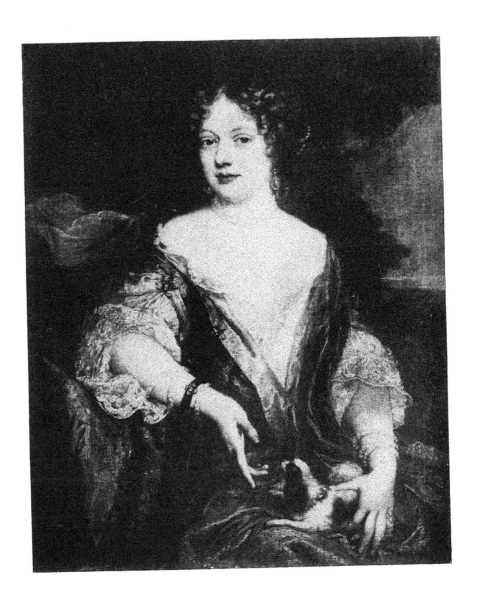

LOUIS TOCQUÉ

Fʀᴇɴᴄʜ: 1696—1772

MADAME DE LA MARTELIÈRE

Canvas: Height, 39 inches; width, 31 inches

Tʜʀᴇᴇ-ǫᴜᴀʀᴛᴇʀ figure, seated on a wood chair, to front, playing a guitar; bluish white low dress, with short lace-trimmed sleeves, elaborately garnished with various colored *immortelle* flower heads; powdered hair with pearls and flowers; gray-blue background with sculptured terra-cotta vase to left.

Signed and dated in black letters at foot of vase: Tocǫᴠé, 1752.

The name is probably an error for "de la Mazelière."

No. 92

ANTOINE VESTIER
FRENCH: 1740—1824

COMTESSE DE LA GARDE

Canvas: Height, 35 inches; width, 28 inches

HALF-FIGURE, about twenty-three, seated on red upholstered chair, to front, looking at spectator; green low dress with wide skirt, narrow long bodice, short sleeves with white frills, white fichu, bow of gray ribbon at center of corsage; powdered hair dressed high, a broad curl falling on each shoulder, bound with slate colored ribbon and ornamented with white feather and red rose; hands on lap, left holding two roses; gray background.

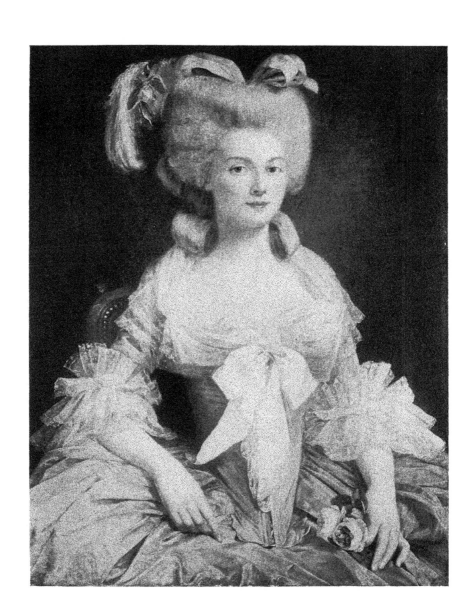

No. 93

NICOLAS DE LARGILLIÈRE

FRENCH: 1656—1746

AMPHITRITE AND ATTENDANTS

Canvas: Height, 35 inches; length, 49½ inches

THE wife of Neptune in slight draperies of white, blue and red, riding on a Dolphin, with attendants including Cupid holding torch; to right on the rocks is a figure playing a flute.

Collection: H. M. W. Oppenheim, London, June, 1913.

MADAME VIGÉE LE BRUN

FRENCH: 1755—1842

MADAME VESTRIS

Canvas: Height, 35½ inches; width, 28 inches

HALE-LENGTH, about twenty-five, walking in the open to left, looking to right; white bodice edged with gold, short sleeves, flowing blue robe embroidered with gold, the end held in left hand, right hand resting on left arm; red coral necklace, ruddy hair over forehead and flowing in the wind at back of neck, bound with red and golden ribbon; sunset background.

Signed and dated in lower left hand corner: L. E. VIGÉE LEBRUN, 1804, À LONDRES.

Exhibited: Portraits de Femmes et d'Enfants, Paris, 1897. Described and illustrated in Sedelmeyer's "Fourth Hundred Paintings by the Old Masters," 1897, No. 74.

Collections: D. H. King, New York, 1905; and "A Gentleman," London, May 15, 1908.

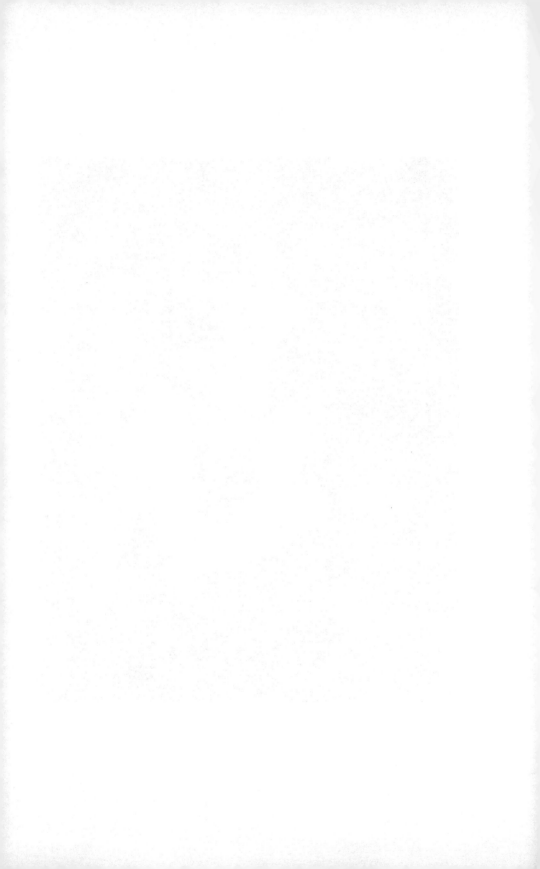

NICOLAS DE LARGILLIÈRE

FRENCH: 1656—1746

VERTUMNUS AND POMONA

Canvas: Height, 37 inches; length, 49½ inches

POMONA in blue, white and yellow classical draperies, seated on a bank, with gardening implements, pointing with the left hand to a group of fruit; on the right Vertumnus in the guise of an old woman, in red robe and green head covering, is directing the attention of Pomona to an elm entwined with a grape-bearing vine; to left conservatory, to right blue sky and hills.

Collection: H. M. W. Oppenheim, London, June, 1913.

NICOLAS DE LARGILLIÈRE

French: 1656—1746

DUC DE PENTHIÈVRE

Canvas: Height, 35½ inches; width, 29 inches

Louis Joseph, Duc de Penthièvre and afterwards Duc de Vendôme; born in 1654; entered the French army and distinguished himself in many battles; died at Tinaroz, Valencia, June 15, 1712.

HALE-LENGTH, about forty, standing, directed to right, head turned and looking at spectator; deep red patterned robes, white lace neckerchief; long flowing curly wig; white lace cuffs; right hand extended, ring on last finger; red curtain to right.

FRANÇOIS GUÉRIN

FRENCH: DIED 1791

FILLETTE JOUANT AVEC UN GARÇON ENDORMI

Canvas: Height, 39 inches; length, 58 inches.

GROUP of two figures in a landscape; the sleeping youth reclining on a golden-yellow cloak, in *négligé* dress of white shirt, yellow breeches and stockings; to left golden-haired girl in brown velvet low bodice with pink and white sleeves, bunch of forget-me-nots at center of corsage and band of flowers in her hair, holds in her left hand a wisp of grain with which she is tickling her fair companion; by his side a battledore and shuttlecock, which he has recently been playing.

Signed and dated on trunk of tree to left: F. GUÉRIN FEC. PINXIT EN 1791" (*last letter indistinct*).

An overdoor decorative painting by an artist whose works are now rarely met with; he was a popular painter of his time and was a member of the French Royal Academy of Painting, exhibiting at the Salon from 1761 to 1783. He painted many *genre* pictures, landscapes and portraits of famous men and women; the present example of his work is one of the most attractive of his fancy subjects which have come down to us.

HYACINTHE RIGAUD

FRENCH: 1659—1743

THE DUC D'ANTIN

Canvas: Height, 38 inches; length, 47 inches

Louis Antoine de Pardaillan de Gondrin, son of the Marquise de Montespan; born in 1665; Lieutenant General of the King's armies; died in 1736.

HALF-FIGURE of elderly man, to front, looking to right, in armor, blue and ermine cloak fastened with ruby and pearl brooch; right hand resting on staff or baton, left on hip; long gray wig; fort to right, landscape to left; background, blue sky and clouds.

Painted about 1720.

There is another portrait of the Duc d'Antin by Rigaud at Versailles, ' No. 2500.

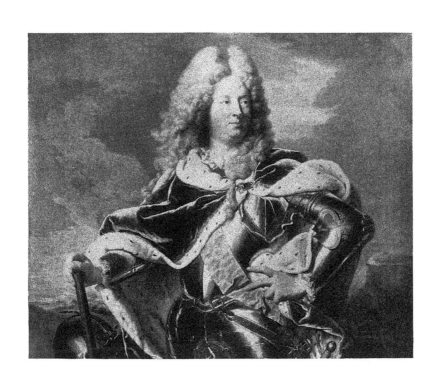

No. 99

CARLE ANDRÉ VAN LOO
FRENCH: 1705—1765

PORTRAIT OF A GIRL

Canvas: Height, 43½ inches; width, 33 inches

SMALL whole length of a fair-haired child about three or four; white and blue low dress, right hand holding letter addressed "Au Roy," left holding scarlet ribbon, one end of which is tied to the collar of a dog whose front paw is resting on gilt pink-upholstered chair, on which is child's plumed blue hat; yellow and red curtains and paneled background.

No. 100

CARLE ANDRÉ VAN LOO
FRENCH: 1705—1765

COMTESSE DE BEAUFORT AS SULTANA

Canvas: Height, 45 inches; width, 35 inches

THREE-QUARTER length, about thirty, to front, looking at spectator, full face, black low dress with red and gold bands, embroidered shawl loosely tied around waist, the end over right arm; jeweled brooch at center of corsage, jeweled neck chain with pendant; powdered hair, white turban with red crown and feather aigrette; right hand holding black mask, left arm resting on table; pillar to left, green curtain to right.

Collection: Duc de Praslin.

No. 101

LOUIS JOSEPH WATTEAU (of Lille)

FRENCH: 1758—1813

PORTRAIT OF A LADY

Canvas: Height, 46½ inches; width, 36 inches

NEARLY whole length of middle-aged lady, seated on red upholstered chair, directed to left, looking at spectator; old gold low dress with white gauffered fichu and white waistband; golden hair bound with white ribbon and pearl rope, gold earrings; right arm resting on table, holding two red roses in hand, left hand on lap holding greenish shawl; background gray curtain.

Signed at right hand bottom corner: WATTEAU (?DEL).

From the Abeille Collection.

No. 102

FRANCIS POURBUS

FRENCH: 1569—1622

ANNE OF AUSTRIA

Canvas: Height, 49 inches; width, 39 inches

Daughter of Philip III of Spain; born at Madrid, September 22, 1601; married Louis XIII of France by proxy at Burgos, October 18, 1615; Regent of France during the minority of her son, Louis XIV, 1643-61; died January 20, 1666.

THREE-QUARTER length, about twenty, standing to front in full robes, ermine cloak, green dress embroidered with golden fleurs-de-lis, white tripartite corsage studded with large pearls and precious stones, green sleeves with small white puffs and jewels; large white ruff, white lace cuffs, pearl bracelets and earrings; fair hair with crown; right hand resting on cloak, of which a fold is held in the left; red curtain background.

No. 103

JEAN FRANÇOIS DE TROY

FRENCH: 1679—1752

PORTRAIT OF A LADY

Canvas: Height, 49½ inches; length, 39½ inches

THREE-QUARTER length, middle-aged, standing, directed to left and looking at spectator; blue low dress with short broad sleeves trimmed with lace, red cloak over right shoulder; curly hair; right hand pointing to right and holding flower; large sculptured flower vase on left, blue curtain.

No. 104

ADÉLAÏDE LABILLE-DES-VERTUS GUIARD

FRENCH: 1749—1803

PRINCESSE DE LAMBALLE

Canvas: Height, 50 inches; width, 38 inches

Marie Thérèse Louise, daughter of the Prince de Carignan; born at Turin in September, 1749; married in 1767 Louis of Bourbon, Prince de Lamballe, the intimate friend of Marie Antoinette; died in 1792.

NEARLY whole length, under thirty, to front, seated in green armchair; red low dress trimmed with brown fur, short sleeves edged with white lace, pearl bracelets, powdered hair, white head-dress, the ends loosely folded over bosom; right elbow on edge of chair, hand holding tortoise-shell fan; left hand on lap, index finger extended; green curtain and pillar background, clouds to right.

A different portrait of the Princess, by the same artist, is reproduced in the *Gazette des Beaux Arts* (1902), *Vol.* 27, *p.* 113.

No. 105

HYACINTHE RIGAUD

FRENCH: 1659—1743

MADAME RIGAUD

Canvas: Height, 50 inches; width, 37½ inches

Elisabeth de Gouix (or Goion), widow of Jean Lejuge of Paris; married in 1710, Hyacinthe Rigaud, Painter-in-ordinary to the King—the original marriage contract appeared in a sale held in London on November 28, 1913; she died March 15, 1743, aged 75.

NEARLY whole length, about thirty, standing, directed to left, looking at spectator; green low dress with white insertion, corsage embroidered with gold and the skirt with silver, short sleeves, blue cloak over right shoulder and arm; right hand extended, left holding end of cloak; black hair in curls with white ribbon; to left dark curtain, to right large sculptured flower vase; gray background with two pilasters.

Described and illustrated in Sedelmeyer's "Fifth Hundred of Paintings by Old Masters," 1899, pp. 100-101.

Rigaud painted several portraits of his wife before and after his marriage. A romantic story of his first portrait of her is told in *L'Artiste* of March, 1870, pp. 275-6.

No. 106

HYACINTHE RIGAUD
FRENCH: 1659—1743

LADY IN RED

Canvas: Height, 54 inches; width, 40 inches

THREE-QUARTER length, middle-age, standing to front; old-gold low dress
with white lace insertion, short sleeves edged with white lace, blue and red
asters at center of corsage; rich scarlet overdress with pearl ornament; pow-
dered hair with pearl pin and spray of foliage; right hand extended, left
holding fold of dress; to left pillar with pedestal carved with boys, goats,
and vine-leaves, to right trees.

Collection: H. M. W. Oppenheim, June 13, 1913.

No. 107

ADÉLAÏDE LABILLE-DES-VERTUS GUIARD
FRENCH: 1749—1803

LADY AND CHILD

Canvas: Height, 56 inches; width, 44 inches

WHOLE length of a young lady seated in a gilt and blue upholstered chair,
directed to left, looking at spectator; greenish shot silk low dress, double row
of buttons at corsage, broad white collar, sleeves trimmed with white; pow-
dered hair, light blue hat with blue ribbon; left arm resting on blue cushion;
infant in white and red dress on lap, end of its pink sash held in mother's
left hand; to left sculptured urn and low table with tea things.

No. 108

NICOLAS DE LARGILLIERE
French: 1656—1746

PORTRAIT OF A LADY OF THE COURT OF LOUIS XIV

Canvas: Height, 63 inches; width, 50 inches

THREE-QUARTER length of a middle-aged lady at her toilet, to front; white gold-embroidered low dress with short lace-trimmed sleeves; dark hair with pearl and ribbon bands which she is fastening with both hands; rich blue shawl over shoulders; to left dressing-table with mirror; blue Chinese vase with flowers, jewel case and pink drapery; to right carved wood red upholstered chair; pillar and red curtain background.

Collection: Mrs. Lyne Stephens, June, 1911, No. 105.

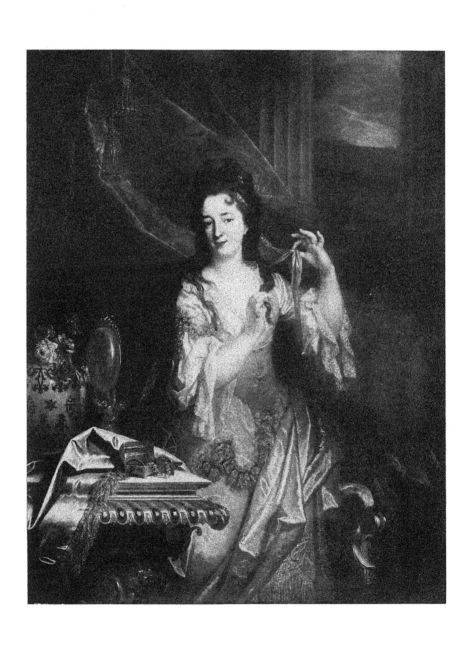

No. 109

JACQUES LOUIS DAVID

FRENCH: 1748—1825

NAPOLEON BONAPARTE

Canvas: Height, 59½ inches; width, 43½ inches

WHOLE length seated on a rocky coast, directed to left, looking at spectator; in uniform, green coat with gold buttons and epaulettes, red cuffs and collar, red and green sash seen under coat, red rosette with eagle pendant and star of an order on breast; white waistcoat (with gold snuffbox in pocket) and breeches, top boots, gold handled sword by side; hands crossed on lap, left holding paper; gloves and hat on floor; to right eagle on rock above, nest of dead eagles and snake below, to left cottage with awning, and sea in distance.

This appears to be an unrecorded portrait of Napoleon; is probably by one of David's pupils, and not done *ad vivum.*

No. 110

NICOLAS LANCRET (School of)

FÊTE CHAMPÊTRE

Canvas: Length, 71 inches; width, 61 inches

GROUP of eighteen figures near the stone steps of the entrance to a richly wooded garden; the two central figures, a youth in fancy costume and a girl in plain gray dress, are dancing to the strains of a fife, guitar and tambourine; in the middle distance three seated figures are taking refreshments; to left a youth playing a violin and reading the music from a page held by a seated girl; to right, and near a carved fountain, are three figures in conversation; other features in the composition are two dogs and bagpipes, the latter presumably the instrument of the youth dancing.

Collection: Lesser Lesser, February 10, 1912, No. 9.

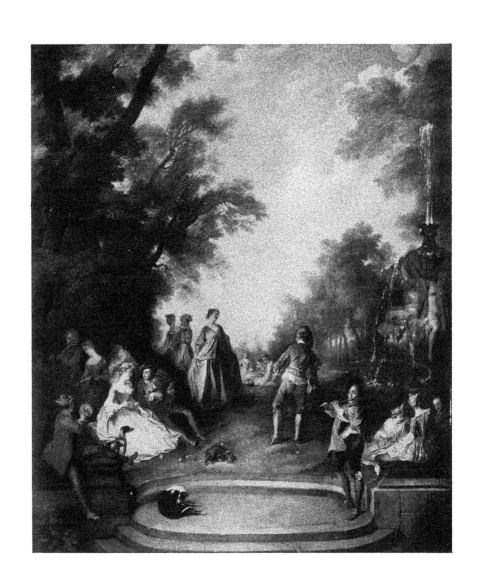

No. 111

CARLE ANDRÉ VAN LOO
FRENCH: 1705—1765

EMPEROR OF GERMANY

Canvas: Height, 87 inches; width, 49 inches

WHOLE length, when young, standing to front, looking to right, in state robes; gold patterned coat and breeches, white stockings, black shoes with jeweled buckles and red heels; long flowing gold embroidered cloak, the folds of which fall over green and gold upholstered state chair; gray wig, white lace collar, the Order of the Golden *F*leece suspended by red ribbon; to right carved gilt table with red drapery on which are scarlet and ermine cloak, crown and orb; gold staff or scepter held by right hand; overhead gold curtain to right with rope and tassels to left.

This and the following are referred to at length in Mr. Roberts's Introduction.

No. 112

CARLE ANDRÉ VAN LOO
FRENCH: 1705—1765

EMPRESS OF GERMANY
(The pendant of the preceding portrait)

Canvas: Height, 87 inches; width, 49 inches

WHOLE length, about forty, to front, in state robes, gray satin low dress and short sleeves, elaborately decorated with pearls and precious stones, black gold-embroidered underskirt, scarlet and white cloak across shoulders; right hand holding gold double cross, left resting on stool; crown and orb on table to left, dark curtain background, alcove to left.

FLEMISH SCHOOL

No. 113

SIR ANTHONY VAN DYCK

FLEMISH: 1599—1641

ST. ANDREW

Height, 16 inches; width, 13 inches

HEAD and shoulders of the elderly saint, directed to left, his right hand resting on what appears to be his cross. Chalk drawing on canvas.

No. 114

BERNARD VAN ORLEY
FLEMISH: 1490—1542

VIRGIN AND CHILD

Height, 17 inches; width, 12½ inches

THE Virgin, beneath a canopy of dark draperies, seated on a plain wood bench in front of a long table on which fruit is spread; blue dress, rich scarlet cloak across her shoulders and lap, white head-dress with long ends; the child seated on his mother's lap, holding an apple in his right hand, a red-breasted bird perched on his left; in the distance to right a country scene with cottages, river and high peaked hills.

Transferred from wood to canvas

Collection: Charles Butler, May 26, 1911, No. 204.

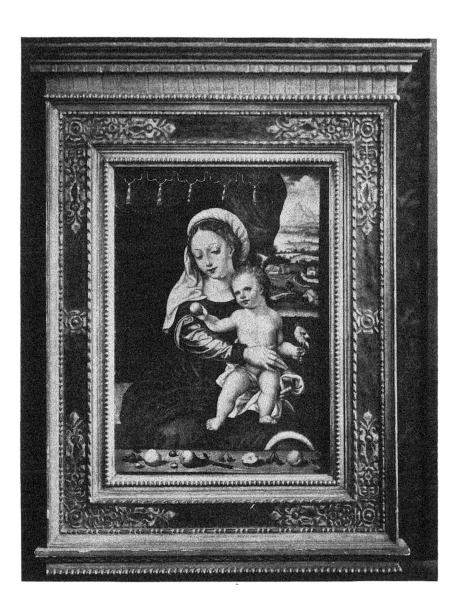

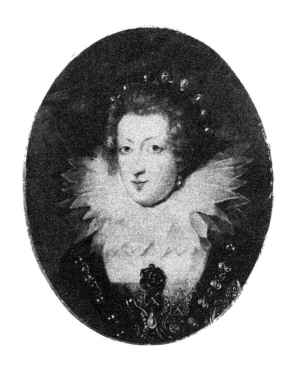

No. 115

SIR PETER PAUL RUBENS

Flemish: 1577—1640

HEAD OF PRINCESS ELIZABETH

Canvas: Height, 24 *inches; width,* 19 *inches*

Bust of Princess in middle age, to front, blue and black low dress cut square, with pearl pendant and band of pearls and precious stones, white large wedge-tipped ruff; fair hair with pearl band, drop pearl earrings; scarlet curtain background.

No. 116

JUSTUS SUTTERMANS

Flemish: 1597—1681

LADY IN RED DRESS

(Probably a member of the Medici family)

Canvas: Height, 50 inches; width, 36 inches

NEARLY whole length of a lady of quality about thirty, standing, directed slightly to left; looking at spectator; large sleeveless cloak elaborately embroidered with gold; red dress embroidered with gold in perpendicular lines, corsage terminating in long tongue-shaped flap and similarly embroidered, creamy white sleeves with gold pattern, white lace cuffs, red bead bracelets, broad stiff lace collar edged with red and tied with red ribbon bow; red bead necklace, and long rope of same passing over shoulders, long gold necklace in which is entwined second finger of left hand; right hand resting on green covered table; brown hair with red ribbon and jeweled aigrette or comb.

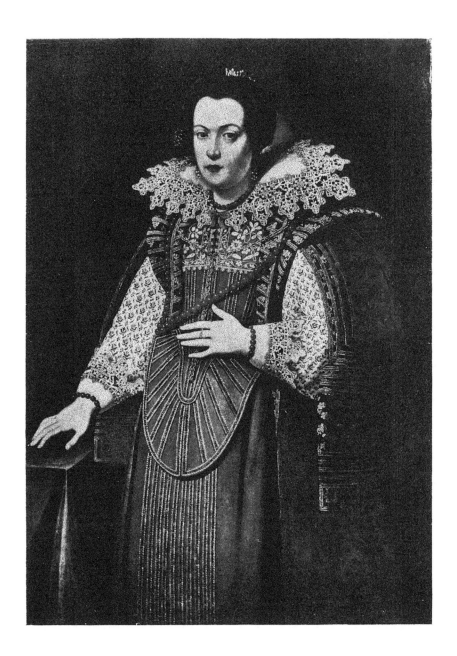

No. 117

JUSTUS SUTTERMANS

FLEMISH: 1597—1681

PORTRAIT OF A SPANISH LADY

Canvas: Height, 33 inches; width, 26 inches

HALF figure of a young woman standing to front, looking at spectator; brown dress, white sleeves with small richly-worked cuffs, double-row gold neck chain and long necklace of black beads and gold; brown hair with red flower, gold and pearl earrings, elaborate white stiff collar; left hand with ring on last finger, holding open book; right hand, ring on penultimate finger, holding handkerchief.

Sold at Christie's on June 14, 1852, No. 76, as a Velasquez: "Head of a Spanish Princess in rich dress."

No. 118

SIR ANTHONY VAN DYCK

FLEMISH: 1599—1641

A LADY OF THE CONINGSBY FAMILY

Canvas: Height, 71½ inches; width, 42 inches

WHOLE-LENGTH portrait of lady under thirty, walking to left up the stone steps of a balcony; pink low dress embroidered with gold, pink and bluish bodice with pink bows, black lace shawl over head and shoulders and flowing at back, deep white lace cuffs; pearl and gold necklaces, pearl pendants suspended by colored ribbon from gold earrings; golden curly hair, pink head-dress with pearl border; gloved right hand resting on fruiting orange tree, left hand holding fan and fold of dress; trees to left.

Exhibited: Edinburgh Loan Exhibition, 1883, No. 184 (Sir George D. Clerk).

Collections: Sir George Clerk, Bart., 1896; Charles Butler, 1911, No. 220.

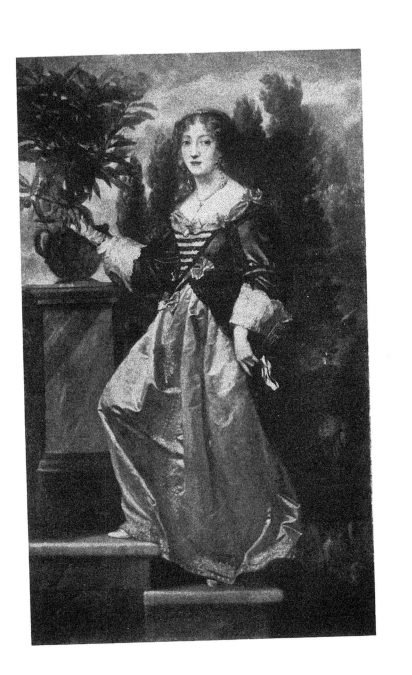

No. 119

SIR PETER PAUL RUBENS

Flemish: 1577—1640

THE ADORATION OF THE MAGI

Canvas: Height, 96½ inches; length, 120 inches

On the extreme left are observed the heads of the ass and the ox. Then towards the right the Virgin holds the Child on her knees. She has a grayish-white cloth over her head, she wears a red dress with white sleeves and blue drapery; her feet are bare. Beside her is St. Joseph draped in neutral tones. In front of the Virgin, the Wise Man with the white hair and beard who holds out to the Child a basin filled with pieces of gold. He wears a simple white alb, over which is thrown a pink chasuble with a golden stole. In the middle of the picture the black King with white cloth around his head, and over his body an ample red cloak lined with gold and yellow with golden fringes and dressed in red. The very long skirt of the red cloak is supported at the end of the picture by a pretty page boy whose head and leg are alone seen. Behind the negro King is the third King bearing a gold censer, dressed in a neutral tinted grayish cloak over a dark-blue dress, and having black hair and beard. Behind this last King a tall page and a negro whose head and neck alone are seen, two men on horseback, one wearing a red cap and the other a cloak. Finally coming down a slope, six men, four of whom are soldiers, one officer and a Court dignitary.

(See illustration, second page following)

AUTHENTICITY: The above descriptive particulars were drawn up by the late Mr. Max Rooses, the eminent authority on Rubens, and dated Antwerp, December 7, 1912. Mr. Max Rooses also wrote: "The composition is by Rubens entirely, and so are the principal figures. The Virgin is entirely painted by the hand of Rubens, as well as the child Jesus, of a beautiful bright color, standing out clearly. St. Joseph of a moderately conspicuous color by

the hand of Rubens. The hand of St. Joseph is much more touched up than the rest. The Wise Man with the white hair is entirely by the hand of Rubens. The painter has placed a clear note in the middle of the picture; the drawing of this figure is less careful. The Negro King is the dominating feature of the picture. The red cloak trimmed with yellow and with a white fur collar fills the entire picture with an enormous brilliant touch and is one of the most admirable pieces the master ever produced. The light on the lining flashes the red color with the dark shades standing off against a brilliant light color, one of the most beautiful pieces of coloring it is possible to see. They form a blaze of color calculated to eclipse the richest picture in tones, and they dominate this picture powerfully and happily. The little page who holds the skirt of the cloak adds a broadly painted note of color and beauty, without very successful drawing, but admirable as a feature of the whole. The figures in the background decline in value and liveliness. The black-haired King and the Courtier are pretty abundantly retouched by Rubens; the steers, vaguer in the background, are executed by a pupil. The heads of the ox and the ass and the column on the ground are retouched by Rubens, in order to bring them into harmony with the vibrating part of the picture.

"Rubens has divided this picture into three grounds. The foreground contains the Virgin, the Infant, the old man with the white hair, the Negro King and the little page, to which are added the heads of the oxen and the broken recumbent column. The second ground contains St. Joseph, the black-bearded Wise Man, the courtier, the tall page and the black servant. In the third ground are the seven figures in the background, and the latter itself.

"The composition is facile and ample. The picture does not possess the exceptionally high value of his best productions, but it is authentic and would do credit to a high-class collection. To sum up, the picture is composed by Rubens; it is painted in his hand as regards the figures in the foreground, and by that of a pupil retouched by Rubens in the background figures." (Translation.)

HISTORY: This picture was painted for the principal Altar of the Church of St. Martin in Bergues, French Flanders. It was sold in 1766 by the church authorities to meet the expenses for the repair of the building, and was bought by the celebrated amateur, Randon de Boisset. On the sale of his Gallery in 1777, the upset price of 10,000 livres (francs) was not reached. At Lebrun's sale in 1791 it was sold at 9,500 francs and at Robit's sale in 1801 for 7,950 francs, when it was purchased for Cardinal Fesch. It remained in the Cardinal's fine collection until after his death in 1839. This Gallery was dispersed at the Palais Ricci, Rome, during the spring of 1845,

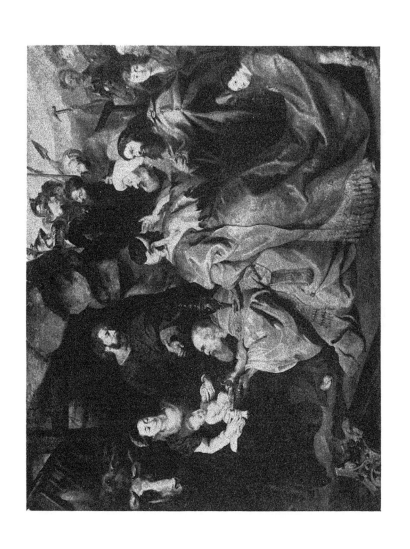

and this Rubens is described at great length in the Expert George's "Catalogue Raisonné," No. 199 (pp. 222-226). It was acquired by Thibaut at 2,500 "écus romains" (13,750 francs) for a member of the family (the Cardinal was Napoleon's uncle), in which it appears to have remained until March 12, 1853, when it was sold at Christie's as the property of Charles Lucien Bonaparte, Prince de Canino; it then realized £1,200, and was bought by Bentley, the well-known dealer. Since then it has been practically lost.

The picture is fully described in Smith's "Catalogue Raisonné," Part 2, No. 119, where the size is not correctly given. It has been engraved by Nicolas Ryckman, with various differences in details, the engraver choosing an upright form for his engraving and not that of the picture, which is oblong.

VERSIONS OF THE SAME SUBJECT: Rubens painted this subject several times:—(1) In the Madrid Museum, done in 1610; (2) Brussels Museum, done 1618-19, for the Capucin Fathers of Tournai; (3) Louvre, about 1627, for the Annunciades of Brussels; (4) Dublin Gallery, belonging to Lord Ardilaun, repetition of the preceding by a pupil; (5) an example done in 1621 for the Church of Ste. Gudule—this has disappeared; (6) Church of St. Jean, Maines; (7) the same, a sketch, the property of the Marquis of Bute, both painted in 1624; (8) Lyons Museum, a pupil's work retouched by Rubens about 1619; (9) Antwerp Museum, 1624, done for the Church of the Abbey St. Michel at Antwerp; (10) The Hermitage, St. Petersburg, pupil's work touched by the master; (11) the above described version for the Church of St. Martin, Bergues St. Winoc; (12) the Duke of Westminster's version done for the Convent of the Dames Blanc at Louvain, of which there is a sketch in the Wallace Collection; and (13) the version done for the famous printer, Balthasar Morctus, at the New Palace, Potsdam.

ENGLISH SCHOOLS

INTRODUCTION

GENERALLY speaking, a picture dealer's stock, when it comes to be sold by auction, presents a somewhat miscellaneous contingent of derelicts—pictures which for various reasons have not attracted collectors of very different tastes and buying capacities. This is inevitable in the case of a dealer who caters for all classes of buyers. For the few who are satisfied with the purchase of an occasional masterpiece there are hundreds who are constantly on the lookout for inexpensive pictures of good decorative and artistic qualities. The late Mr. Blakeslee catered for all classes of buyers, and probably during his long business career had a larger number of clients than any other picture dealer on the American continent.

A mere glance through this catalogue will more than demonstrate that his stock, so far from being a mass of "derelicts," is, in point of fact, of a very high order in quality and importance. There are not perhaps many superb masterpieces—for such are rare even in a well-weeded private collection—but there are here pictures which will withstand every test of authenticity, and which possess every artistic claim to the right of entry into the best of collections.

The collection is especially remarkable for its portraits by English artists, and these comprise works by men who rank as Sir Joshua Reynolds's predecessors, by those who were his contemporaries, and by those who carried on the traditions of the great founder of what is now comprehensively known as the Early English School, in which Sir Joshua himself is represented by at least one great picture and a number of others of smaller size. It cannot be doubted that many of these will in due course find permanent homes in one or other of the public galleries or private collections of which there are so many throughout the United States.

Portrait painting in England from the time of Van Dyck to Reynolds is represented by five of the leading artists, ranging from Dobson, who died in 1646, to Highmore, who lived to 1780. By Dobson there are not only two copies after his great master, Van Dyck, but also an interesting group of two children and another of Sir Charles and Lady Lucas—the latter an excellent picture which offers a somewhat difficult problem. It came from a well-known collection, and has apparently always been known as representing the famous Royalist and his wife; but there is no evidence so far as can be found that he was ever married, and probably the lady in the picture is his devoted sister, Margaret Duchess of Newcastle, an accomplished lady of literary tastes whose agreeable countenance has been preserved to us in Diepenbeke's portrait. The best of the Lely portraits is that of Frances Lady Digby, which must have been painted towards the end of his career; another good picture is the group of the Prince and Princess of Orange, at whose marriage the artist was presented to Charles I. No other version of the picture is known.

Among the works catalogued under Kneller, attention will be at once arrested by the fine whole length in state robes of a lady. This came from the very large collection of historical portraits formed by James Earl of Fife towards the end of the eighteenth century and which remained at Duff House, Banffshire, until 1907. It has always passed as a portrait of Sophia, wife of George I, and by some attributed to Kneller, whose companion portrait of the king was also in the same collection. In the matter of family and other portraits tradition counts for much, and it is not always easy to prove that it is wrong. There are, however, many reasons against accepting this as a portrait of the unhappy consort of George I, who did not succeed to the throne of England until 1698, or four years after his divorce. It is probable that the portrait represents their daughter, Sophia Dorothea, who married Frederick William I, King of Prussia, and may have been painted by A. Pesne, a French artist who had a large practice as official portrait painter in Berlin and to whom the Queen undoubtedly sat. When the portrait was exhibited in London the critic of The Times (December 30th, 1890) pointed out that "this finely painted full length of a lady in

Royal Robes, with the Crown of England by her side, was certainly painted long after 1726," and suggested that it may be a posthumous portrait commanded by George II as a memorial of his mother. And here for the present the matter must rest.

By Jacob Housman, or Huysmans, a Dutch painter, who, as we know from Pepys, had a considerable vogue in London, there are two interesting portraits which help us to realize that many of his works now pass under the name of his more famous contemporary, Lely. Joseph Highmore, with his refined portrait of the celebrated actress, Mrs. Pritchard, and Hogarth, with an equally good portrait of another famous actress, Peg Woffington, help us to bridge the story of the art of portrait painting from Van Dyck to Reynolds.

The examples of Sir Joshua Reynolds are dominated by the magisterial portrait of Annabella Lady Blake as "Juno," which was one of the sensations of the Royal Academy of 1769, the one jarring note in the criticisms of the day being a protest against "transferring ladies of the eighteenth century into heathen goddesses." The picture is well known through the superb mezzotint by John Dixon, which has been copied times out of number. Nearly all the Bunburys—and Lady Blake was a Miss Bunbury—with their wives, children and friends—sat to Sir Joshua, and this fine picture is only one of the many tokens of the friendship which existed between the artist and a distinguished family. Of other well-known people represented here who sat to Sir Joshua, special reference can only be made to the Countess of Ancrum, Dr. John Armstrong, a now entirely unread poet, Kitty Fischer, a lady more celebrated for her beauty than for her virtue, the artist's niece, Miss "Offie" Palmer, and the Countess of Strafford.

Two exceedingly attractive among other examples of Romney's art will be found in this collection: Mrs. Drake, a member of a once famous and wealthy Norwich family, and Mrs. Uppleby. Both were painted in Romney's best time and each is of first rate quality. The latter portrait of an old lady is a brilliant piece of characterization, and either of these two portraits would be an ornament to any collection. Most of the best known contempo-

raries of Reynolds and Romney are represented by examples of varying excellence. Raeburn's Lord Craig and Mrs. Stewart Richardson are well-known examples of the greatest portrait painter which Scotland has yet produced. Although the pictures by Benjamin West are not of the first rank, they have special interest to Americans.

Sir Thomas Lawrence and Sir William Beechey, and the many artists who may be grouped around them, are well represented, some by unrecorded examples. The best known of the Lawrences is the "noble portrait," as Boaden calls it, of "Kemble as Rollo," which for a century formed part of the Peel Collection at Drayton Manor, and which ought to find a permanent home in some theatrical club or in the *foyer* of one of the theaters in the States. The portrait of Lady Harriet Vernon, catalogued under Beechey, is so much in the manner of Reynolds and so unlike any other Beechey known to the present writer that it is difficult to accept the present attribution without reserve. It is curious to note that whilst we have in this picture a portrait of the youngest daughter of Thomas Earl of Strafford, we have in Reynolds's Countess of Strafford the wife of William Earl of Strafford, both painted 1755-58, when the artist of one was a child.

There are several interesting examples of Early English artists whose work is often found under better-selling—because better known—names. For instance, the group by Mason Chamberlin of Mr. and Mrs. Hopkins, and the canal picture by *F. W. Watts*, which long passed as a Constable.

Sir Martin A. Shee and George *F.* Watts (the former was born in 1769 and the latter died in 1904 at the age of eighty-seven) furnish us with a continuity of over a century and a quarter, from Reynolds to our own day. By Shee we have a character portrait of Mrs. Kemble, and by Watts an exceedingly interesting group signed and dated 1837. This group is an important "document" in the early artistic life of one of the greatest idealists of our time. In those early days, as his widow informs the present writer, Mr. Watts painted many portraits, but, so far, a search through his sketchbooks has failed to identify the lady and her two children in this picture. Mrs. Watts also states that the size of the canvas on which he usually painted at the date of this picture was much smaller than this. Contemporary with

both Shee and G. *F.* Watts, Sir *D*avid Wilkie is represented not only by two official portraits, but by a subject picture which very strongly appeals to American sentiment and is based upon a well-known passage in Washington *I*rving's "Life" of Columbus.

There are few pictures of the present, but they are all important, and, it may be added, all well known through frequent reproductions. We have a transcript of Ancient Rome in Alma-Tadema's "Sculpture Gallery," a scene of Jacobean England in Orchardson's "Young *D*uke," and what might well be a passage from the Mort d'Arthur or a verse from William Morris's poems in Burne-Jones's "Psyche's Wedding."

My object in compiling this catalogue has been to describe the pictures under the names of the artists whom I believe to have painted them, irrespective of the names under which some of them have been purchased. In several instances it has not been possible to solve some of the problems which have arisen. But a fine picture remains a fine picture, to whomsoever it be attributed. The practice which, for commercial reasons, has been so long in vogue, of fathering on Beechey and Harlow pictures below the standard of Hoppner and Lawrence, has caused a great amount of confusion, and even after the counterfeits have been separated from the genuine, other difficulties in the way of attribution arise. Many well-selected private collections in the *U*nited States afford problems of this character, and some of these will not be settled until we possess a thoroughly comprehensive history of English art during the first fifty years of the last century.

<div style="text-align: right;">W. ROBERTS.</div>

London, November, 1914.

No. 120

A. W. DEVIS

1763—1822

PORTRAIT OF A LADY

Canvas: Height, 29¾ inches; width, 18¾ inches

SMALL whole length of a middle-aged lady, white dress with broad frilled pleats round shoulders, blue bow at neck, black broad waistband with blue bow; right hand holding large black high-crowned felt hat trimmed with blue bands and white feathers; powdered curly hair, long gold earrings.

From an anonymous sale at Christie's, May 13, 1899, No. 116.

No. 121

JOHN OPIE, R. A.

1761—1807

THE YOUNG MUSICIAN

Canvas: Height, 28 inches; width, 23 inches

HALF-FIGURE of a peasant boy, standing, directed to left; green sleeveless waistcoat, white shirt open at neck, red breeches, black felt hat, dark long hair; playing on a red whistle which he is holding to his mouth with both hands; gray background.

No. 122

FRANCIS COTES, R.A.

1726—1770

PORTRAIT OF A LADY

Canvas: Height, 23 inches; width, 18 inches

HEAD and shoulders, to front, looking to right, three-quarter face; low white dress with lace insertion, pearl and ruby brooch at center of corsage, pink cloak trimmed with ermine; dark hair dressed high, with white turban, of which the end falls over left shoulder; pearl necklace and earrings, gray background.

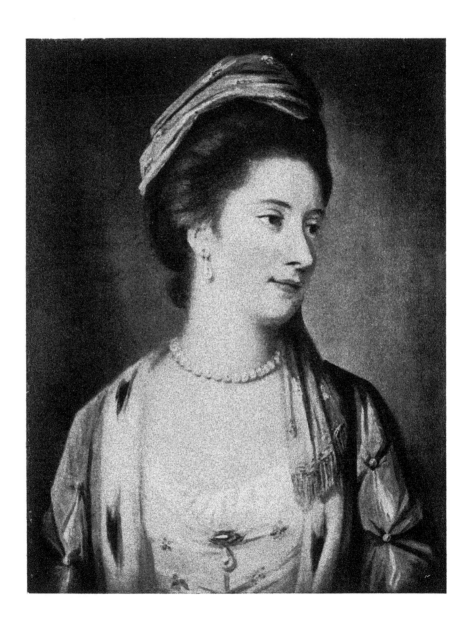

No. 123

ALFRED EDWARD CHALON, R.A.

1781—1860

MRS. FAIRLIE AND CHILD

Canvas: Height, 28½ inches; width, 23½ inches

Probably Louisa Fairlie (née Purves), wife of John Fairlie and niece of Lady Blessington; an authoress; died in 1843.

THE mother, about thirty, seen to waist, seated in dull green covered chair, directed slightly to right, looking at spectator, full face; low white dress with jewel, bright scarlet jacket lined with white and fastened with red band at waist, black hair in curls, gold earrings and thin gold necklace; left arm around the child's neck, ring on penultimate finger; golden-haired child in blue and white dress nestling close to her mother; dull gray background.

Chalon exhibited a group of Mrs. Fairlie and her two children—an engraved work—at the Royal Academy of 1834. The Mrs. Fairlie in the above picture is probably the same lady.

No. 124

SIR JOSHUA REYNOLDS, P.R.A.
1723—1792

JOHN ARMSTRONG, M.D.

Canvas: Height, 29 inches; width, 24 inches

Poet, physician and essayist; born at Castleton, N. B., in 1709; studied medicine at Edinburgh; physician to Hospital for wounded soldiers, London, 1746; to the army in Germany, 1760; traveled in Italy with Fuseli, 1771; an intimate friend of John Wilkes and Sir Joshua Reynolds; died September 7, 1779. His most famous work is a didactic poem entitled "The Art of Preserving Health," 1744.

HEAD and shoulders of elderly man, directed and looking to right with cynical expression, dark-brown coat, buttoned up, with double row of gold buttons; white stock, gray-bottomed wig.

From the Harper Collection, New York, April 20, 1911.

Dr. Armstrong sat to Reynolds in 1755-6, and again in 1767. The engraved picture in which the coat is unbuttoned belongs to Mr. Burdett-Coutts.

No. 125

SIR THOMAS LAWRENCE, P. R. A.

1769—1830

FRANCIS MOUNTJOY MARTYN

Canvas: Height, 28 inches; width, 24 inches

Youngest son of *Charles Fuller Martyn, of Calcutta*; educated at Eton (1826) and Trinity College, Oxford, where he matriculated October, 1827, aged 18; entered the 2nd Regt. of Life Guards, of which he became Colonel.

HEAD and shoulders of a young man, painted on entering his regiment; to front, looking to right; blue uniform with gold buttons and epaulettes, scarlet cloak across shoulders and held with left hand; brown curly hair; gray and blue background.

No. 126

BENJAMIN WEST, P. R. A.

1738—1820

MRS. WEST AND CHILD

Canvas: Height, 25 inches; length, 30 inches

AN interior, the central figure in which is a small whole-length figure of an oval-faced young lady of about twenty-five, seated on a red-covered bench, in white dress, blue sash and white Oriental cap, sewing a yellow garment which rests on her lap; sleeping child in blue and white covered cot to left; in a doorway to right are seen elderly man and woman, tree and distant landscape; grayish curtain background.

Note: Probably intended to illustrate a Biblical scene, or one from a popular story, in which the artist has introduced his wife and child.

No. 127

GEORGE ROMNEY

1734—1802

LADY GRANTHAM

Canvas: Height, 29 inches; width, 24 inches

Mary Jemima, second daughter of Philip, second Earl of Hardwicke; born February 9, 1757; married August 17, 1780, Thomas, second Baron Grantham; died January 7, 1830.

HALF-FIGURE, middle age, directed to right, looking at spectator; blue low dress, corsage edged with white, brown overdress trimmed with fur; powdered hair dressed high with curl on neck, white head-dress; right hand extended holding partly opened volume; blue curtain or cloak to left; dark background.

Romney painted two portraits of Lady Grantham in 1780-1; the late Earl Cowper's version is described in Ward and Robert's "Romney," p. 64, but the above is a later picture. Lady Grantham was also painted by Reynolds, Lawrence and Edridge.

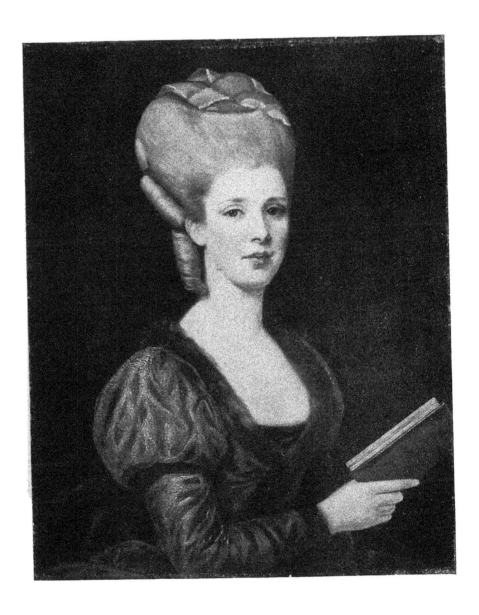

No. 128

SIR JOSHUA REYNOLDS, P.R.A.
1723—1792

SIR WALTER BLACKETT, BART.

Canvas: Height, 29½ inches; width, 24½ inches

Son of Sir Walter Calverley of Wallington; born in 1708; assumed the surname of Blackett in 1733; M.P. for Newcastle (to which place he was a great benefactor) in seven parliaments; died in 1777.

HALF-FIGURE, age about sixty, to front, looking at spectator; dark-blue velvet coat and waistcoat edged with white; white stock; gray wig, dark background.

Sir Walter Blackett sat several times to Sir Joshua, in 1759, 1760, 1766 and 1777. One whole length is at the Infirmary, Newcastle-on-Tyne, and another belongs to Sir George Trevelyan.

No. 129

TILLY KETTLE
1740—1786

PORTRAIT OF A LADY

Canvas: Height, 28 inches; length, 36 inches

HALF length of middle-aged lady seated to front and looking to left, pink patterned low dress with white insertion, short sleeves with broad white edging; dark hair dressed high with white and gold patterned head-dress; left arm resting on pedestal, hand against chin, wedding ring on penultimate finger, right arm on lap; sculptured wall and pillar background.

Dated on pedestal to right: 1770.

No. 130

SIR JOSHUA REYNOLDS, P.R.A.

1723—1792

PORTRAIT OF THE ARTIST

Canvas: Height, 29 inches; width, 24 inches

PORTRAIT of himself as an elderly man with large spectacles; half figure to front; dark-green coat with brown collar, white stock, gray curly wig.

One of several versions of the well-known portrait.

No. 131

SIR JOSHUA REYNOLDS, P.R.A.

1723—1792

SIR ROBERT PALK, BART.

Canvas: Height, 29½ inches; width, 24½ inches

Born about 1718, educated at Wadham College, Oxford; married in 1761, Anne, daughter of Arthur Vansittart; Governor of Madras, 1763, M.P. for Ashburton and Wareham, 1767, 1774-87; created a Baronet June 19, 1782; died April 29, 1798, aged 81.

HALF-FIGURE in an oval, directed to right, head slightly turned, looking at spectator three-quarter face; red coat with gold buttons and embroidered with gold bands, white neckerchief, gray wig.

Collection: C. A. G. Palk, of Halden Hall, Exeter, March 13, 1913, No. 102.

Reynolds painted two portraits of Sir Robert Palk, one in 1760 and the other in 1768; the above is the later of the two.
Graves and Cronin's "Reynolds," ii., pp. 719-20.

No. 132

GEORGE ROMNEY (Period of)

LATTER HALF OF THE EIGHTEENTH CENTURY

DAPHNIS AND CHLOE

Canvas: Height, 39 inches; length, 48 inches

A SYLVAN scene with two youthful figures seated near a clump of tall over-hanging trees. Chloe in pink and rose draperies, fair hair bound with blue ribbon, is holding in her left hand her *quenouille* or distaff. Daphnis, in blue and white draperies, is seated at her feet and is leaning against her, playing on his pipe; to right two sheep are seen, to left a winding road with figures and trees.

From the Sedelmeyer sale, Paris, May, 1907, No. 153 (illustrated in the sale catalogue).

No. 133

FRANCIS COTES, R.A.

1726—1770

PORTRAIT OF THE DUCHESS OF MARLBOROUGH (?)

Canvas: Height, 30 inches; width, 24 inches

HALF-FIGURE of a lady about twenty-five, standing to front, looking at spectator; dark patterned dress cut square at neck, trimmed with lace, short sleeves with elaborate lace edgings and pearl ornaments, bluish overmantle with lace; necklace of many rows; fair hair dressed flat with flowers in center; left arm resting on pedestal (on which is an indecipherable signature), hand holding end of bodice; gray background.

No. 134

SIR JOSHUA REYNOLDS, P.R.A.

1723—1792

FELINA

- Canvas: Height, 30 inches; width, 25 inches

NEARLY whole-length figure of a little red-haired girl in white dress, crouching on the ground by the side of a tree, holding a kitten in her arms.

A version of the Earl of Normanton's engraved picture.

No. 135

SIR THOMAS LAWRENCE, P.R.A. (Period of)

1769—1830

THE COUNTESS OF GALLOWAY

Canvas: Height, 36 inches; width, 28 inches

Jane, daughter of Henry, first Earl of Uxbridge; born September 1, 1774; married April 18, 1797, Admiral George Stewart, who succeeded his father as eighth Earl of Galloway in 1806; died June 30, 1842.

HALE-FIGURE, about forty, seated to front, looking at spectator full face with smiling expression, head slightly inclined to left; dark-brown V-shaped low dress trimmed with blue and edged with white; brown curly hair, lace head-dress with long white satin streamers which fall over left shoulder and are held by right hand, left arm resting on blue-covered table, ring on penultimate finger; greenish background with brown curtain to right.

Collection: Earl of Galloway.

No. 136

RICHARD COSWAY, R.A.

1740—1821

PORTRAIT OF LADY WENTWORTH

Canvas: Height, 42 inches; width, 33 inches

THREE-QUARTER length, age about twenty-five, seated near a balcony on plain wood chair, directed to right and looking at spectator, low black dress trimmed with white lace, white bodice and fichu, large white apron; powdered curly hair with band of black ribbon, white feather aigrette, black earrings, long gold necklace with miniature of a gentleman set in pearls as pendant; short gold chain with gold watch at waist; extended fan held by both hands, volume on brown table to right; trees in distance to right.

No. 137

JOHN DOWNMAN, A.R.A.

1750—1824

PORTRAIT OF MRS. MAIR

Canvas: Height, 44 inches; width, 34 inches

THREE-QUARTER length of a lady about thirty, seated at a table near an open window, directed and looking to right; white low dress and loose fichu, brownish cloak across shoulders, powdered hair dressed high, bound with pearl ropes and green ribbon; both hands holding leaves of a volume which rests on table partly covered with green cloth, and on which also are seen a porcelain vase, scissors, etc.; background, red curtain and trees.

Signed and dated in lower right hand corner: J. DOWNMAN PINX^t
17— (last two figures indistinct).

No. 138

HENRY R. MORLAND
Circa 1730—1797

MRS. THORNTON, AN ARTIST
Canvas: Height, 46½ inches; width, 36½ inches

THREE-QUARTER length, age about thirty, standing to front and looking at spectator; white low dress, short sleeves, pink bodice, white lace crossover, broad pink neck ribbon; fair hair dressed flat, white lace bonnet with pink ribbon bow at center; to left an easel on which is a picture of a landscape with river; right hand holding paint brush and resting on picture on easel, left hand holding palette, brushes and mahl-stick; gray background.

No. 139

JOHN OPIE, R.A.
1761—1807

MUSIDORA
Canvas: Height, 47 inches; width, 30 inches

NEARLY whole-length figure of a young woman seated, directed to front and looking down; white loose robe, right arm and bosom bare, light-blue cloak across left arm and lap; abundant brown hair bound with ribbon, left hand holding red drapery.

No. 140

WILLIAM DOBSON

1610—1646

THE MISSES VENABLES

Canvas: Height, 41½ inches; length, 45½ inches

P. AND M. VENABLES. Whole-length figures of two fair-haired children about four or five, to front, in long white satin dresses trimmed with lace and yellow ribbons, each with a narrow gold neck chain and pendant; the younger child with lace bonnet and holding her sister's hand; a pet dog is jumping up by the side of the elder.

Formerly ascribed to Van Dyck, according to a paper pasted on the back of the picture.

No. 141

SIR MARTIN ARCHER SHEE, P.R.A.

1769—1850

PORTRAIT OF A LADY

Canvas: Height, 49 inches; width, 38 inches

THREE-QUARTER length, about twenty, walking in a landscape to left, looking at spectator; white low dress with loosely fastened blue corsage, short sleeves, pearl necklace; brown curly hair, large white straw sun hat garnished with flowers and flowing blue ribbons; rustic basket filled with flowers on left arm; background, trees and distant hilly landscape to left.

No. 142

GEORGE HENRY HARLOW
1787—1819

MRS. RICHARDSON AND CHILDREN

Canvas: Height, 49 inches; width, 39 inches

GROUP of five figures, the mother, aged about thirty, and her four children, all in white dresses, ranging from an infant of a year old upwards, the oldest seven or eight. Mrs. Richardson, seated looking at spectator and holding the two youngest children on her lap, is in blue low dress, short sleeves trimmed with lace, white frilled collar, ruby brooch, pearl necklace and small earrings; brown curly hair with pearl ornament, pearl bracelet on left arm and rings on fingers of both hands. The elder child by her side and clasping the infant, the second child standing behind its mother; both are auburn-haired, and the three eldest wear coral necklaces; distant landscape with hills and flowering rose-trees to left, green patterned curtain overhead and to right.

No. 143

FRANCIS COTES, R.A.

1726—1770

PORTRAIT OF MRS. JONES (AFTERWARDS WALLEY)

Canvas: Height, 49 inches; width, 39 inches

Maria Kenyon of Scarborough, married first, Robert Jones of Liverpool (by whom she had two children, Robert and Mary); and secondly, Joseph Walley.

THREE-QUARTER length of a young lady, twenty-five to thirty, seated near a balcony, directed to left and looking at spectator; old-gold low dress with sleeves to elbows trimmed with white lace, white lace fichu with light-blue ribbons; powdered curly hair, white cap with broad band passing around throat; right arm on balcony, hand holding gold-mounted miniature with black ribbon suspender; to left on balcony rests a thin gray-covered volume; pillar, blue curtain and sky background.

This excellent portrait came from an anonymous sale at Christie's, May 4, 1907, when it was catalogued as "Early English." Its attribution to Cotes is not altogether convincing, as the style of dress would suggest the late 80's of the eighteenth century, and some years after Cotes's death.

No. 144

JOSEPH HIGHMORE

1692—1780

MRS. PRITCHARD, THE ACTRESS

Canvas: Height, 49 inches; width, 39 inches

Hannah Vaughan, born in 1711, married a poor actor named Pritchard, appeared at the Haymarket Court in 1733, and at Drury Lane 1734-40; the greatest *Lady Macbeth* of her day and sustained many other leading characters; died in 1768.

NEARLY whole length, age about fifty, seated on a red high-backed settee, to front, looking at spectator; gray-patterned dress with short frilled sleeves, white low bodice with two yellow bands and pearl square buckles, yellow waistband from which depends chain with gold watch and ruby seal; gray hair, white cap, black lace scarf around head, the ends falling over bosom, pearl earrings; right elbow on arm of chair, hand resting against forehead, rings on last two fingers, left hand on lap holding partly opened book, rings on first and second fingers.

Exhibited: Guildhall, London, 1902, *No.* 56 (*C. Butler*).

Collections and sale: W. Twopenny, 1874; *and Charles Butler, May* 26, 1911, *No.* 149.

On the back of the canvas is pasted a piece of paper with the following inscription: "Portrait of Mrs. Pritchard the actress by W. Hogarth, Bot of W. B. Tiffin in 1853. There is a portrait of her by Hogarth, head and shoulders only, exactly like this at Lord Talbot de Malahide's in Ireland." The above is probably the portrait of Mrs. Pritchard sold in the Campbell Sale at Christie's in 1867 as by Hogarth.

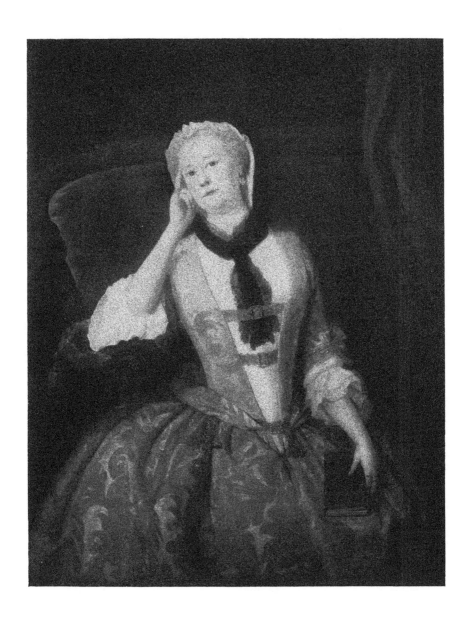

SIR THOMAS LAWRENCE, P.R.A. (?)

1769—1830

MR. LAMBERT

Canvas: Height, 49 inches; width, 39 inches

Probably James Staunton, of Watervale, born March 5, 1789; J.P. and D.L., High Sheriff, 1813, and M.P. for Co. Galway from 1826 to 1833, a Liberal Conservative "most conscientious in the discharge of every duty"; died July 1, 1867.

THREE-QUARTER length figure of a middle-aged gentleman, standing, directed to left, looking at spectator; black frock coat, dark breeches, red plush waistcoat, white turned-down collar with black stock, long gold chain; dark hair, grayish side whiskers; right hand holding scroll inscribed "Public Accounts," and resting on two volumes respectively labeled "Reports on Ireland" and "Commons Vol. XIII," on which rests red dispatch case; to right red armchair and old-gold curtain, to left stone pillar with distant view.

This portrait, which came from Castle Lambert, in Ireland, was painted in the thirties of the last century, and is probably the work of an Irish portrait painter. It is too late for Lawrence.

No. 146

THOMAS PHILLIPS, R.A.

1770—1845

PORTRAIT OF A LADY

Canvas: Height, 49 inches; width, 39 inches

THREE-QUARTER length of middle-aged lady, standing directed to front, head turned and looking to right; blue velvet low dress cut square, short sleeves trimmed with old gold, blue cloak over shoulders and around arms, white lace corsage, old-gold waistband with large ruby in center, pearl necklace and drop pearl earrings; white turban head-dress with pearl rope, ruby and pearl bracelets and rings; scarlet tablecloth to right, brown background.

No. 147

MASON CHAMBERLIN, R. A.

Died in 1787

PORTRAITS OF MR. AND MRS. HOPKINS

Canvas: Height, 40 inches; length, 50 inches

Benjamin Bond Hopkins, of Pain's Hill, Surrey, son of Benjamin Bond of Leadenhall Street, London, a Turkey merchant (who inherited the estates of "Vulture" Hawkins and assumed that surname); married as his second wife, May 20, 1773, Mary, daughter of Captain Tomkins of Downing Street, London; died January 30, 1794, aged 48. Mrs. Hopkins, a literary lady who translated several parts of the Bible, separated from her husband about a year after their marriage, and died September 27, 1788. For a further account see *Gentleman's Magazine*, February, 1794, pp. 183-4.

Two half-length figures seated in a landscape facing each other. Mr. Hopkins in blue coat and waistcoat embroidered with gold and with lace neckerchief, lace cuffs, wig. Mrs. Hopkins in pink dress with short sleeves, lace fichu and pearl necklace, earrings and bracelets, playing a guitar, her husband holding a music book; spray of flowers at center of corsage; trees and shrubs in background.

Collection: Mrs. Henshaw Russell, 1907.

No. 148

SIR EDWARD BURNE-JONES, A.R.A., D.C.L.

1833—1898

PSYCHE'S WEDDING

Canvas: Height, 46 inches; length, 84½ inches

A PROCESSION of nine blue-clad maidens and an old man pass across the foreground to the right, the girlish Psyche in gray in the center; the girls in front strew flowers as they go, while those behind play musical instruments; in the distance a river and low hills.

Signed with initials and dated in left hand corner: E. B. J., 1895.

Exhibited: New Gallery, 1899 (A. Tooth & Sons), and Burlington House, London, 1909 (G. McCulloch).

Collection and sale: George McCulloch, Christie's, May 29, 1913; purchased for Mr. Blakeslee.

Etched by F. Jasinski, 25 by 13½ inches; 1901.

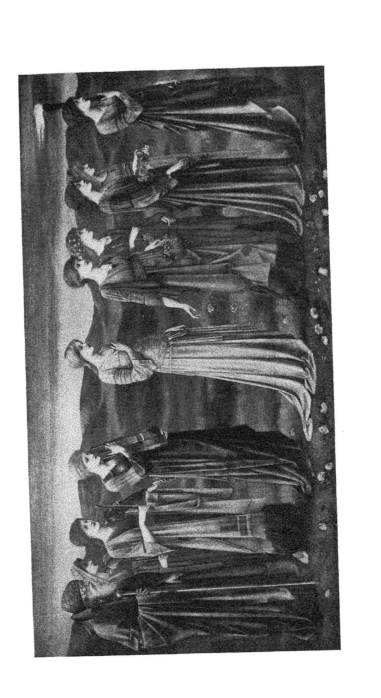

No. 149

JACOB HOUSMAN (or HUYSMANS)

Circa 1633—1696

MRS. BLOUNT

Canvas: Height, 52 inches; width, 35½ inches

THREE-QUARTER length, in a landscape, walking to right and looking at spectator; old-gold shot-silk low dress edged with white and fastened in front with pearl buttons, short sleeves with broad white trimming, brownish gray cloak around shoulders fastened with small brooch; brown curly hair with pearl ornament; pearl necklace and drop earrings, waistband of large blue-glass beads; right hand holding fold of dress, left hand extended and holding a sheet of music; to left trees and blue sky, clouds and distant view of building to right.

Inscribed to left in gold letters: MRS. BLOUNT.

No. 150

SIR WILLIAM BEECHEY, R.A.

1753—1839

ADMIRAL BRIDPORT, K.B.

Canvas: Height, 50 inches; width, 40 inches

Alexander, second son of the Rev. Samuel Hood, younger brother of Admiral Samuel Viscount Hood; born in 1724; entered the Navy; rear-admiral in 1780; K.B., 1788; created Baron Bridport 1794, Viscount 1800; died May 3, 1814.

THREE-QUARTER length, standing to front looking to right, in naval uniform, blue coat with star of an order and gold chain with pendant, white waistcoat and breeches; gray hair; right hand holding sword.

No. 151

WILLIAM DOBSON (after VAN DYCK)
1610—1646

THE EARL OF PORTLAND

Canvas: Height, 52 inches; width, 39 inches

Richard Weston, the statesman; born in 1577; M.P. for various constituencies from 1601 to 1626; knighted 1603; Chancellor of the Exchequer 1621; created Baron Weston, 1628; Lord High Treasurer 1628-33; created Earl of Portland 1633; died in 1635.

THREE-QUARTER length of elderly man, standing to front, looking to right; black dress with pearl fastener, white reflected cuffs and elaborately gauffered broad ruff, broad blue band suspended from neck with locket pendant; blue cloak over shoulders, right arm resting on ledge of pedestal, the ungloved hand holding open document, left hand gloved and holding wand of office; gray hair, pointed beard; background, brown curtain and stone pillar.

A copy of the Van Dyck portrait engraved by Hollard and described in Smith's "Catalogue Raisonné" No. 575.

No. 152

MRS. MARIA COSWAY

1759—1838

LADY SEATED AT A PIANO

Canvas: Height, 50 inches; width, 40 inches

THREE-QUARTER length figure of a young woman, about twenty-five, seated
at an open rosewood piano or spinet, in white low dress with broad gray
sash, fair hair bound with white, black felt hat with large black feather;
right arm resting on piece of open music on piano and turning over a page
with her fingers; left arm on lap, tips of fingers on keyboard; trees in back-
ground with distant view to left.

No. 153

SIR GODFREY KNELLER

1648—1723

PORTRAIT OF A MAN

Canvas: Height, 50 inches; width, 40 inches

THREE-QUARTER length of a young man, standing to front; red coat with
gold buttons and white sleeves, gold-embroidered waistcoat, white necker-
chief; flowing brown wig, black felt hat in right hand, left hand inserted in
opening of coat; stone balcony with distant landscape to left.

*From an anonymous sale at Christie's, July 12, 1912, No. 11, when it was
described as a portrait of George, Prince of Wales.*

No. 154

SIR PETER LELY

1617—1681

DUCHESS OF RICHMOND ("LA BELLE STUART")

Canvas: Height, 50 inches; width, 40 inches

Frances Teresa Stuart, granddaughter of first Lord Blantyre; born in France in 1647, maid of honor to Queen Catherine; mistress of Charles II; married the Duke of Richmond; a famous beauty, and probably the original of the figure of Britannia on the copper coinage; died in 1702.

THREE-QUARTER length, age about thirty; seated near a balcony, directed to left, looking at spectator; scarlet low dress with short white full sleeves, blue mantle across waist and over knees, jeweled brooch at center of corsage; fair curly hair; large, broad-brimmed black felt hat with white feathers; end of narrow brown shawl held with left hand, tassel of blue cloak in right; earthenware jar with flowers to left, blue curtain to right.

Inscribed in right hand lower corner: DUCHESS OF RICHMOND.

From an anonymous collection sold at Christie's, July 12, 1912, No. 8.

No. 155

ALLAN RAMSAY

1713—1784

PORTRAIT OF A LADY

Canvas: Height, 50 inches; width, 40 inches

THREE-QUARTER length, age about fifty, standing to front, looking at spectator; white satin low dress, short sleeves edged with broad white frills; white muslin fichu, black scarf across shoulders and linked at center of corsage with pearl fastener; three-row pearl necklace, powdered hair dressed high, right hand with gold and ruby chain, left hand holding miniature pendant with a man in blue dress; sculptured alcove and pillar background.

Collection and sale: Sir Walter Bartellot, of Stopham House, Pulborough, Sussex, June 19, 1911, No. 150.

No. 156

SIR PETER LELY
1617—1681

THE PRINCE AND PRINCESS OF ORANGE

Canvas: Height, 69 inches; width, 53 inches

William II of Nassau, Stadtholder of the Netherlands; born in 1627. Succeeded his father in May, 1647, as William II, Prince of Orange; died at The Hague in 1650.

Mary, daughter of Charles I of England; born in November, 1631; married, May 2, 1648, the above Prince of Orange; died in September, 1660.

Two seated figures to front on a balcony. To right the Prince in black robes, with broad white cuffs, scarlet band showing under cloak, white cravat, right hand holding fold of cloak, left on hilt of sword. To left the Princess in rich brown dress with lace insertion, short sleeves with broad white trimming, blue cloak around back and on lap; pearl necklace and earrings, dark hair; right hand holding spray of orange plant with fruit, left hand holding pomegranate; red curtain to left, landscape in the distance.

From a collection of historical portraits (formed about 1860-70), at Christie's "the property of a gentleman," November 19, 1910, No. 81.

No. 157

SIR JOHN WATSON GORDON, R.A. and P.R.S.A.

1790—1864

THE MACKENZIE CHILDREN

Canvas: Height, 63 inches; width, 46 inches

GROUP of three children near a balcony; the elder boy of five or six in Scotch kilts with white waistcoat, white socks and black shoes, standing by a large-arm high-backed chair, on which are seated his younger brother in brownish-red dress and white lace collar and his sister in white dress and blue apron; she is holding flowers in her left hand, other flowers are on her lap and on the ground; pillar and green curtain background.

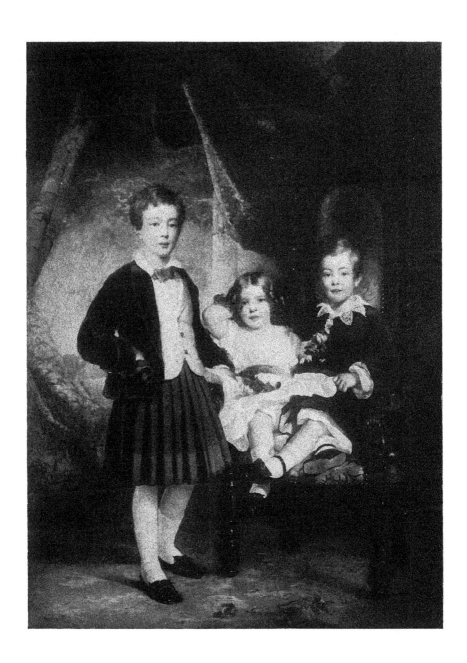

No. 158

SIR WILLIAM BEECHEY, R.A. (Ascribed to)
1753—1839

THE STAR

Canvas: Height, 86 inches; width, 51 inches

WHOLE-LENGTH, life-size figure of a young woman about twenty, emblematical of the Star, floating in mid-air, in dark-brown dress with jeweled star over forehead; brown hair; right arm upraised, hand over head, left arm extended holding in hand a phial from which incense is pouring; flowering plant to right.

No. 159

FRANCIS WHEATLEY, R.A.
1747—1801

PORTRAIT OF A LADY

Canvas: Height, 87 inches; width, 56 inches

WHOLE-LENGTH, life-size, about twenty-five, walking in a wooded landscape, white low dress, short sleeves, blue sash, right hand carrying straw bonnet with blue bows, left hand extended; fair curly hair.

No. 160

WILLIAM DOBSON (after VAN DYCK)
1610—1646

LORD JOHN AND LORD BERNARD STUART

Canvas: Height, 85 inches; width, 48 inches

Sons of Esme, third Duke of Lenox. Two whole-length, life-size figures, standing in front of a pillar and blue curtain; the younger brother to front and looking to left, scarlet dress, brown cloak, leather top boots; fair curly hair. The elder brother to right, back to spectator, head turned, looking to front, white satin dress, stockings and shoes, blue cloak over left shoulder, gold hilt of sword partly covered by cloak; fair, long, curly hair.

A copy of Van Dyck's famous picture, which for generations belonged to the Earl of Darnley at Cobham Hall, but which was sold by private treaty in 1912.

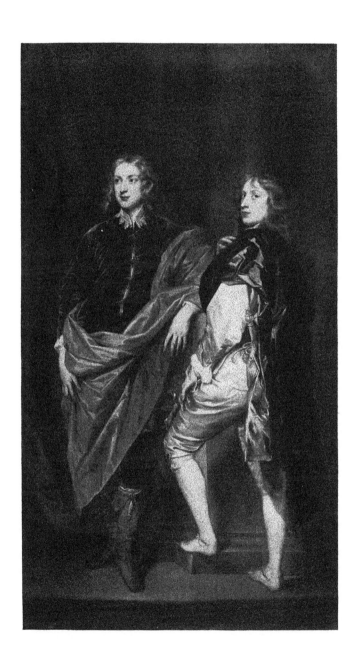

No. 161

JOHN SINGLETON COPLEY, R.A.

1737—1815

BATTLE OF DUNKIRK (*September,* 1793)

Canvas: Height, 59 inches; length, 94 inches

A BATTLE scene under the walls of Dunkirk with numerous figures, masses of red-coated soldiers on the right are pressing home a bayonet charge against blue coats, fallen and wounded soldiers are seen on both sides; in the center a fallen officer in yellow coat with red facings, white waistcoat and breeches, is surrendering his sword to a soldier.

Painted in 1800.

No. 162

BENJAMIN WEST, P.R.A.

1738—1820

CONVERSION OF ST. PAUL

Canvas: Height, 68 inches; length, 104 inches

A BROAD, hilly landscape, with towers, aqueduct and building in the middle distance; the foreground occupied with a large company of civilians and soldiers in medieval costumes; to left a group of travelers with St. Paul in red dress and white head-covering and hands upraised as in supplication; dark masses of trees and rocks to right and left.

From the Torre Abbey Collection, and sold at Christie's, February 26, 1859, *No.* 73.

> *Note:* This is doubtless "The Conversion of St. Paul, a finished sketch for the painted window in St. Paul's Church, Birmingham," exhibited at the Royal Academy, 1791, No. 426. Another sketch for the same picture was exhibited at the Royal Academy of 1801, No. 80.

No. 163

BENJAMIN WEST, P.R.A.

1738—1820

DEATH OF HYACINTHUS

Canvas: Height, 89 inches; width, 73 inches

The story is taken from Ovid's "Metamorphoses," Book x. Hyacinthus, a son of Amyclas and Diomede, greatly beloved by Apollo and Zephyrus. He returned the former's love, and Zephyrus, incensed at his coldness and indifference, resolved to punish his rival. As Apollo, who was entrusted with the education of Hyacinthus, once played at quoits with his pupil, Zephyrus blew the quoit, as soon as it was thrown by Apollo, upon the head of Hyacinthus, and he was killed by the blow. Apollo was so disconsolate at the death of Hyacinthus that he changed his blood into a flower which bore his name, and placed his body among the constellations.

Two whole-length life-size figures in a rocky landscape; Hyacinthus, clad only in a white cloak attached by a narrow band over left shoulder, is dying, and is supported by Apollo in flowing dark-red drapery, his right around his waist, the left hand resting gently on the forehead; two cupids floating in the air to left.

Signed and dated in lower left hand corner: B. WEST, PINXIT, 1771.

Exhibited: Royal Academy, 1772, No. 273. The companion picture of "Juno receiving the Cestus from Venus," exhibited in the same year, was also acquired in recent years by Mr. Blakeslee and is now in an American collection.

ENGLISH SCHOOLS

[CONTINUED]

THIRD AND LAST NIGHT'S SALE

FRIDAY, APRIL 23, 1915

IN THE GRAND BALLROOM

OF

THE PLAZA

FIFTH AVENUE, 58th to 59th STREET

BEGINNING PROMPTLY AT 8.15 O'CLOCK

No. 164

JOHN OPIE, R.A.
1761—1807

PORTRAIT OF A BOY

Canvas: Height, 24 inches; width, 19½ inches

HEAD and shoulders, to front, yellow dress with white collar; portfolio under left arm; long golden hair.

No. 165

SIR THOMAS LAWRENCE, P.R.A.
1769—1830

THE COUNTESS OF ESSEX

Canvas: Height, 21 inches; width, 17½ inches

Catherine Stephens, vocalist and actress, daughter of a carver and gilder; born in London in 1794; appeared at Covent Garden in 1813 as *Mundane* in "Artaxerxes," acted *Polly* in "The Beggars' Opera," etc.; said to have had the sweetest soprano voice of the time; retired in 1835; married in 1838 the fifth Earl of Essex; died in 1882.

HEAD and shoulders of a beautiful young woman about twenty-five, directed to front and looking to right; scarlet low dress trimmed with white; black curly hair with white band, pearl drop earrings; grayish background.

No. 166

SIR THOMAS LAWRENCE, P.R.A.
1769—1830

HEAD OF A GIRL

Canvas: Height, 17½ inches; width, 13 inches

HEAD and shoulders of a pretty child of about three or four, looking at spectator full face; white low dress with purple waistband; brown hair; blue background.

From an anonymous sale at Christie's, June 7, 1912, No. 57.

No. 167

GEORGE ROMNEY

1734—1802

LADY HAMILTON AS "MIRANDA"

Canvas: Height, 18 inches; width, 15 inches

HEAD and shoulders, directed to right, head leaning to left, looking up with open-mouthed grieved expression; long auburn hair falling over shoulders, bare arms, white light drapery over shoulders.

From an anonymous sale at Christie's, June 13, 1913, No. 115.

No. 168

JOHN HOPPNER, R.A.

1758—1810

PORTRAIT OF LADY CAMPBELL

Canvas: Height, 24 inches; width, 20 inches

HEAD and shoulders of an attractive-looking lady about twenty-five, directed and looking to right, white semi-low dress, brownish waistband, powdered curly hair with white turban-like broad band; red curtain background.

From the collection of Lady Sassoon.

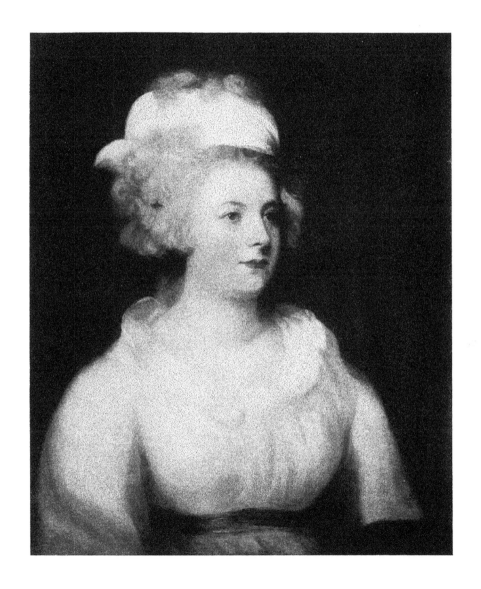

No. 169

GEORGE HENRY HARLOW
1787—1819

PORTRAIT OF A LADY WITH RED HAT

Canvas: Height, 28 inches; width, 23 inches

HALF-FIGURE of young lady about eighteen to twenty, to front, in gray low V-shaped dress bordered with old gold, white chemisette, red patterned belt; large broad-brimmed red velvet hat, black hair falling in curls over neck and forehead; left arm resting on a volume and holding another in hand.

No. 170

SIR PETER LELY
1618—1680

THE DUCHESS OF CLEVELAND

Canvas: Height, 28 inches; width, 23 inches

Barbara, daughter of William Villiers, second Viscount Grandison, born in 1641; married Roger Palmer, Earl of Castlemaine; Lady of the Bedchamber to Queen Catherine; notorious for her amours and trafficking in state appointments; mistress of Charles II, who created her Duchess of Cleveland in 1670; died in 1709. Frequently painted by Lely.

HALF-FIGURE, about thirty, seated to front, head inclined to left and supported by right hand, elbow on red-covered table; grayish low dress trimmed with lace and garnished with rope of pearls, short sleeves with full white cuffs, white-lined black cloak to left; pearl necklace and earrings; brown hair falling over right shoulder; brown curtain background.

No. 171

JOHN CONSTABLE, R.A.

1776—1837

HAMPSTEAD HEATH

Canvas: Height, 24 inches; length, 29 inches

BROAD sweeping view of the heath, with row of trees in center; to right high hill with square white house with smoking chimney, and cows on the horizon to right; the foreground to right, cart and two horses at the entrance to a gravel pit; pool, with donkey and driver, in center.

This is a variant of the Sheepsbans picture etched by David Lucas and as plate 22 in "English Landscape Scenery," 1855.

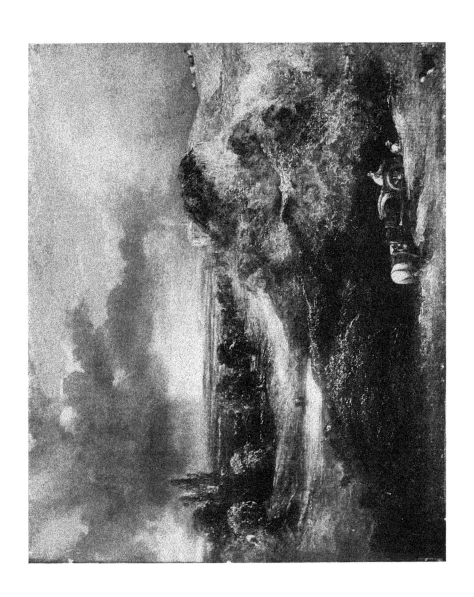

No. 172

JOHN OPIE, R.A.

1761—1807

GOING TO SCHOOL

Canvas: Height, 28 inches; width, 23½ inches

HALF-FIGURES of two children in the open; the elder, a girl in green low dress
with patterned crossover and white mob cap with blue band, satchel hanging
on gloved right hand. She is holding the right hand of a curly brown-haired
boy who is dressed in dark-brown jacket with white open collar and dark
felt hat; he is holding a book in the left hand; blue sky and tree background.

Collection: The late Capt. Warner of Leicestershire.

No. 173

GEORGE HENRY HARLOW

1787—1819

GROUP OF TWO CHILDREN

Canvas: Height, 29 inches; width, 24 inches

Two young, fair-haired girls, seated to front in an open landscape, white low
dresses, the elder with red coral necklace looking up to left and holding a
robin in her hands; the younger looking at spectator, her right hand on her
sister's shoulder; background, autumnal trees and sky.

*Purchased from an anonymous sale at Christie's, May 15, 1913, No. 149, when
it was ascribed to "Lawrence."*

No. 174

SIR JOSHUA REYNOLDS, P.R.A.

1723—1792

MISS THEOPHILA PALMER

Canvas: Height, 29 inches; width, 24 inches

"Offie," second daughter of John Palmer, of Torrington, Devon, and the favorite niece of Sir Joshua; born in 1756; married in January, 1783, Robert Lovell Gwatkin, of Plymouth; died at Bideford, Devon, July 5, 1848.

HALF-FIGURE, age about thirty, to front, head slightly inclined over right shoulder, looking to left; dark dress with short sleeves, trimmed with white, white fichu, narrow black neck ribbon tied in a bow; dark hat trimmed with blue ribbon and with white ostrich feathers; right arm leaning on table.

Purchased from the Palmer family and sold by Messrs. Agnew to Mr. Blakeslee.

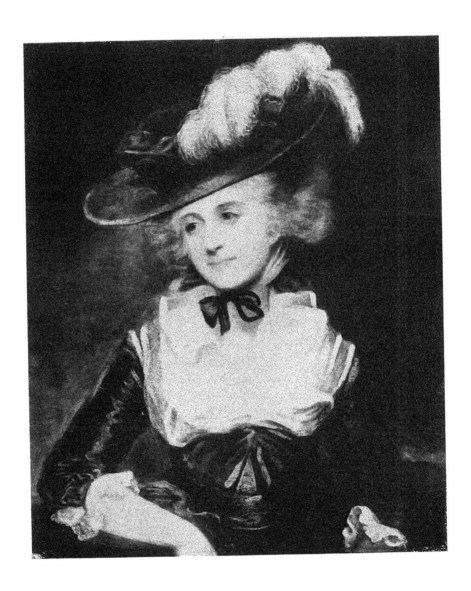

No. 175

WILLIAM HOGARTH

1697—1764

PORTRAIT OF PEG WOFFINGTON

Canvas: Height, 29 inches; width, 24 inches

The famous actress often painted by Hogarth. A bricklayer's daughter, born in Dublin, October 18, 1720; acted on the Dublin stage from the age of seventeen to twenty; appeared at Covent Garden in 1740, and was for many years the leading British actress, as famous for her beauty and coquetry as for her talents on the stage, from which she retired in May, 1757; died March 28, 1760.

HAF-FIGURE of the actress when about thirty, in an oval, directed to left and looking at spectator; grayish bodice, white fichu with pink ribbon bow at center of corsage, brown hair, white lace tight-fitting cap fastened under chin with pink ribbons.

From an anonymous sale at Christie's, June 22, 1903, No. 97.

No. 176

SIR THOMAS LAWRENCE, P.R.A.

1769—1830

SIR THOMAS BUCKLER LETHBRIDGE, BART.

Canvas: Height, 29 inches; width, 24 inches

Son of John Lethbridge, Esq., who was created a Baronet of Sandhill, Somersetshire, in 1804; born in February, 1778; M.P. for Somersetshire 1806-12, 1820-30; Colonel of the second Somerset Militia; succeeded his father in 1815; died October 17, 1849.

HALF-FIGURE, age about forty, to front, looking to right, grayish military coat fastened, embroidered with gold stripes across chest, scarlet collar, gold epaulettes, black stock; fair, straggling hair, dark background.

Described in Sir Walter Armstrong's "Sir Thomas Lawrence," 1913, p. 146.

From the family.

No. 177

SIR JOSHUA REYNOLDS, P.R.A.

1723—1792

MRS. MUSTERS AS "HEBE"

Canvas: Height, 29 inches; width, 24 inches

Sophia Catherine, daughter of James Modyford Heywood, of Marston, Devon; married, in 1776, John Musters of Colwick Hall, Notts; died in 1819. She is described by Miss Burney in 1779 as "the present beauty, whose remains our children may talk of, the reigning toast of the season." She frequently sat to Sir Joshua from 1777 to 1782.

HEAD and shoulders, aged twenty-five to thirty, directed to right; looking at spectator full face; flowing pinkish dress with white chemisette and short sleeves; right hand holding reddish jug; brown wind-blown hair with blue and gold band; blue-gray background.

The engraved whole-length portrait of Mrs. Musters as "Hebe," painted *circa* 1782, is in the Iveagh Collection.

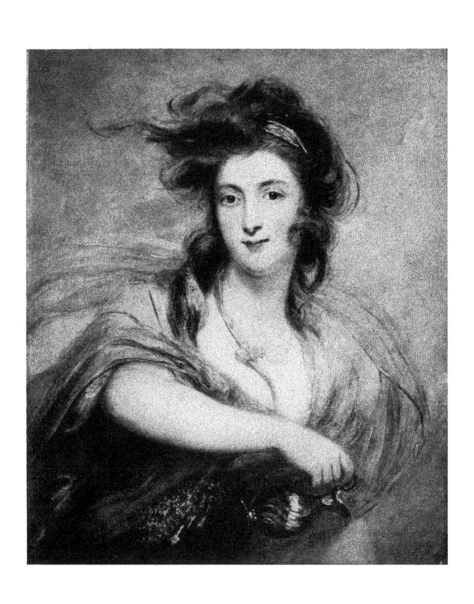

No. 178

SIR JOSHUA REYNOLDS, P.R.A.

1723—1792

COUNTESS OF STRAFFORD

Canvas: Height, 29 inches; width, 24 inches

Lady Anne Campbell, second daughter of John, second Duke of Argyle; born in 1715, married April 28, 1741, William Wentworth, Earl of Strafford (a title created in 1711 by Queen Anne and extinct in 1799); died February 7, 1785, from her clothes having accidentally caught fire.

HALF-FIGURE, middle age, to front, head slightly inclined and looking to left; white low dress with two strings of pearl and precious stones on corsage, blue and ermine cloak over right shoulder, on which a plait of her brown hair, bound with blue ribbon, falls; pearl earrings, blue neck ribbon with double row of pearls.

Engraved by J. McArdell, 11 by 19, 1762; also (reversed) by J. Brookshaw, 1770, by J. Johnson, T. Johnson and by Spicer.

From Thomas McLean's Sale, January 18, 1908, No. 135.

Note: According to Graves and Cronin's "Reynolds" the Countess of Strafford paid £15-15-0 (which would be the first half payment) for this portrait on February 3, 1761. Possibly neither this nor the companion portrait of the Earl was delivered; at Sir Joshua Reynolds's sale at Greenwood's rooms, Savile Row, London, on April 15, 1796, the portraits of Lord and Lady Strafford were sold for two and three and a half guineas respectively to "Byng of St. James's Square." The portraits were only known through the engravings and were not traced by Graves and Cronin. This one of the Countess at one time belonged to Messrs. Agnew.

No. 179

SIR THOMAS LAWRENCE, P.R.A.

1769—1830

CHARLOTTE LADY STRANGE

Canvas: Height, 29 *inches; width,* 24 *inches*

Charlotte Margaret, second daughter of the Rev. Geoffrey Hornby; married June 30, 1798, her cousin Edward Lord Strange (who succeeded his father in 1834 as thirteenth Earl of Derby); died June 16, 1817.

HALF-FIGURE, age twenty-five to thirty, seated to front looking to right, three-quarter face; white low dress with frilled collar and short sleeves, gold and ruby brooch at center of corsage, reddish waistband, long yellow glove on left arm (which is only partly seen); black curly hair falling over forehead and ears; stone pillar to left.

Collection: Captain Phipps Hornby.

This is sometimes ascribed as a portrait of the thirteenth Countess of Derby, but Lady Strange died many years before her husband succeeded to the title.

No. 180

TILLY KETTLE

1740—1786

COUNTESS OF STRAFFORD

Canvas: Height, 29 inches; width, 24 inches

HALF-FIGURE, middle-aged, to front looking to left, three-quarter face, low dark dress, short white sleeves with pearl fasteners, and white lace at neck, pearl ornament at center of corsage, yellow waistband, dark cloak over shoulder; two-row pearl necklace with pearl pendant; powdered hair with pearl band, black aigrette.

> This is a variant by Tilly Kettle of the portrait of the Countess of Strafford, described under Sir Joshua Reynolds in this sale; Catalogue No. 178.

No. 181

SIR JOSHUA REYNOLDS, P.R.A.

1723—1792

MRS. FORTESCUE

Canvas: Height, 29 inches; width, 24 inches

Mary Henrietta, eldest daughter of Thomas Orby Hunter of Croyland Abbey, Lincolnshire, a Lord of the Admiralty; born about 1734; married the Right Hon. James Fortescue, of Ravensdale Park, P.C., M.P.; died December 24, 1814, aged eighty. Her second son succeeded his uncle as second Baron Clermont in 1806.

HALF-FIGURE, age about twenty-five, seated to front; head slightly inclined to left; blue and white dress, white fichu, flowers in corsage; brown hair dressed high, with string of pearls and red ribbon, pearl drop earrings; arms folded and resting on brown ledge, on which are roses; dark background.

> Mrs. Fortescue sat to Reynolds in 1761.

No. 182

SIR HENRY RAEBURN, R.A.
1756—1823

MRS. CATHCART

Canvas: Height, 29 inches; width, 24 inches

HALF-FIGURE, age twenty-five to thirty, seated in a landscape, directed to front, looking slightly to left; white satin low dress with high waist, black mantle, arms crossed on lap, ring on penultimate finger of left hand; brown hair falling in curls over forehead; background balustrade and trees.

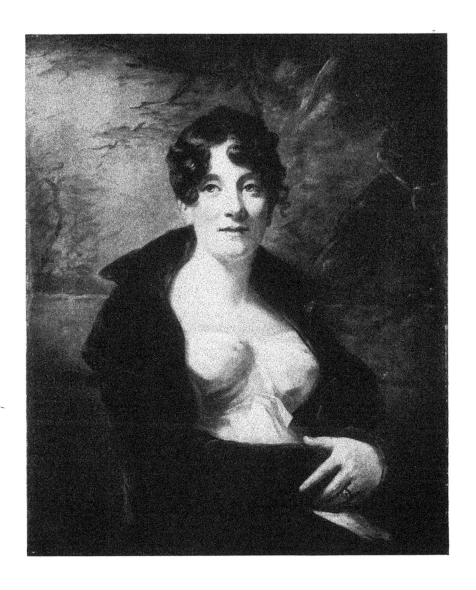

No. 184

GEORGE ROMNEY

1734—1802

LORD HUNTINGDON

Canvas: Height, 29 inches; width, 24 inches

Francis, eldest son of ninth Earl; born in 1734; succeeded his father in 1746; carried Sword of State at the Coronation of George III, 1761; died without issue October 2, 1789, when the ancient baronies were carried by his eldest sister into the Rawdon family and thence to the Earldom of Loudoun.

HALF-FIGURE of elderly man about sixty, directed to left, head turned, looking at spectator; brown coat, white tie, dark felt hat with blue trimming, powdered wig, rustic walking stick under left arm; background balustrade and distant view.

The canvas has been relined and is inscribed "Painted by G. Romney 1790." It is, there can be no doubt, one of the two copies of a portrait by an artist whose name is not stated, done by Romney in 1791 and 1795; see Ward & Roberts' "Romney," p. 83.

No. 185

SIR JOSHUA REYNOLDS, P.R.A.

1723—1792

THE COUNTESS OF ANCRUM

Canvas: Height, 29 inches; width, 24½ inches

Elizabeth, only daughter of Chichester Fortescue, and granddaughter of first Lord Mornington; born in 1745; married in 1763 William John, Earl of Ancrum, afterwards fifth Marquis of Lothian; died September 30, 1780.

HALF-FIGURE, looking to left; pink overdress trimmed with fur; gray low bodice; powdered hair dressed high and bound with pink ribbon, plait over left shoulder; right arm resting on pedestal; dark background.

From the Lesser sale, February 10, 1912, No. 30.

Sir Joshua painted several portraits of the Countess of Ancrum from 1769 to 1771.

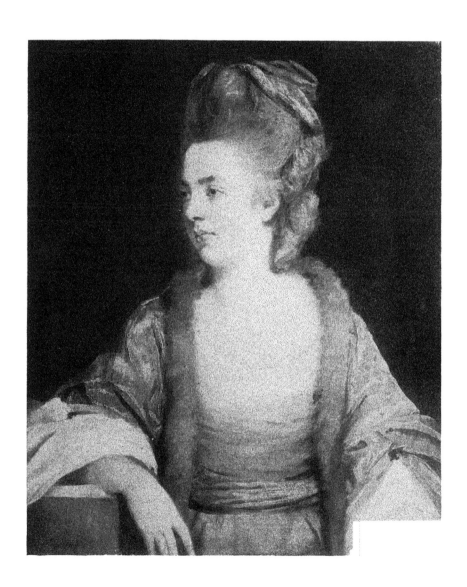

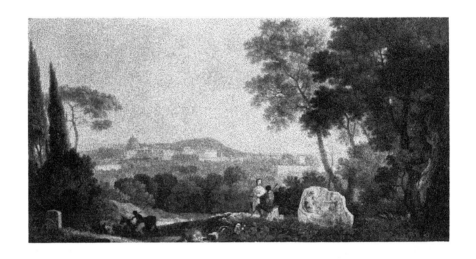

No. 186

RICHARD WILSON
1713—1782

ROME AND THE CAMPAGNA

Canvas: Height, 28 inches; length, 51 inches

BROAD view of the Campagna, with distant hills; trees to left and right, figure driving cattle to left; in the foreground two figures conversing near a portion of a carved *stela* or ancient tombstone.

Signed at bottom to left with entwined monogram: **R. W.**

JOHN CONSTABLE, R.A.

1776—1837

THE OLD MILL

Canvas: Height, 27 inches; length, 35 inches

A RICHLY foliaged summer scene, in which an old water mill, red-tiled house and overhanging trees occupy the left side of the picture; in the distance an undulating country with tall poplar and other trees and a cottage are seen; in the middle distance, and on the mill-pool, dammed up with a wooden palisade, is a sailing boat; in front on the shallow water a small boat with fishermen is seen near a willow tree; on the bank to left are two youthful figures, one of whom is fishing.

Signed to left at bottom edge: JOHN CONSTABLE.

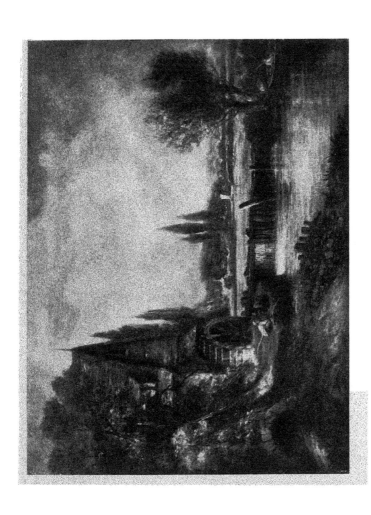

No. 188

ALFRED EDWARD CHALON, R.A.
1781—1860

PORTRAIT OF A LADY

Canvas: Height, 30 inches; width, 25 inches

HEAD and shoulders, age about twenty, directed to left, head turned looking at spectator; red cloak trimmed with fur, white collar; dark curly hair, large black felt bonnet, with black feathers and edged with white lace, fastened under chin with dark ribbon; gloved hands only partly seen.

No. 189

FRANCIS COTES, R.A.
1726—1770

PORTRAIT OF THE HON. CHARLOTTE JOHNSTON

Canvas: Height, 30 inches; width, 25 inches

HALF-FIGURE, in an oval, about thirty years of age, to front, head turned and looking to left, three-quarter face, white dress with lace at corsage, scarlet and ermine overmantle, scarlet waistband tied at center; black hair, strand falling over right shoulder; gray background.

No. 190

GEORGE ROMNEY
1734—1802

MRS. DRAKE

Canvas: Height, 30 inches; width, 25 inches

Rachael, daughter and heiress of Jeremiah *I*ves of Norwich; married August 21, 1781, as his second wife, William Drake, M.P., of Amersham, Bucks; died August 3, 1784. Her elder daughter married the third Lord Boston.

HALF-FIGURE, directed to right, head turned and looking at spectator; white dress, powdered hair dressed high, white head-dress; left arm resting on a brick-red balcony; red curtain background.

Painted in 1783, the artist receiving £21.

Purchased in 1903 from Lord Boston by Messrs. Colnaghi & Co.

Reference: T. H. Ward and W. Roberts, "Romney," 1904, p. 46, where a full list of the various sittings is printed.

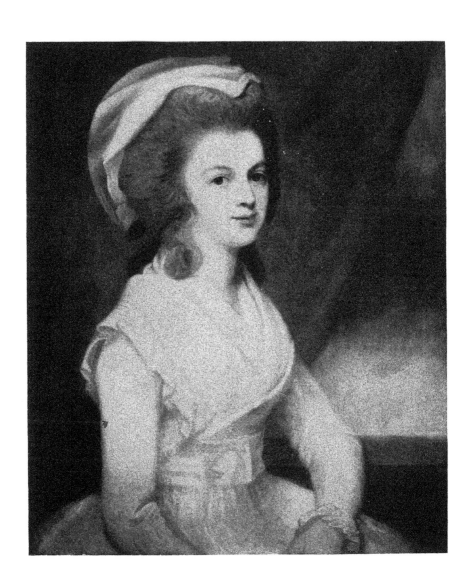

No. 191

FRANCIS COTES, R.A.
1726—1770

PORTRAIT OF A LADY

Canvas: Height, 30 inches; width, 25 inches

HALF-FIGURE, about twenty-five, in an oval, directed and looking to right; white low dress edged with lace, white and pink sleeves, flowers at center of corsage, lace frilled collar; black hair with string of pearls and white feather, pearl earrings.

No. 192

SIR THOMAS LAWRENCE, P.R.A.
1769—1830

MR. E. J. BLAMIRE

(Chairman of the Commission on Sewers)

Canvas: Height, 30 inches; width, 25 inches

HEAD and shoulders of an elderly man, to front, looking at spectator full face, black coat and vest, white stock, gray wig, hands only partly seen on lap; red table and curtain background.

Collections: The late Mrs. J. M. Kennedy, until July, 1902; and Sir Edgar Vincent.

Sir Walter Armstrong's "Lawrence," 1913, p. 115.

No. 193

JOHN HOPPNER, R.A.

1758—1810

THE COUNTESS OF GUILDFORD

Canvas: Height, 30 inches; width, 25 inches

Maria Frances Mary, daughter of George, third Earl of ·Buckinghamshire, born in 1760; married September 30, 1785, the Hon. George North, who succeeded his father in August, 1792, as third Earl of Guildford; died April 23, 1794. A famous beauty, described by the Prince of Wales (George IV) as "the only modest woman of position that he was acquainted with."

HALF-FIGURE, seated to front and looking to left; white dress and fichu, black satin sash, black gauze scarf over left arm; powdered hair bound with band of silk; gold neck chain; rich red curtain background.

Collection: Capt. G. W. Tyler, of Tidmarsh Grange, Pangbourne, who inherited it from his father, Admiral Sir George Tyler, who married a twin sister of Lady Guildford. Sold by order of the High Court of Justice, August 6, 1913, to Mr. Neville Cooper, of 37 Duke Street, London, who sold it to Mr. Blakeslee.

Described and illustrated in the Supplement (1914) to "John Hoppner, R.A.," by W. McKay and W. Roberts.

Although this portrait has always been known as a Hoppner, it possesses more of the characteristics of Sir Thomas Lawrence than Hoppner.

No. 194

JOHN OPIE, R.A.
1761—1807

GIRL WITH CAT

Canvas: Height, 30 inches; width, 25 inches

WHOLE-LENGTH seated figure of a little girl about five, directed to left and looking at spectator; dull-brown low dress trimmed with white; brown curly hair; gold bracelet, hands clasped over a tabby cat which rests on her lap; dark background with window or balcony to right.

No. 195

SIR THOMAS LAWRENCE. P.R.A.
1769—1830

MISS HARE

Canvas: Height, 30 inches; width, 25 inches

HALF-FIGURE, age about twenty-five, standing to front; white high-waisted dress cut to V-shape, white collar, short sleeves, gray belt and gray cloak around shoulders and arms; red coral necklace, black curly hair with broad white band, right arm resting on red-covered table; pillar to left, tree to right.

Back of canvas inscribed: SIR THOMAS LAWRENCE, P.R.A., 1824.

No. 196

HENRY R. MORLAND

Circa 1730—1797

PORTRAIT OF A LADY

Canvas: Height, 30 inches; width, 25 inches

HALF-FIGURE, about twenty-five, to front, looking at spectator; blue low dress with white lace insertion, puffed white sleeves, bow at center of corsage, purple shawl over right arm; long white lace head-dress with blue ribbon.

No. 197

JOHN OPIE, R.A.

1761—1807

MR. RICHARDSON

Canvas: Height, 30 inches; width, 25 inches

HEAD and shoulders of elderly man, to front, brown coat and waistcoat closely fastened, white neckerchief slightly seen; gray wig; dark background.

No. 198

SIR HENRY RAEBURN, R.A.

1756—1823

LORD CRAIG

Canvas: Height, 34¾ inches; width, 26½ inches

William Craig, the Scotch Judge; born in 1745, educated at Edinburgh, Advocate 1768; Sheriff-Deputy of Ayrshire 1787; Lord of Session 1792; died in 1813. A contributor to *The Mirror* and *The Lounger*, two famous weekly periodicals on the plan of Addison's *Spectator*, edited by Henry Mackenzie, author of the once famous "Man of Feeling."

HALF-LENGTH, directed to right, in crimson gown with white cape, crimson ribbon and rosettes, large white cuffs; hands clasped, resting on arm of chair, gray wig; red curtain background.

Raeburn Exhibition, Edinburgh, 1876 (by Mr. Andrew Hay Wilson).
Sale: "The property of a gentleman," Christie's, May 10, 1912, No. 54.
James Greig, "Raeburn," 1911, p. 42.

No. 199

ALLAN RAMSAY
1713—1784

PORTRAIT OF A LADY

Canvas: Height, 30 inches; width, 25 inches

Bust of young woman to front and looking at spectator with smiling expression; gray low bodice almost entirely hidden by a brown and blue cloak or overdress; blue plush turban head-dress; black hair, of which a plait falls over right shoulder.

Collection: Robert Hoe, New York, February, 1911, No. 64, illustrated in the sale catalogue.

No. 200

JOHN OPIE, R.A.

1761—1807

MR. JAMES WHITBREAD

Canvas: Height, 30 inches; width, 25 inches

HEAD and shoulders of elderly man, age 55-60, to front, looking up to left; brown coat fastened with one button, yellow patterned waistcoat, white stock, gray wig.

No. 201

GEORGE ROMNEY (Period of)

LATTER HALF OF THE EIGHTEENTH CENTURY

COUNTRY GIRLS

Canvas: Height, 31½ inches; width, 28½ inches

SMALL whole-length figures, in an open landscape with evening effects, of three young women in red, brown and gold low dresses, probably illustrating a classical scene or story; two are pointing to a distant scene and trying to induce their companion to look that way, but she is recoiling in horror; gray sky background.

No. 202

FRANCIS COTES, R.A.
1726—1770

MISS MARY DASHWOOD

Canvas: Height, 36 inches; width, 28 inches

HALF-FIGURE of a young lady about twenty-five, to front, looking to right, white low dress with pink bow, elaborately pleated bodice, short sleeves with broad muslin and lace cuffs, black bracelets, black shoulder band tied in center of corsage with pink bow, black velvet band around neck; brown hair with pearl ornament; right hand holding shuttle, the cotton from which is held in left hand, arm on red table.

No. 203

SIR WILLIAM BEECHEY, R.A. (?)
1753—1839

LADY HARRIET VERNON

Canvas: Height, 35 inches; width, 27 inches

Youngest daughter of Thomas, Earl of Strafford; married, in 1743, Henry Vernon of Hilton Park, Co. Stafford; died April 12, 1786.

HALF-LENGTH, about twenty-five, to front, looking to left, brown and white low dress with gold insertion and short sleeves, broad blue waistband, ermine cloak over shoulders, pearl bracelet; powdered hair, gold and white turban with border of rubies; right arm resting on ledge, hand supporting face.

An excellent portrait much more suggestive of Sir Joshua Reynolds than Beechey, and to which reference is made in Mr. Roberts's *Introduction.* It is curious to note that in 1775 a "Lady Harriet Vernon" sat to Reynolds for a picture which has never been traced.

No. 204

GEORGE ROMNEY

1734—1802

MAJOR PEIRSON

Canvas: Height, 36 inches; width, 27 inches

Born at Cote, near Burton-on-Kendal, about 1740; entered the Honourable East India Co. 1771 and attained the rank of Major; died at Calcutta, August 5, 1781.

HALF-FIGURE, directed to left and looking downwards; red coat with large gold buttons, white neckerchief, long staff held by left arm, hand hidden in fold of coat; fair brown hair, dark background.

Note: This is the principal figure cut out from the group of Major Peirson, a Brahmin and servant exhibited by Romney at the *Society* of *Artists*, 1771, and described in T. H. Ward & W. Roberts's "Romney, Catalogue Raisonné," p. 120. This group remained in the collection of W. Miller-Rawlinson, of Duddon Hall, Broughton-in-Furness, until its sale in July, 1902.

No. 205

RICHARD COSWAY, R.A.

1742—1821

LADY BOYNTON AND CHILD

Canvas: Height, 46½ inches; width, 36 inches

Mary, eldest daughter of James Heblethwayte; married, as his second wife (after 1767), Sir Griffith Boynton, sixth Bart., of Barton Agnes, Yorkshire (he died in 1778); she married secondly John Parkhurst, of Catesby, and died May 13, 1815.

THREE-QUARTER length of a young woman, seated to front in plain wood chair, looking at spectator, white low dress with broad stiff lace collar, powdered curly hair; gold ring on penultimate finger of left hand, which supports the child's shoulders. The infant in long clothes and lace cap on the mother's lap is looking up towards her; gray background with door to left, cradle seen to right.

From an anonymous sale at Christie's, March 19, 1904, No. 94.

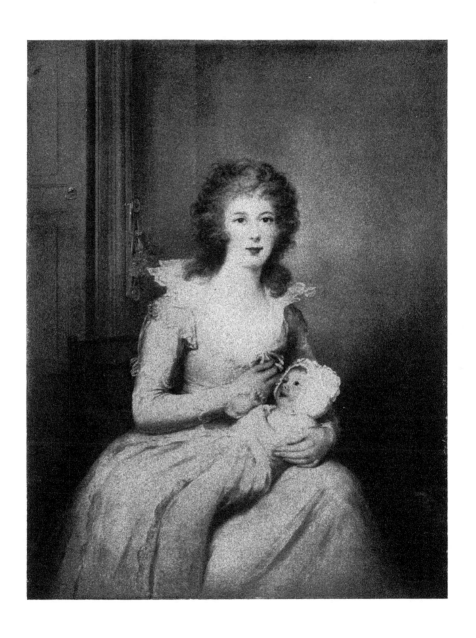

No. 206

SIR JOSHUA REYNOLDS, P.R.A.

1723—1792

MISS KITTY FISCHER

Canvas: Height, 35 inches; width, 27 inches

The most celebrated woman of the town of her time. Katherine Maria, daughter of a German staymaker, named Fischer; married at Haddington, Scotland, October 25, 1766, John Norris, Jr., grandson of Admiral Sir John Norris; lived under the protection of Captain Keppel; sat to Sir Joshua Reynolds frequently between 1759 and 1767; died at "The Three Tuns" Inn, Stall Street, Bath, March 10, 1767, aged about twenty-six, "a victim to cosmetics"; buried at Benenden, Kent.

THREE-QUARTER figure, directed and looking to right, seated on a blue sofa; white low dress, yellow cloak trimmed with ermine; holding dove in lap, another dove perched on edge of sofa; brown hair with plait falling over left shoulder; blue curtain and brown pillar background.

Collection: E. W. Beckett, M.P., May 23, 1903, No. 85.

The version of the same portrait which formerly belonged to A. Geddes, A.R.A., is in the Lenox Collection in the New York Public Library.

No. 207

FRANCIS COTES, R.A.
1726—1770

PORTRAIT OF MRS. OLIVE

Canvas: Height, 49 inches; width, 39 inches

NEARLY whole length of a lady about thirty, seated to front in a carved wood and red plush upholstered armchair, looking to left; green satin dress with short sleeves, white fichu, white long gloves, three dark bands around waist, each with a square jeweled buckle; right arm resting on table, left elbow on arm of chair, hand holding glove; fair hair with tight-fitting flat white bonnet fastened around neck with dark ribbons; pearl earrings; grayish background with red curtain to left.

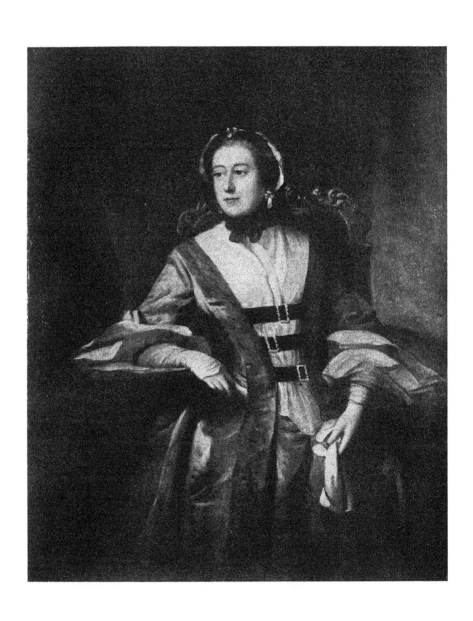

No. 208

BENJAMIN WEST, P.R.A.
1738—1820

DEATH ON THE PALE HORSE

Canvas: Height, 38 inches; length, 55 inches

SKETCH for the finished picture in the Pennsylvania Academy.

Signed and dated in center at lower edge: B. WEST, 1804.

Exhibited at the Royal Academy, 1804.

No. 209

SIR PETER LELY
1617—1680

MISS ELIZABETH LIDDELL

Canvas: Height, 49½ inches; width, 32 inches

Probably Elizabeth, daughter of Sir Henry Liddell, Bart., of Ravensworth Castle, who married, in 1696, Robert Ellison of Hebburn, Co. Durham.

WHOLE-LENGTH portrait of a young girl about nine or ten, in a landscape leaning against a rock; gray satin low dress with flowing blue mantle; fair hair; holding a flat rustic basket of flowers which is resting on a rock, near which is a growing large thistle.

No. 210

SIR THOMAS LAWRENCE, P.R.A.
1769—1830

LADY MELVILLE

Canvas: Height, 49 inches; width, 39 inches

Anne, daughter of Huck Saunders, M.D., and sister of the Countess of West-moreland; married August 29, 1796, Robert, second Viscount Melville; died in 1841.

THREE-QUARTER length, about twenty-five, standing in a landscape directed slightly to right, looking at spectator; black low dress with short sleeves, edged with white, right sleeve with pearl and ruby fastener; white flowing scarf around neck, pearl bracelet; golden hair dressed in curls; left hand resting on bosom, gold ring set with ruby on penultimate finger; stone pillar and flowering shrubs to left, blue sky and shrubs and trees to right.

Collection: Fischhof of Paris, 1906.

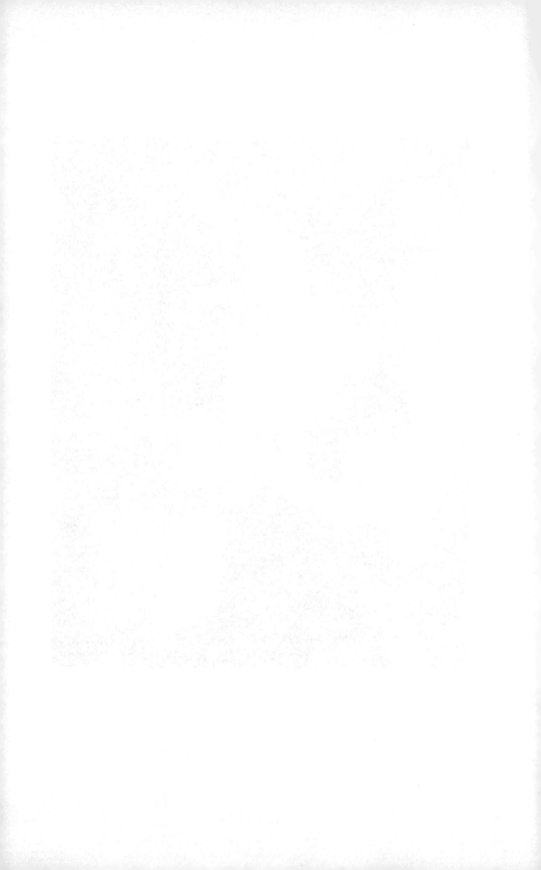

No. 211

GEORGE HENRY HARLOW
1787—1819

GIRL PLAYING THE HARP

Canvas: Height, 49 inches; width, 36 inches

NEARLY whole length of a young lady about twenty, standing looking at spectator and playing a harp; low white satin dress with short sleeves, blue sash; brown curly hair; background crimson curtain and pillar, landscape seen through an open window.

No. 212

FREDERICK W. WATTS
EXHIBITED FROM 1821 TO 1862

THE CANAL BOAT

Canvas: Height, 47 inches; width, 37 inches

A RIVER scene with rustic bridge and a barge containing three figures, two harnessed horses standing on the bank beyond; dense clump of willows and other trees to right, distant view to left.

Collections: William Cave, 1859; Viscount Falkland, June 14, 1907, No. 23.

Note: This is one of the many excellent works by F. W. Watts which long passed as by John Constable.

No. 213

SIR MARTIN ARCHER SHEE, P.R.A.

1769—1850

MRS. KEMBLE AS "COWSLIP"

Canvas: Height, 49 inches; width, 39 inches

Elizabeth Satchell, daughter of a musical instrument maker; born about 1763; appeared at Covent Garden in September, 1780, as P*olly* in "The Beggars' Opera," played *Desdemona* to Stephen Kemble's *Othello* in 1783, about which time she married him; one of her successes was as *Cowslip* in O'Keefe's "The Agreeable Surprise"; died at The Grove, near Durham, January 20, 1841. "A little woman but a great actress," says one of her biographers.

THREE-QUARTER length, walking to right, looking at spectator, and carrying a white bowl; white low dress, pale-blue shawl over shoulders, red rose in center of corsage, gold necklace; brown curly hair, white high-crowned Welsh hat trimmed with blue ribbon; sculptured stone urn to left, autumnal tinted trees in background, distant landscape to right.

Exhibited: Royal Academy, 1793, No. 32.

Collections: H. A. Rannie of Glasgow; and Sir Cuthbert Quilter, London, 1909, No. 96.

Reproduced under the title of "The Country Girl," and as by Sir Joshua Reynolds in the "Pall Mall Magazine," January, 1905; and in the privately printed "Catalogue" of Sir Cuthbert Quilter's Pictures, 1909.

Shee's "Life of Sir Martin A. Shee," 1860, p. 173.

Note: This has been cut down from a whole length since it left the Quilter Collection.

No. 214

SIR PETER LELY

1617—1680

FRANCES LADY DIGBY

Canvas: Height, 49 inches; width, 39 inches

Daughter of Edward, first Earl of Gainsborough; married Simon, fourth Baron Digby; died in child-birth September, 1684, aged twenty-three. Funeral sermon preached by J. Kettlewell; see "Wilford's Memorials and Characters with Lives of Eminent Persons," 1741.

THREE-QUARTER figure seated at the foot of a large tree, directed to left and looking at spectator; brown low dress trimmed with white, short sleeves, gray overmantle with brooch of precious stones, brown curly hair falling in ringlets over neck, large pearl drop earrings, right hand holding edge of cloak, left hand on lap; distant view to left.

Inscribed in lower left hand corner in gold letters: FRANCES LADY DIGBY.

Collection and Sale: Earl of Gainsborough, April, 1902, No. 98.

No. 215

GEORGE ROMNEY

1734—1802

MRS. UPPLEBY

Canvas: Height, 49 inches; width, 39 inches

Dorothy, second daughter of George Crowle, of Fryston, Yorkshire; married, as his second wife, in 1745, John Uppleby of Wooton and Barrow Hall, Lincolnshire; died September 15, 1787.

NEARLY whole length of elderly lady, seated at a balcony in a red chair, directed to right and looking at spectator; grayish slate-colored dress with short sleeves, long white gloves to elbows; black lace shawl over shoulders, white satin gauffered bonnet tied with white chiffon; gray hair, hands folded on lap.

Painted in 1783.

In T. H. Ward and W. Roberts's "Romney," 1904, through the artist's almost indecipherable entries in his "Diaries," this portrait is incorrectly entered as "Appleby" (p. 4), under which name will be found a record of the picture. The portrait remained untraced until 1911, when it was purchased privately by Messrs. Sulley & Co., London.

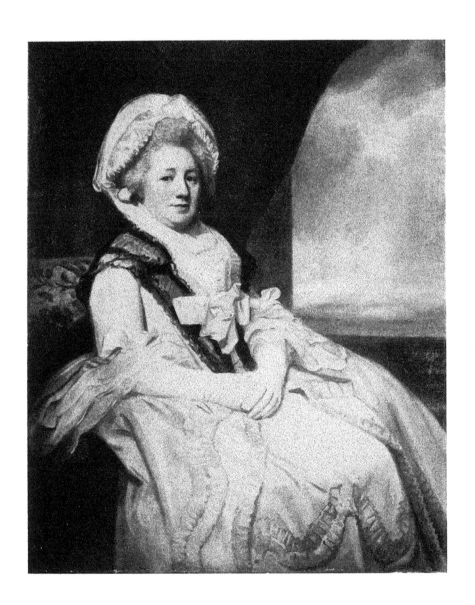

No. 216

JOHN SINGLETON COPLEY, R.A.

1737—1815

THE FORTUNE-TELLER

Canvas: Height, 49½ inches; width, 39 inches

THREE-QUARTER length portrait of a lady in the character of Fortune-Teller, standing to front, in brown dress, short sleeves trimmed with white, partly tucked up white apron, white fichu, pink cloak over shoulders; brown hair with long curl resting on shoulder, bluish-white head-dress with pink bow; left hand extended and holding a coin, right hand raised as if in protest; background a wall and overhanging trees, distant landscape to right.

Exhibited: Worcester, Mass., Museum, circa 1910.

Briefly described in F. W. Bayley's *"Sketch of the Life of J. S. Copley,"* 1910, p. 38.

No. 217

SIR HENRY RAEBURN, R.A.

1756—1823

MRS. STEWART RICHARDSON

Canvas: Height, 50 inches; width, 40 inches

Elizabeth Ann, eldest daughter and co-heir of James Stewart of Urrard, Perth; married James Richardson of Pitfour, Perth (who died July 26, 1825). Their eldest son, John Stewart Richardson, succeeded his kinsman as thirteenth Baronet of Pitfour in 1837.

HALF-LENGTH, middle age, seated in armchair, directed to left, looking at spectator; red dress cut to V-shape, white muslin collar and cuffs, white turban head-dress, fair curly hair; right arm resting on table and holding gloves; to left table with books and black shawl, the end of latter on lap; gray background with red curtain overhead to right.

Exhibited: French Gallery, Pall Mall, 1911; illustrated in the volume of "Pictures by Sir Henry Raeburn, R.A., exhibited at the French Gallery."

James Greig: "Raeburn," 1911, p. 58.

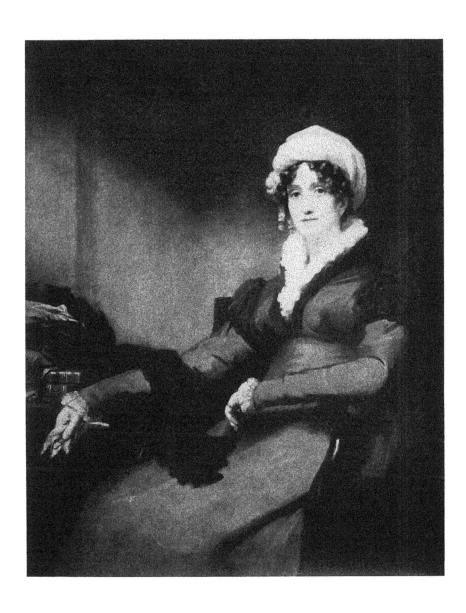

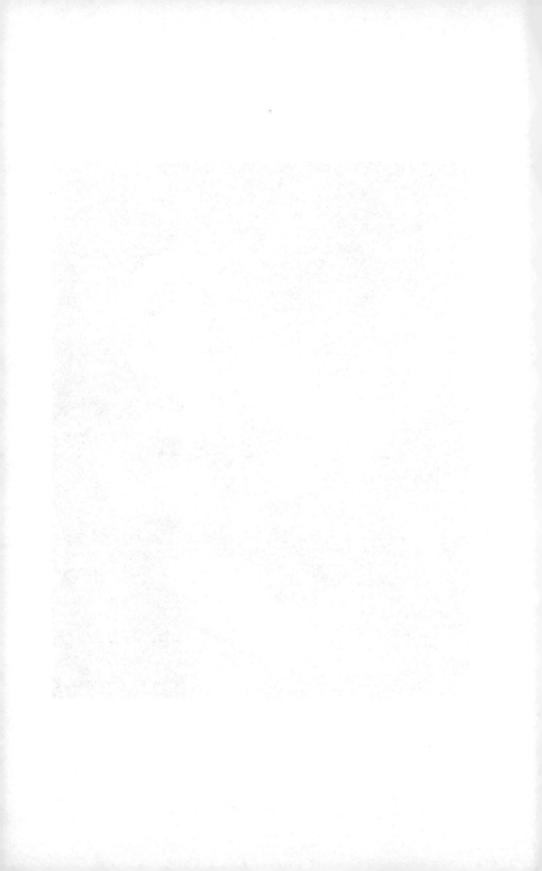

No. 218

FRANCIS COTES, R.A.

1726—1770

PORTRAIT OF MISS HASTINGS

Canvas: Height, 49½ inches; width, 39½ inches

THREE-QUARTER length of a young lady about twenty-five, in a landscape, standing, directed to right, looking at spectator, white dress, broad white gauffered collar; brown curly hair, straw hat edged and trimmed with blue, black shawl under left arm; trees and shrubs to right.

From an anonymous sale at Christie's, July 12, 1912, No. 10.

No. 219

FRANCIS COTES, R.A.

1726—1770

GIRL WITH A HARP

Canvas: Height, 50 inches; width, 40 inches

WHOLE length of a young girl about ten, seated in a landscape, directed to right, looking at spectator; white low dress, long creamy white jacket edged with gold, pink shoes with gold buckles; long, fair hair, right hand resting on knee, left hand on small harp-like instrument; trees with autumnal foliage to left, distant landscape to right.

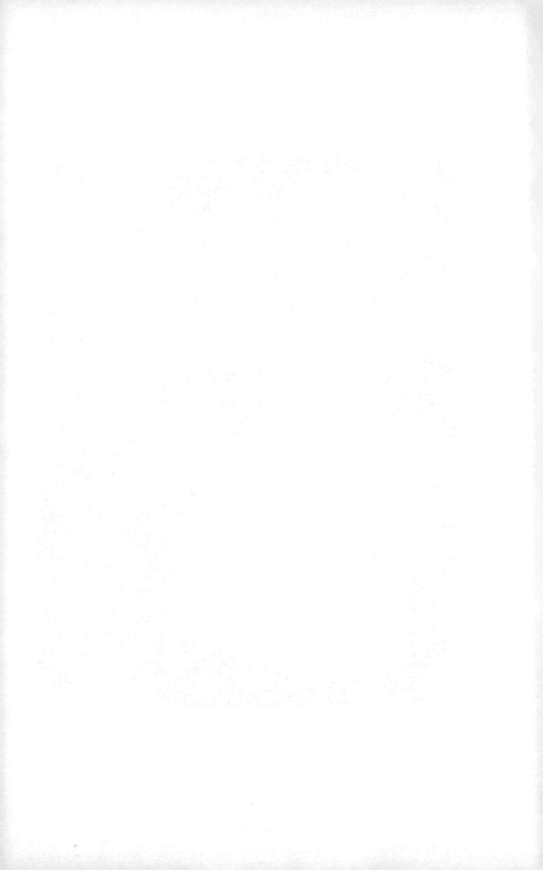

No. 220

GEORGE FREDERICK WATTS, R.A.
1817—1904

LADY AND TWO CHILDREN

Canvas: Height, 49 inches; width, 39 inches

GROUP of a mother, about twenty-five to thirty, and two young children near a balcony. The mother seated, and embracing the elder child, who is in red low dress, white stockings and black shoes; the younger child on its mother's lap in white dress and arms extended; pillars and red curtain background.

Signed and dated to left across rug on the mother's lap: G. F. WATTS, 1837.

Note: A very interesting picture, probably the earliest in existence, of this great master and differing totally from his well-known style of later date. He first began to exhibit at the Royal Academy in 1837.

No. 221

SIR THOMAS LAWRENCE, P.R.A.

1769—1830

MARQUIS OF HERTFORD

Canvas: Height, 50 inches; width, 40 inches

Francis Charles Seymour, Earl of Yarmouth; born in March, 1777; M.P. for Oxford, Lisburne and Camelford, 1819-22; Vice Chamberlain to the Prince Regent; succeeded his father as third Marquis of Hertford in 1822; died in March, 1842. He was the original of Thackeray's "Lord Steyne," and one of the most notorious "men about town" during the latter part of the eighteenth and early nineteenth centuries; his wife was the heiress Maria Fagnini, and their son, the fourth Marquis, was the founder of the Wallace Collection in London.

HALF-LENGTH, standing to front, looking to right; black buttoned-up coat with velvet collar, the red lining of vest showing at neck, white collar, black stock, wearing the star of the Order of the Garter; red hair and side whiskers.

Painted about 1825.

Engraved by W. Holl, 4½ by 3½ inches, for Jerdan's "National Portrait Gallery," 1833.

Collections: Marquis of Hertford; Sir Richard Wallace; and Sir John E. A. Murray Scott.

Murray Scott Sale, June, 1913, No. 109.

Sir W. Armstrong's "Lawrence," 1913, p. 139.

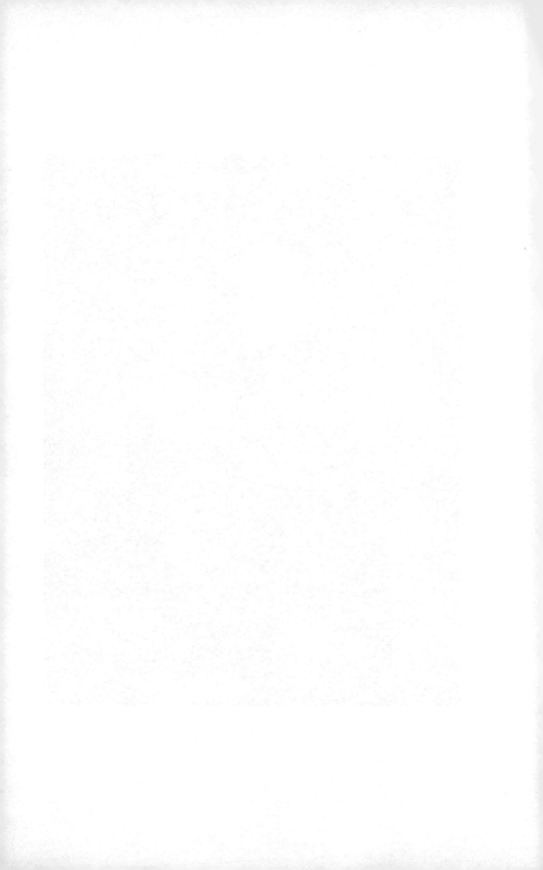

No. 222

JACOB HOUSMAN (or HUYSMANS)
1656—1696

MRS. HOBEY

Canvas: Height, 53 inches; width, 37 inches

THREE-QUARTER length figure, age about thirty-five, seated, directed to left and looking at spectator; bluish low silk dress, short broad sleeves with fast-teners and brooch of precious stones; brown curly hair with blue ribbon and pearl ornaments; right arm on rock, hand resting against face, left arm on lap, fingers extended; stag to right; background stone wall, with foliage to left.

Signed to right on rock in gold letters: MRS. HOBEY. J. HOUS-MAN PINX.

No. 223

SIR JOSHUA REYNOLDS, P.R.A.

1723—1792

EARL GOWER (MARQUIS OF STAFFORD)

Canvas: Height, 88 inches; width, 57 inches

Son of John 1st Earl Gower; born August 4, 1721; M.P. for Westminster 1747-1764; Lord Privy Seal, Lord Chamberlain and Lord President of the Council; succeeded as second Earl Gower in 1754; created Marquis of Stafford, March 1, 1786; died October 26, 1803.

Whole-length, middle-aged, standing on a balcony, in Peer's robes with chain and pendant of St. George; coronet in right hand, left holding ribbon of cloak; wig; pillar and red curtain to left.

Earl Gower sat to Reynolds in 1760-1.

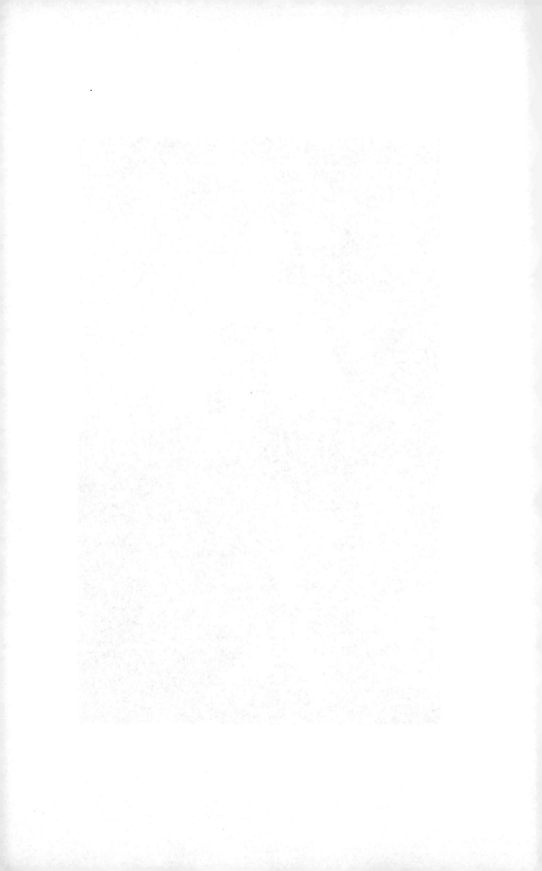

No. 224

SIR GODFREY KNELLER

1646—1723

PORTRAIT OF WILLIAM III

Canvas: Height, 50 inches; width, 40 inches

THREE-QUARTER length, middle age, standing to right, looking at spectator full face; in demi-suit of armor, blue and gold dress, white lace scarf and cuffs, red cloak flowing across shoulders and fastened with large brooch set with a miniature, long black wig; left hand resting on hip, right hand holding baton; to right table with crown; to left sculptured wall or pillar.

Inscribed at lower left hand corner: WILLIAM III.

Collection: The Earl of Sheffield, December 11, 1909, No. 99.

No. 225

SIR GODFREY KNELLER

1646—1723

SOPHIA, WIFE OF GEORGE I (?)

Canvas: Height, 87 inches; width, 52 inches

Only daughter and heiress of George, Duke of Zelle; born February 3, 1666; married November 21, 1682, George, Elector of Hanover, who succeeded as George I of Great Britain in August, 1714; divorced in 1694; died November 13, 1726.

WHOLE length, about twenty-five to thirty, life size, standing near a balcony, in state robes, blue ermine lined gown and mantle and white satin gold-embroidered petticoat, richly studded with pearls and precious stones, fair hair with pearl and other ornaments; left hand holding robes, right hand on orb which, with crown, rests on blue-covered table; red curtain background. .

Exhibited: Guelph Exhibition, New Gallery, 1891, No. 11.

Collection: Duke of Fife, of Duff House, Banffshire, June 7, 1907.

No. 3152 in the old catalogue of the Fife pictures. This was No. 17 in the Duke of Fife sale and was included among the portraits by unknown artists. It is a very fine portrait of a beautiful woman, more in the style of a French artist than Kneller and probably represents some other Queen Sophia than the wife of George I, to whose other known portraits it bears no resemblance. A lengthy reference to the picture will be found in Mr. Roberts's Introduction.

No. 226

SIR DAVID WILKIE, R.A.

1785—1841

KING WILLIAM IV

Canvas: Height, 51 inches; width, 41 inches

Third son of George III; born August 21, 1765, created Duke of Clarence and Earl of Munster; entered the Navy in 1779; succeeded to the throne June 26, 1830; died June 20, 1837.

THREE-QUARTER figure to front, looking at spectator, in full robes, with the decorations of the Garter, St. George and other orders; right hand resting on hilt of richly jeweled sword, left hand hanging down by side; bareheaded.

Painted about 1833.

SIR LAURENZ ALMA-TADEMA, R.A.

1836—1912

THE SCULPTURE GALLERY

Canvas: Height, 86½ inches; width, 66 inches

INTERIOR view of a Roman sculptor's studio. In the center a slave is turning a bronze vase mounted on a marble pedestal, which is being inspected by a lady (who holds a large blue fan) and two gentlemen seated on a marble bench on the left; near them stand a lady and two children; a marble seated figure is seen on the right, and through a porchway men are seen at work.

Signed to right on pillar: L. ALMA-TADEMA, OP. CXXV.

Exhibited: Royal Academy, 1875; Grosvenor Gallery, 1883 (E. Gambart); Chicago, 1893 (C. McCulloch); Burlington House, London, 1909 (Mrs. McCulloch); same place, 1913 (Mrs. Coutts-Michie—formerly Mrs. McCulloch).

Engraved in pure line by Augusta Blanchard, 20 by 15¾ inches, 1877; and frequently reproduced (e. g. "The Art Journal," March, 1883, p. 65).

Collections: Ernest Gambart and George McCulloch.

George McCulloch sale, May 29, 1913, No. 111 (illustrated in the sale catalogue); purchased for Mr. Blakeslee.

This famous work is the *pendant* of "The Picture Gallery," which appeared at the Royal Academy of 1874. Both pictures were commissioned by the dealers, Messrs. Pilgeram and Lefevre, for the Gallery of the late Ernest Gambart, NVO, Consul-General for Spain, at Les Palmiers, Nice. After hanging there for many years, Mr. Gambart was induced to sell "The Sculpture Gallery" to Messrs. Tooth, who sold it to the late George McCulloch. The

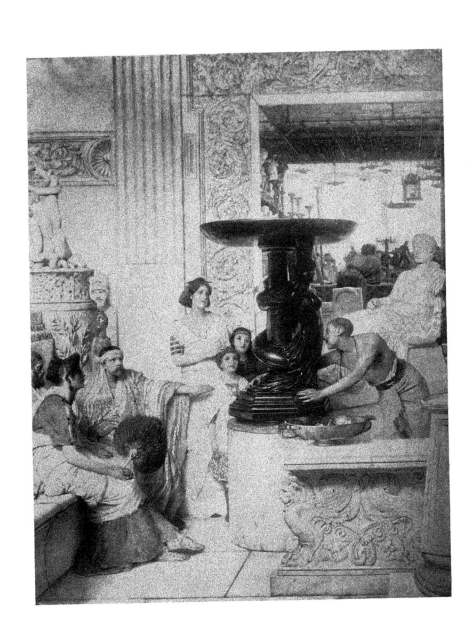

figures in the picture are all portraits. The lady seated and holding a fan was a great beauty and an intimate friend of the Tadema family; the man next to her, and whose head is only partly seen, was Dr. Washington Epps, the artist's brother-in-law; Alma-Tadema himself is seen giving directions by extending his arm to his two children—Lawrence and Anna Tadema—by his first wife, to stand on one side whilst the slave is turning the vase. The lady standing up behind the children is the artist's second wife (née Laura Epps). The objects depicted in the picture are from celebrated antique works: The vase in the center from that in the Naples Museum; the portrait of Agrippina from that in the Capitol at Rome; the portrait of Pericles from that in the Vatican; the silver dish upon the table from that in the Berlin Museum; the table from that in the Casa Rufi at Pompeii; and the Hercules Strangling the Serpent is also well known to archæologists.

After the picture was engraved Alma-Tadema introduced several modifications which may readily be traced on comparing the picture with the engraving. These alterations are in all cases improvements. For instance, the bronze horse from that in the Naples Museum, and of which the forequarters only are seen on the right in the engraving, has been eliminated, as well as the winged monster on which the horse rested; the latter is substituted by a dwarf marble column on which is the artist's signature; on the upper left hand corner some plain paneling has been replaced by a frieze and a sculptured column.

No. 228

SIR WILLIAM Q. ORCHARDSON, R.A.

1835—1910

THE YOUNG DUKE

Canvas: Height, 58 inches; length, 98 inches

THE scene is laid in a tapestried banqueting-hall; a number of guests, dressed in costumes of the period of James II, are standing around the dining-table at the conclusion of the repast, with their glasses held on high, toasting the young Duke, their host, who is seated in an arm-chair at the head of the table; there are numerous dishes of fruit, silver ornaments and glasses decorating the dinner-table, and a large bowl of roses stands upon a serving-table in the foreground.

Signed and dated: W. Q. ORCHARDSON, '88.

Exhibited: Royal Academy, 1888; Guildhall, London, 1897 (*G. McCulloch*); Burlington House, London, 1909 (*Mrs. McCulloch*); *International Exhibition, Rome, 1911 (Mrs. Coutts-Michie—formerly Mrs. McCulloch*).

Etched by F. A. Laguillermie, 28 by 16½ inches; reproduced by permission of Mr. Robert Dunthorne, the owner of the copyright, as the frontispiece to Christie's catalogue of the McCulloch sale.

Collections and sale: Charles Neck, until 1896, and G. McCulloch, May 29, 1913, No. 178; purchased for Mr. Blakeslee.

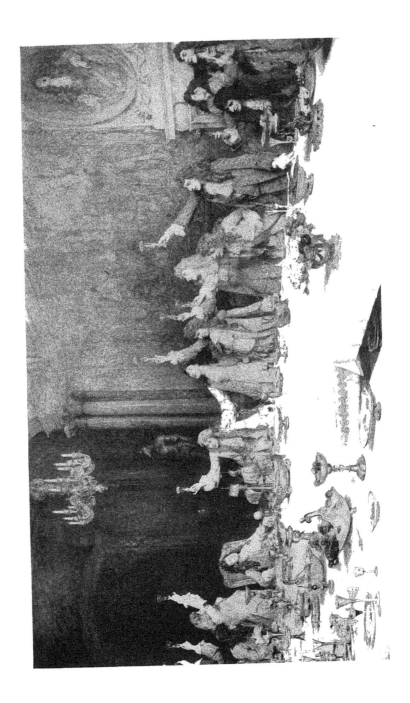

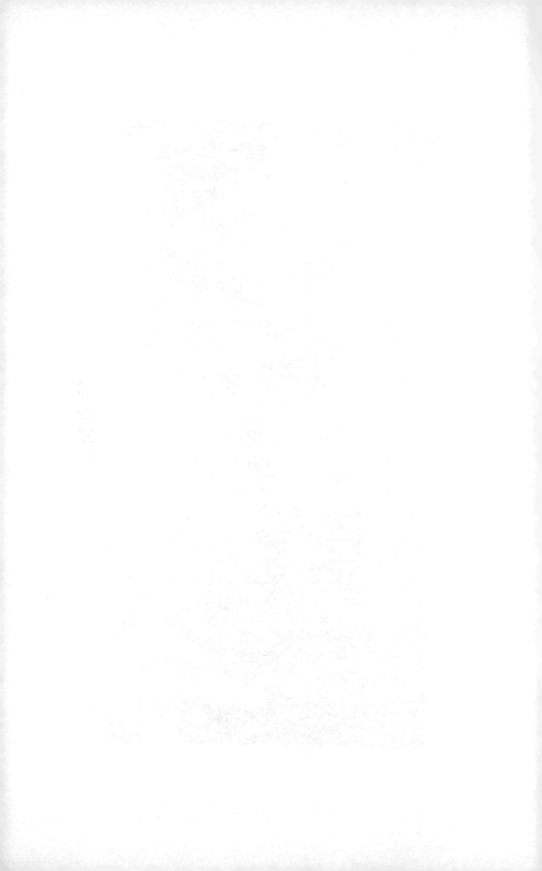

No. 229

SIR DAVID WILKIE, R.A.

1785—1841

QUEEN ADELAIDE

Canvas: Height, 51 inches; width, 41 inches

H.S.H. Amelia Adelaide Louise Terese Caroline Wilhelmina, eldest daughter of the Duke of Saxe-Meiningen; born August 13, 1792; married the Duke of Clarence (afterwards William IV) July 11, 1818; died December 2, 1849.

THREE-QUARTER length to front, looking to left, in coronation robes, white low dress, blue and ermine cloak, brown hair in curls over forehead, coronet with three drop pearls; three-row pearl necklace, jeweled bracelets and rings; fingers of left hand resting on book which lies on scarlet covered table, right hand holding white gloves; scarlet curtain to right, doorway to left.

Painted about 1831-2.

No. 230

MARTIN CREGAN, P.R.H.A.

1788—1870

MRS. HAWKINS AND CHILDREN

Canvas: Height, 46 inches; length, 60 inches

The wife and children of Captain J. Hawkins, of the Bombay Engineers.

A GROUP of five figures. The mother with golden hair, seated to left in low blue silk dress, with scarlet and gold cloak over her shoulders; the youngest child in white on its mother's lap, holding her hand, gray felt hat in its left hand; the elder, golden, curly-haired girl, in white, rests her right hand on the child's shoulder and is pointing with a rose to her left; the second youngest child is standing by a red-covered table and is holding a spray of flowers; to the right, a gold-haired boy in blue suit with gold buttons and white lace collar is looking towards the mother; landscape background.

From the collection of the family of Admiral Hawkins. Formerly ascribed to Sir William Beechey, and probably the picture exhibited at the Royal Academy of 1819, No. 202.

No. 231

SIR THOMAS LAWRENCE, P.R.A.

1769—1830

LADY SHAW

Canvas: Height, 92 inches; width, 57 inches

WHOLE length, life size, about twenty-five, walking to left on a seashore; red low dress, with short sleeves trimmed with white lace, golden waistband, gold bracelet on right arm, ring set with ruby on last finger; dark curly hair with gold band and sprig of foliage; white shawl edged with gold flowing over right shoulder and held with right hand, left hand with ring on penultimate finger and holding fold of dress; black shoes; to right massive cliffs with flowers, to left view of sea, red flowering poppies, etc., on shore.

No. 232

WILLIAM DOBSON

1610—1646

SIR CHARLES AND LADY LUCAS

Canvas: Height, 47 inches; length, 66 inches

The famous Royalist, knighted in 1638, taken prisoner at Marston Moor, 1644; took a leading part in the defence of Colchester, and on its capitulation was condemned to death, August 30, 1648. His portrait was painted several times by Dobson. There is apparently no record that Sir Charles Lucas ever married, and the lady may be his sister Margaret, Duchess of Newcastle.

Two half-length seated figures; to left a stout, middle-aged man, in red and brown dress with steel gorget and gold-handled sword, white lace collar and white cuffs, long brown hair; right arm resting on stone ledge, left hand extended towards his companion, who is about thirty years of age and is fondling a King Charles spaniel. She is in white satin low dress with pearl and ruby ornaments, red cloak, blue coverlet or shawl on lap; pearl necklace, brown hair with pearl ornaments.

Collection: The late Colonel W. E. G. Lytton-Bulwer, Quebec Hall, Norfolk.

This picture is referred to in Mr. Roberts's Introduction.

No. 233

SIR PETER LELY

1617—1680

TWO LADIES AND CUPID

Canvas: Height, 50 inches; length, 57 inches

Two middle-aged ladies seated in a landscape; the principal figure to right in blue velvet dress garnished with pearls and precious stones, large pearl earrings, long brown curly hair; she is holding the end of a chaplet of flowers which is offered her by Cupid, who occupies the center of the picture and is encircled by a scarlet robe and his fair hair with a floral wreath. The lady to the left is in brown dress with pearl and other ornaments, large drop pearl earrings, black hair of which a curl rests on the right shoulder. A second Cupid is seen in the air behind a tree; distant landscape and houses to right.

No. 234

SIR WILLIAM BEECHEY, R.A.

1753—1839

THE STANLEY CHILDREN

Canvas: Height, 74 inches; width, 54 inches

GROUP of three children near a balcony, looking at spectator; to left the eldest boy, in blue dress, white broad collar and fair hair, is supporting the younger girl, who is standing on a blue upholstered chair and is dressed in white with lace frilled cap and yellow sash; the elder girl is seated on a footstool, dressed in white, with red coral necklace and fondling a spaniel, on the edge of the chair hangs her large straw hat; to left a second dog is seen, flowers and a whip-top on the floor; to left distant hill landscape, to right red curtain.

From Heydon Hall, Norfolk, the residence of the Bulwer family.

SIR DAVID WILKIE, R.A.

1785—1841

CHRISTOPHER COLUMBUS EXPLAINING THE PROJECT OF HIS INTENDED VOYAGE FOR THE DISCOVERY OF THE NEW WORLD IN THE CONVENT OF LA RABIDA

Height, 57 inches; length, 73 inches

A STRANGER traveling on foot, accompanied by a young boy, stopped one day at the gate of the Convent of *F*ranciscan friars, dedicated to Santa Maria de Rabida, and asked of the porter a little bread and water for his child. While receiving this humble refreshment the guardian of the convent, *F*riar Juan de Perez La Marchena, happening to pass by, was struck by the appearance of the stranger, and observing from his air and accent that he was a foreigner, entered into conversation with him. That stranger was Columbus.

The conference which followed, remarkable for opening a brighter prospect in the fortunes of Columbus, forms the subject of the picture, in which he is represented seated at the convent table, with the *F*riar on his right, to whom he is explaining on a chart the theory upon which his long-contemplated discovery is founded. At his left is his young son *D*iego, with a small Italian greyhound at his feet, supposed to have accompanied them on their voyage from Genoa.

At the other side of the picture, resting on the table, is the physician of Palos, Garcia *F*ernandez, who, from scientific knowledge, approved of the enterprise, and whose testimony has recorded this event. Behind him, with the telescope in his hand, is Martin Alonzo Pinzon, one of the most intelligent sea-captains of his day, who, though tarnished in his fame by subsequent desertion, concurred in the practicability of his plans, assisted in the outfit of the expedition, and sailed with Columbus. With this support in confirmation of his own judgment, the *F*riar Juan de Perez became the friend and benefactor of Columbus, received his son into the Convent to be educated, and furnished to himself a recommendation to *F*ernandez de Talavera, Confessor to the Queen, which eventually obtained for him the assistance of the Court in his adventure, and to Spain the credit of his great discovery (see Washington *I*rving's "Life of Columbus").

Painted for Mr. R. S. Holford, who paid the artist £500 for it, and whose son, Captain (now Sir George L.) Holford, sold it with other pictures

*in 1895 to Messrs. T. Agnew & Sons, who sold it to Messrs. T. Wallis
& Sons, of London.*

*Exhibited: Royal Academy, 1835, No. 64; British Institution, 1842, No. 18;
Art Treasures, Manchester, 1857, No. 618; Burlington House, 1870,
No. 35; same place, 1893, No. 133; and International Exhibition, London, 1874, No. 45.*

Engraved in stipple by H. T. Ryall, 18½ by 25 inches, June 18, 1843, dedicated to Mr. R. S. Holford, by the publisher, F. G. Moon.

*References: Allan Cunningham's "Life of Sir David Wilkie," 1843, Vol. III,
pp. 78, 93, 95-6, 530; J. W. Mollett, "Sir David Wilkie," 1881, p. 89.*

Notes: Writing on December 17, 1834, John Constable says: "I was at Wilkie's all day on Monday; he has painted a noble picture, Columbus with the Monk, where he shows him his plan for overtaking another world." Constable had been asked by Wilkie to sit for one of the heads in the picture of Columbus, that of the physician Garcia Fernandez. Among Constable's papers Leslie found a slight pencil sketch of the whole composition of that fine picture. (See Leslie's "Life of Constable.") "This picture," says Dr. Waagen, "in which the figures are of an unusually large scale, is the chief specimen of the influence of Velasquez and Murillo on this great painter. In truth, with the masses of deep chiaroscuro, the warm, full tones and broad treatment, it gives the impression of an old picture."

With the picture will be sold a red leather volume containing (1) an autograph letter from Wilkie to Sir William Newton referring to a proposal for the engraving of the Columbus, (2) three engraved portraits of Wilkie, and (3) a permit, signed by Wilkie, admitting Lord Mulgrave to the private view of the Royal Academy, 1820.

No. 236

SIR JOSHUA REYNOLDS, P.R.A.

1723—1792

ANNABELLA LADY BLAKE AS "JUNO"

Canvas: Height, 93½ inches; width, 57 inches

Second daughter of the Rev. Sir William Bunbury, fifth Baronet; born in February, 1745; married first, Sir Patrick Blake (which marriage was dissolved in 1778); and secondly George Boscawen of St. Peter's, Isle of Thanet; died April 20, 1841.

WHOLE length, life size, as "Juno" receiving the Cestus from Venus, who is resting on a cloud with two doves, a peacock at her feet; classical pink dress and blue cloak which she holds with her left hand; her hair, adorned with pearl ropes, falls in two plaits over her shoulders; right hand extended to Venus who is partially draped in a pink robe. (The Cestus, a mysterious girdle, worn as an ornament, gave beauty, grace and elegance when used even by the most deformed; it excited love, and through it Juno was able to gain the favor of Jupiter.)

Painted between 1764-9.

Exhibited: Royal Academy, 1769, No. 90; Burlington House, 1908, No. 146 (Charles J. Wertheimer).

Engraved in mezzotint by John Dixon, 24 by 16 inches, 1771; by S. W. Reynolds, 6¼ by 4 inches, and frequently repeated; a full-page plate was published in Christie's sale catalogue, May, 1912.

Collections: The picture remained in the Bunbury family until its sale (with other Bunbury pictures), by private contract, to the late Mr. Charles John Wertheimer, in whose sale at Christie's, May 10, 1912, it was No. 64. The companion whole length of Sir Patrick Blake belonged to Mr. David H. King, Jr., of New York, and was in his sale in March, 1905.

Graves and Cronin's "Reynolds," 1899, Vol. I.

SIR THOMAS LAWRENCE, P.R.A.

1769—1830

KEMBLE AS "ROLLA"

Canvas: Height, 130 inches; width, 85 inches

John Philip Kemble as *Rolla* in Sheridan's "Pizarro." Son of Roger Kemble; born in 1757; educated at Douai, and first appeared in London in 1783, as *Hamlet;* "Pizarro" was produced at Drury Lane in 1799, the cast including Mrs. Jordan and Mrs. Siddons; Kemble retired from the stage in 1817; and died in 1823.

WHOLE length, heroic size, in classical costume, short white coat with gold trimmings, belt studded with diamonds, panther's skin across shoulders, red sandals, jeweled leg-band, left arm outstretched holding golden-haired child, right hand holding sword.

In the original frame.

Exhibited: Royal Academy, 1800, No. 193; British Institution, 1806, No. 46; same place 1844, No. 144 (Sir Robert Peel).

Collection: Sir Robert Peel, until the dispersal of the Peel heirlooms, May, 1900, No. 214.

The body of "Rolla" is said to have been painted from Jackson, the pugilist, and the child from Sheridan's infant son. The picture is painted over Lawrence's "Prospero Calling up the Storm," 1794.

Engraved by S. W. Reynolds, and published by Boydell at the Shakespeare Gallery, June 4, 1803, with the following quotation:

ROL. Then was this sword Heaven's gift, not thine.
 (*Seizes the child.*)
Who moves one step to follow me, dies upon the spot.
 (*Exit with child.*)
 "Pizarro," Act V, Sc. 2.

References: Sir Walter Armstrong, "Lawrence," 1913, p. 142; and James Boaden, "Life of J. P. Kemble," Vol. 2, pp. 240-1.

AMERICAN ART ASSOCIATION,
 MANAGERS.

THOMAS E. KIRBY,
 AUCTIONEER.

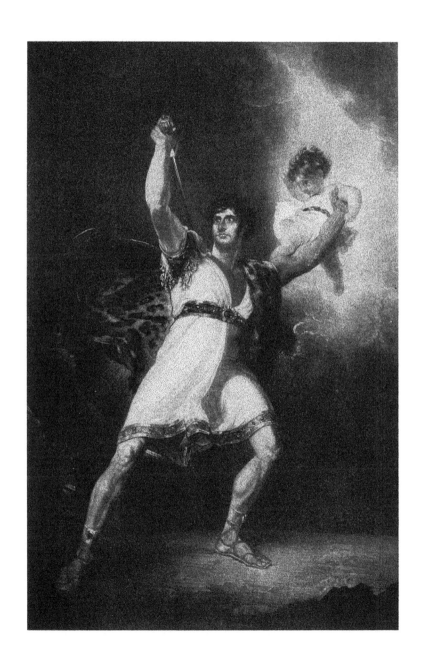

LIST OF ARTISTS REPRESENTED
AND THEIR WORKS

ITALIAN SCHOOLS

TUSCAN SCHOOLS

NORTH ITALIAN SCHOOLS
Milan, Vicenza, Verona, Venice

LATE ITALIAN SCHOOLS

Seventeenth and Eighteenth Centuries

EARLY FRENCH SCHOOL

FLEMISH SCHOOL

ENGLISH SCHOOLS

FOR INHERITANCE TAX

AND OTHER PURPOSES

THE AMERICAN ART ASSOCIATION

IS EXCEPTIONALLY WELL EQUIPPED
TO FURNISH

INTELLIGENT APPRAISEMENTS

OF

ART AND LITERARY PROPERTY
JEWELS AND PERSONAL EFFECTS OF EVERY
DESCRIPTION

IN CASES WHERE

PUBLIC SALES ARE EFFECTED

A NOMINAL CHARGE ONLY WILL BE MADE

THE AMERICAN ART ASSOCIATION
MADISON SQUARE SOUTH
NEW YORK
TELEPHONE, 3346 GRAMERCY

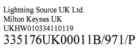

9 780265 857991